YOUNG AND DIE	YOUNG AND LIVE
OLD AND DIE	OLD AND LIVE
CUT AND DIE	CUT AND LIVE
RUN AND DIE	RUN AND LIVE
STAY AND DIE	STAY AND LIVE
PLAY AND DIE	PLAY AND LIVE
KILL AND DIE	KILL AND LIVE
SUCK AND DIE	SUCK AND LIVE
COME AND DIE	COME AND LIVE
GO AND DIE	GO AND LIVE
KNOW AND DIE	KNOW AND LIVE
TELL AND DIE	TELL AND LIVE
SMELL AND DIE	SMELL AND LIVE
FALL AND DIE	FALL AND LIVE
RISE AND DIE	RISE AND LIVE
STAND AND DIE	STAND AND LIVE
SIT AND DIE	SIT AND LIVE
SPIT AND DIE	SPIT AND LIVE
TRY AND DIE	TRY AND LIVE

art:21

Laurie Anderson

Matthew Barney

Louise Bourgeois

Michael Ray Charles

Mel Chin

John Feodorov

Ann Hamilton

Margaret Kilgallen

Beryl Korot

Barbara Kruger

Maya Lin

Sally Mann

Kerry James Marshall

Barry McGee

Bruce Nauman

Pepón Osorio

Richard Serra

Shahzia Sikander

James Turrell

William Wegman

Andrea Zittel

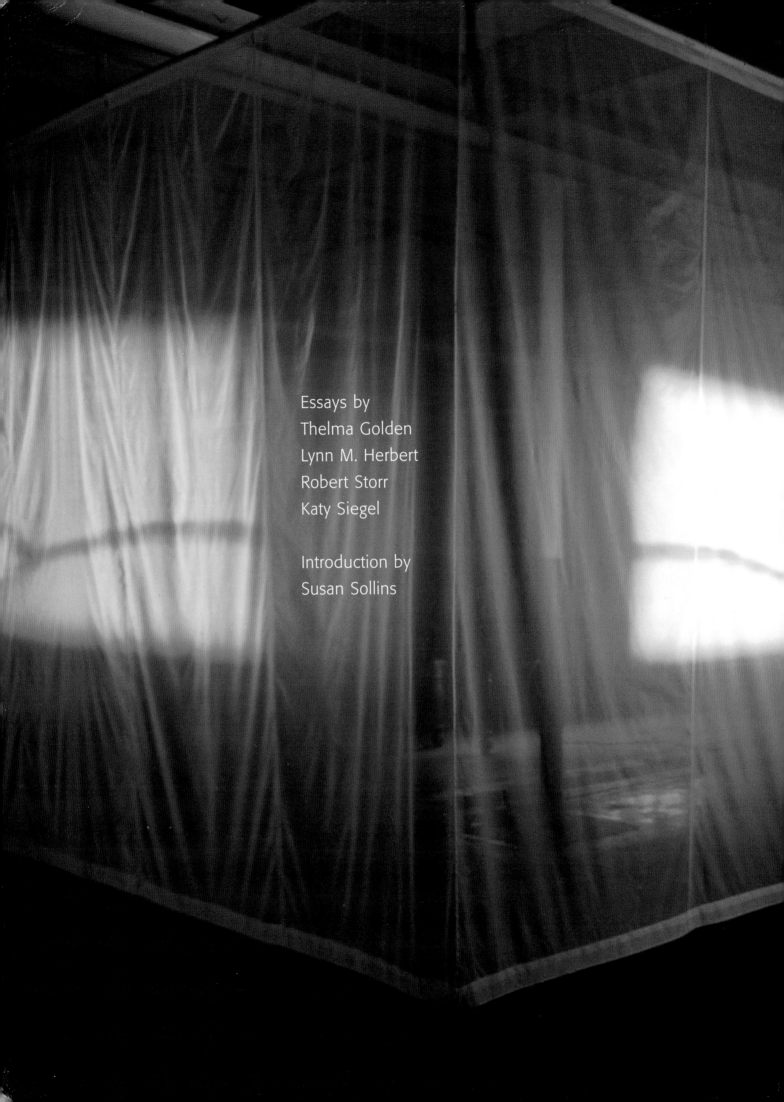

Essays by
Thelma Golden
Lynn M. Herbert
Robert Storr
Katy Siegel

Introduction by
Susan Sollins

art:21

ART IN THE TWENTY-FIRST CENTURY

HARRY N. ABRAMS, INC., PUBLISHERS

For Harry N. Abrams, Inc.:
Project Director: Margaret L. Kaplan
Designer: Russell Hassell

For Art21, Inc.:
Project Director: Susan Sollins
Publication Coordinator: Quinn Latimer

Library of Congress Cataloging-in-Publication Data

Art 21 : art in the twenty-first century / by Robert Storr ... [et al.] ;
introduction by Susan Sollins.
 p. cm.
Summary: Companion book to Art in the Twenty-First Century,
the first broadcast series for National Public Television to focus
exclusively on contemporary visual art and artists in the United
States today.
 ISBN 0-8109-1397-6
 1. Art, American—20th century. 2. Art—Forecasting.
3. Artists—United States—Biography. 4. Artists—United
States—Interviews. I. Title: Art in the 21st century.
II. Title: Art twentyone. III. Storr, Robert.
 N6512 .A6685 2001
 709'.73'09051—dc21 2001001268

Harry N. Abrams, Inc.
100 Fifth Avenue
New York, N.Y. 10011
www.abramsbooks.com

Endpages
Bruce Nauman. *One Hundred Live and Die*
(detail), 1984. See p. 119, fig. 9

Pages 2–3
Ann Hamilton. Installation view of *ghost . . .
a border act*, 2000. See p. 82, fig. 15

Pages 4–5
Richard Serra. Installation view of *Torqued
Ellipse VI*, 1999. See p. 61, fig. 35

Page 7
James Turrell. Site-specific permanent
installation of *Hi Test*, 1997. See p. 72, fig. 5

Pages 206–207
Andrea Zittel. *A–Z Travel Trailer Unit
Customized by Andrea Zittel*, 1995.
See p. 191, fig. 36

Contents

Acknowledgments

I am delighted to acknowledge the involvement and assistance of those who have made this book a reality. Without the television series, "Art:21— Art in the Twenty-First Century," and the team that worked so diligently to create it, the book would not exist. Thanks are thus owed first to Art 21's extraordinary staff—first and foremost to Executive Producer Susan Dowling, whose partnership, wisdom, and experience made this entire project possible—and to Coordinating Producer Eve Moros; Associate Producer Migs Wright; Production Coordinator Laura Recht; Researcher Quinn Latimer; Post-Production-Supervisor Michael Weingrad; and Web Producer Wesley Miller. I am also extremely grateful to Glenn DuBose, Director of Drama, Performance and Arts, Public Broadcasting System, who whole-heartedly supported the television series from its inception, and to Dorothy Peterson, Senior Program Officer, Corporation for Public Broadcasting; Directors Deborah Shafer and Catherine Tatge; and Editors Donna Marino, Kate Taverna, and Amanda Zinoman, who provided invaluable profes-sional expertise, as did the directors of photography and film crew members. For the Louise Bourgeois segment, I wish to thank Producer/Director Marion Cajori and the Art Kaleidoscope Foundation.

This volume serves as a companion to the television series and also stands alone as an engaging and useful docu-ment, thanks to its authors—Thelma Golden, Lynn M. Herbert, Katy Siegel, and Robert Storr. The inclusion of film stills from Art 21's raw footage for the series provides unusual insights into the world of its twenty-one artist partici-pants. Quinn Latimer deserves special thanks for her diligence in accumulating these images and for serving as the primary coordinator of the book. Russell Hassell provided its handsome design, and I am delighted to acknowledge his participation, as well as that of the staff of Harry N. Abrams, Inc., especially Senior Vice President and Executive Editor Margaret Kaplan.

Neither book, television series, nor website would exist without the extremely generous support of its funders: the Corp-oration for Public Broadcasting and the Public Broadcasting Service; the Robert Lehman Foundation, Inc.; The National Endowment for the Arts; the Rockefeller Brothers Fund; Agnes Gund and Daniel Shapiro; The Allen Foundation for the Arts; The Broad Art Foundation; The Jon and Mary Shirley Foundation; the Bagley Wright Fund; The Rockefeller Foundation; The Andy Warhol Foundation for the Visual Arts; The Horace W. Goldsmith Foundation; and The Foundation-To-Life, Inc. I would also like to acknowledge the Art 21 Board of Directors, its distinguished Advisory Council, and the Art 21 Circle.

Special thanks for the provision of images for reproduction are also owed to the Mary Boone Gallery; Deitch Projects; Ronald Feldman Fine Arts; Barbara Gladstone Gallery; the Grey Art Gallery, New York University; Edwynn Houk Gallery; Sean Kelly Gallery; PaceWildenstein; Max Protetch Gallery; Andrea Rosen Gallery; Tony Shafrazi Gallery; Jack Shainman Gallery; Sperone Westwater; Bernice Steinbaum Gallery; Frederieke Taylor Gallery; Donald Young Gallery; and to the UCLA/Armand Hammer Museum; the Museum of the City of New York; the Museum of Fine Arts, Houston; the Solomon R. Guggenheim Museum, New York; and the Whitney Museum of American Art.

Ed Sherin's encouragement, critiques, and advice provided valuable guidance; fur-ther acknowledgments are owed to Susan Delson for her exhaustive research at the earliest stages of this project, and Michael Bond, Trina McKeever, Juliet Meyers, Patrick O'Rourke, Chris Pullman, Chelsea Romersa, Sarah Wayland-Smith, and Wendy Williams for their gracious assistance. I owe my greatest thanks to the twenty-one artists whose work is presented, and who so generously gave their time.

I dedicate this book to Margaret Kilgallen, one of the youngest artists presented here, who died June 26, 2001 as this publication was going to press.

Susan Sollins
Executive Producer
President, Art 21, Inc.

Extending Vision Susan Sollins

This book is the companion to "Art:21— Art in the Twenty-First Century," the first national television series to focus exclusively on visual art and artists in the United States today. While many programs about visual art focus on the past, this series looks to the future to introduce a broad audience to America's diverse artists, both established and emerging, and to the art they are producing now. The series is as forward-looking in form and technique as in content, taking full advantage of new digital technologies.

"Art:21—Art in the Twenty-First Century" presents in-depth profiles of individual artists and examines the contexts in which they work. Viewers will "meet" the artists, see how they work and why, and get to know them as individuals. The artists, who have been encouraged to speak in clear, direct terms about the inspiration, issues, and processes

by showing how artists use new and varied mediums and techniques to respond to new phenomena in the real world. This book, like the television series, has been structured around four themes used as broad categories within which the diverse work being presented may be compared and contrasted. The topics—Place; Spirituality; Identity; Consumption—provide entry points for viewers and readers alike to move toward an understanding of the meaning of art.

What do place, spirituality, identity, and consumption have to do with one another, and why are they part of a discussion of contemporary art? It is because these nouns represent ideas, thoughts, and feelings that all of us know and understand, no matter our circumstances. Where do we live, and what is our environment? What is our place in the world, in the universe? What kinds of spaces do we inhabit or experience? We look at one another or

Steve Martin and Chip Production stills, 2000

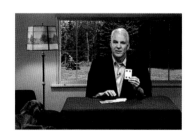
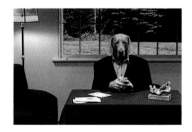

of their art, demonstrate the full breadth of artistic practice across the United States and reveal a nationwide scope of intergenerational and multicultural talent. The series illustrates the direct relevance of contemporary art to everyday life, and offers new definitions of what art is today

at ourselves and ask, "Who am I? Who are you? Who are we? What are our similarities and differences? How do we identify ourselves?" We consume food and information; we exchange goods, services, or money. We all experience the daily impact consumerism—advertising,

buying, and selling—has on our lives. And, whether or not we participate in formal religious practice, the human condition seems to demand that we explore the spiritual, question our existence and a possible afterlife; we ponder our connections to the world around us, and examine experiences

of consumption. Lynn Herbert's discussion presents spiritual contexts for various works of art, but also reveals cultural considerations with all their material components. And so it becomes clear that although each artist and each work of art presented here is unique, multiple meanings and interpretations abound and have

John McEnroe in his gallery Production stills, 2000

that seem to be inexplicable. Artists work surrounded by questions that derive from the experiences and knowledge we all hold in common. This common experience, then, provides a base from which anyone can approach and understand art.

The themes of the four essays that follow intertwine, rebounding one to the other. As Robert Storr writes about art that touches on identity, we also consider the impact of ideas about place and, perhaps, spirituality. Katy Siegel, describing the artists whose work falls under the theme of consumption, also tells us another side of the story—illuminating connections to place or to the decline, as some think, of spiritual concerns in our society. The theme of place, so specific and grounded, addressed by Thelma Golden, also leads us to reflect on a kind of spirituality and on some of the issues presented under the heading

validity; also the assignment of artists to theme-based groups does not limit our ability to interpret their work.

Were we presenting these artists and their works in an exhibition space, the juxtapositions we make here would prove awkward. But in the virtual world, between the covers of this book and in the television series, we have an opportunity to explore and define relationships, creating new paths for understanding artists' methods, practices, and the sources of the works themselves. We have not used terms that are commonly acknowledged constructs in the art world—such as minimal, conceptual, realist, and expressionist—as criteria for grouping artists here; rather, the criteria for inclusion in the television series, and thus in this volume, centered on excellence and also encompassed consideration of differences in age, background, gender,

Bruce Nauman
on his ranch
Production
stills, 2000

location in the United States, and mediums. There are sculptors and painters, artists who create installations, and those whose work overlaps or intersects with the worlds of science, film, popular culture, and design, among others. Other than being artists, their identities range from teacher to rancher, from family member to social activist. Almost all of them immerse themselves in books and are profoundly curious, expanding their knowledge by reading, often using computers to realize their work in a variety of ways. Richard Serra, with the help of an engineer, uses the Catia system to diagram new forms in hyperspace, and is thus able to show fabricators how to torque enormous steel plates to create his sculptures that speak eloquently of space and place. Shahzia Sikander uses a computer to store images of family,

happens. So no matter what the medium or whether there's a real figure there or not, there is always some idea of public and private and social context. . . ." In Nauman's three-dimensional work *South American Triangle* (1981), a hanging chair becomes a surrogate for a human figure, to chilling effect. Of his video *Clown Torture* (1987), Nauman says, "A lot of the things I have worked on, especially in that period . . . had a lot to do with a frustration about people's inability to treat each other better . . . and trying to find some way to express that and talk about that." In short, Nauman challenges us, often confrontationally, to consider and question our collective identity.

Although Kerry James Marshall strives for and achieves visual beauty in paintings whose structural compositions reflect the centuries-old European tradition of history

Kerry James
Marshall in
his studio
Production
stills, 2000

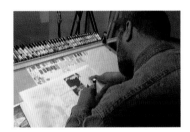
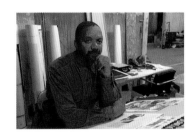

friends, and objects—artifacts of her life in Pakistan and the United States—that she uses in her miniature paintings, the making of which functions as meditational exercises.

We have grouped Bruce Nauman, Louise Bourgeois, Kerry James Marshall, Maya Lin, and William Wegman in a discussion of the theme of identity. Nauman states that his work "always involves some idea of a human being in an unusual situation and . . . what

painting, his work also raises questions about our collective identity. He says in *Kerry James Marshall* (2000), "I look for ways to place works in the museums that foreground African-American subjects, which are otherwise largely missing. To do that, the works have to operate on the same scale and with the same aesthetic ambitions as the art we commonly see there. I made a conscious decision to position my work inside the genre of history painting. . . . If my work embodies

the same principles as that work, handling imagery under the terms it sets, then it has a chance." The extreme blackness of the male figures in the painting *Many Mansions* (1995), has provoked controversy. Marshall says, "There are a lot of black people who are offended by the representations simply because they are painted so

wall dematerializes as a form and allows the names to become the object . . . a space we cannot enter and from which the names separate us, an interface between the world of the dead and the world of the living." Recently, Lin has discussed her reticence or withdrawal in her work as part of her aesthetic and her heritage as an Asian-American.

 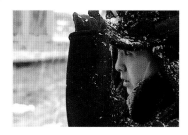

Maya Lin in Grand Rapids, Michigan Production stills, 2000

extremely black. . . . But there is also a side of the black community that sees that representation of extreme blackness as a confirmation of the kind of beauty and power that can exist in something that's so emphatically and extremely what it is. . . . I tend to think . . . that kind of black is amazingly beautiful and powerful." Since early childhood, Marshall's personal quest has been the accumulation of the requisite knowledge and skills to become an artist: he taught himself to etch and draw, to make woodcuts and cartoons, to paint with a palette knife and with a Japanese brush and, recently, to sew; he collects visual images of all kinds in an ongoing series of notebooks that he uses as a resource bank for himself and his students.

Just as Marshall and Nauman filter aspects of our collective history through a private and personal lens, so does Maya Lin. And, like them, she both removes and presents herself in the work. Of her memorials, the Vietnam Veterans Memorial (1981–82) in Washington, D.C., and the Civil Rights Memorial in Montgomery, Alabama (1987–89), she says (in a November 2000 *New York Review of Books* article): "[They] make people cry and feel emotion . . . because I remain at a distance." She describes the Vietnam Veterans Memorial, in part, stating, "The

In contrast, Louise Bourgeois's personal history and Jungian stance are a forthright presence in her work. While Nauman, for example, holds a finger in our collective wound, Bourgeois has never ceased to dwell on and expose her personal psychic wounds and her early childhood experiences in a (seemingly unhappy) family that became both metaphor and source for her art. Unremittingly personal, her work is also universal: the subjects are familiar to all of us, based frequently on

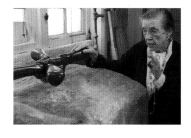

Louise Bourgeois in her studio Production stills, 2000

juxtapositions, no matter how apparently abstract, that refer symbolically to male-female and child-parent roles and relationships. In the television program that this volume accompanies, William Wegman's gentle, witty riff with comedian and writer Steve Martin addresses similar concerns about identity as Chundo the dog, drives the lawnmower and Martin metamorphoses from host icon to Everyman, from art collector to magician, to Chip, the card-playing blue-blazered weimaraner, and back.

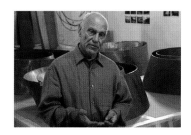

Richard Serra
in his studio
Production
stills, 2000

We move to a consideration of the theme of place to find that notions of identity are also clearly notions about place. Its echoes resound in the works of the artists mentioned above—from the emotional place or physical space occupied by Bourgeois's sculpture to the grounded horizontality of Lin's large-scale monuments or her smaller works of art; from Wegman and Martin's tacky "home" set to Marshall's vantage point both within and outside of an African-American narrative; and from Nauman's intrusion into our private space. In the television program, the topic of

pieces became bigger and you walked into and through and around them, they took on other concerns which were more psychological, even though implied and not specific, than in the early work where process was the key to organizing the principle of how one would structure something." About *Torqued Ellipses* he says, "If you asked me beforehand if I knew what kind of effect the pieces are going to produce, no, I have to build the pieces to understand that. . . . Then, I try to see if I can point to a differentiation in terms of how to evoke a different experience by changing the module,

Sally Mann and
Jessie Mann in
Sally's studio
Production
stills, 2000

place juxtaposes unlikely neighbors: Richard Serra, Sally Mann, Pepón Osorio, Margaret Kilgallen and Barry McGee, all introduced by a short video work created by Laurie Anderson.

In filmed interviews in Bilbao (Spain), New York, and San Francisco, Richard Serra talks about the "spaces and places" of *Charlie Brown* (1999), a sixty-foot-tall sculpture, and of *Torqued Ellipses* (1996–98), and his own surprise at the evident pleasure that the public has found in a sensory exploration of this new work. Comparing his early work to his current work, Serra says, "As the

changing the overhang, changing the relationship of the interior to the exterior. . . . You think, how can I go to the extreme of the opposite end and do it in a way that reflects another emotion or evokes another attitude."

Sally Mann, a Virginian who is deeply rooted in the South and her family life there, presents her work to us—actually and metaphorically—through collodion, a chemical she uses to create her glass-plate photographs which, she discovered, was also used by surgeons during the American Civil War to seal wounds and cement dressings. Mann aptly describes

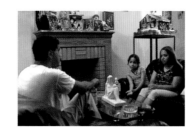

Pepón Osorio
with the
Rosado family
Production
stills, 2000

herself as an individual and as a photographer when she says that the writer Reynolds Price "makes the point frequently that . . . there are a number of things that set Southern artists apart from anyone else: their obsession with place and their obsession with family; their love of the past, and their susceptibility to myth . . . their willingness to experiment with romanticism."

Like Mann, Pepón Osorio investigates the spirit of a specific place but, unlike Mann, he creates or builds that space or sculptural object with the help of others. His process as a sculptor is unusual: he often begins with a dialogue, one-on-one or within a community, posing questions

troubled by the intrusion of what they call "mind garbage"—the billboards and advertisements that bombard our senses and infiltrate urban and rural spaces. They want, instead, to draw our attention to the beauty and inspiration that they find in the visual language of street art, railroad-car markings, and signage or typography of various kinds and from many cultures.

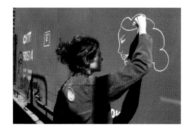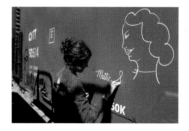

Margaret
Kilgallen in a
trainyard
Production
stills, 2000

Barry McGee
installing at the
UCLA/Armand
Hammer Museum,
Los Angeles
Production stills,
2000

or investigating situations that frequently relate to displacement, an issue that has roots in experiences as a child and youth. In fact, Osorio says that it is only through his work as an artist that he has "found his place."

Margaret Kilgallen and Barry McGee, who work in museum and gallery settings as well as on the streets of San Francisco and other cities, and whose work is found on youth-oriented, pop-culture items such as skateboards or video-game prizes, are

About graffiti Kilgallen says, "I live in a primarily Chicano neighborhood. . . . There are so many murals. I think about that community and how they . . . gave themselves a voice by painting on their own businesses . . . putting a visual out there for the world to see. I feel like graffiti is doing the same thing. . . . Even though the place is unsanctioned, it is providing a space for somebody to have a voice in the world that doesn't have it." While Serra, Kilgallen and McGee, Osorio, and

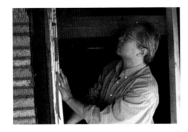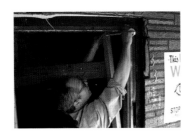

Mel Chin inspecting a burned out home in Detroit, Michigan Production stills, 2000

Mann present the space and place of abstract sculpture, the street, the wall, the installation, and the photographic image of nature and family, it is Laurie Anderson—a remarkably talented performer, storyteller, video artist, and musician who, in her short video introduction to the television segment that examines place, magically moves through urban spaces on a great chair.

Skateboarders and videogamers, art and commerce, objects bought, sold, used, and depicted, billboards and graffiti—all lead us to the next topic: consumption. Barbara Kruger, a master of the topic whose work has influenced commercial advertising since the 1970s, introduces this television segment with a video work that features athlete and art collector John McEnroe as host. A sculptor and fine draftsman, Mel Chin describes art as a "catalytic structure"

the improvement of a burned-out property in an inner-city neighborhood through the cultivation and sale of worms to fishermen and gardeners. To realize the project, Chin will have to mobilize construction engineers, vermiculture experts, construction workers, and a sales force. The model is curiously entrepreneurial, although Chin's goal is to change his collaborators' modes of thinking and living, rather than to achieve personal gain.

Like Chin, sculptor/filmmaker Matthew Barney works with a group, but in his case the group is something of a constant—usually made up of the same people, except for specialists he engages to assist him in realizing his ideas. About the collaborative model and his own roles in his very personal, poetic, and "surreal" CREMASTER film series, Barney says, "Its roots are sort of more in a kind of activation . . . and not really in acting. . . . [It

Matthew Barney directing on the set of CREMASTER 3 Production stills, 2000

and says that the job description of the artist is "to create paths or methods to enlarge on that" or "to set up fields of possibilities." Chin has chosen to forego the making of objects in order to open up new ways to enable himself to work and think collaboratively with others, such as art students, scientists, or computer programmers, and, most recently, residents of inner-city Detroit. In Detroit, his Devil's Night Crawlers project will eventually provide ongoing employment and

has] more to do with athletics than anything else . . . particularly as it becomes more of a team effort. . . .Taking on a role of leadership within that was very familiar from being involved in sports so long." Barney also uses familiar genres to describe aspects of his films. Of CREMASTER 3 Barney says, "It will start within the horror genre very specifically, and then move out of it into a kind of art deco gangster genre." Radiantly colored, flooded with autobiographical

references and mysterious allusions, Barney's films demand intense concentration from the viewer, but always supply references to aspects of American culture that enable the viewer to interpret their content: "Whether it's athletics or car culture . . . those are things I've certainly grown up with and understand. It makes those things very available to me to use as vessels."

Michael Ray Charles offers a far different view of our collective culture of consumption, a view composed of racial stereotypes and slurs in advertising that he believes are deeply embedded in the American consciousness, whether black or white. He transposes this view into his dramatic paintings. Discussing his childhood in a small town in Louisiana,

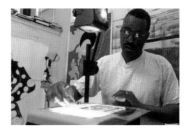

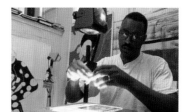

Michael Ray Charles in his studio Production stills, 2000

"Americanism": it is the subject of all his paintings.

If Americanism exists in Andrea Zittel's work, it derives from the pioneer and utopian myths: "We're obsessed with perfection, we're obsessed with innovation and moving forward, but what we really want is the hope of some sort of new and improved or better tomorrow." Zittel, a Californian, takes a pioneer's practical, problem-

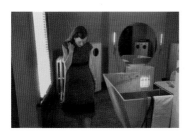

Andrea Zittel in her home Production stills, 2000

Charles explains that school friendships across color lines gradually dissolved in his teenage years as social activities became segregated: by graduation, there was a black graduation party at the school and a white party at the country club. He says, "I am consumed by those things and I studied those things and I thought about those things . . . it started to come out in my work." For him, "The notions of blackness linked to humor . . . to the entertainer . . . to the body, all of those things are embodied, or packaged, with the caricature of the sambo, the darkie, the pickaninnies, and products throughout early advertising, [in the] nineteenth and twentieth century. . . . Blackness continues to hover around this comfort zone of entertainment . . . never intellectualism." Beyond the caricatures used by our advertising culture, which might seem to be his immediate topic, Charles puzzles over what he calls

solving, can-do attitude to an extreme: using herself as a guinea pig, she poses questions and creates solutions about how—and in what surroundings—to live. The results vary from a *bofa*—what she calls the hybrid of box and sofa—to a forty-ton concrete island that she envisions as a prototype for an unusual living unit: a motor-home or caravan of the sea.

The leap from a consideration of consumption to a discussion of spirituality is not large, for utopian dreams and the desire for a more perfect world exist in both realms, albeit in very different forms. James Turrell's almost completed monumental earthwork, *Roden Crater*, an extinct volcanic crater near Flagstaff, Arizona, is described by astronomer Richard Walker as "a perfect place to reunite with a feeling that there is something greater in the universe than your ego." Turrell has re-shaped the crater, making it possible for the viewer to

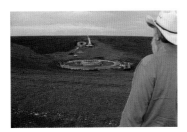
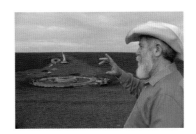

James Turrell at
Roden Crater
Production stills,
2000

experience celestial vaulting, a phenome-
non that causes the viewer to discover or
sense *being* in the atmosphere, a part of
the universe. The interior spaces of the
crater created by Turrell and his team are
"so sensitive to sound and actually make
sound precious . . . so that you tend to
engage in silence . . . that shared medita-
tive silence." Turrell's visual poetics makes
light physically present to us. When the
light that he gathers for us is older than
our solar system, as it is at *Roden Crater,*
its physicality leads us to the spiritual.

For Shahzia Sikander, discipline seems
to be the key. Rigorously trained as a
painter of miniatures in Pakistan, Sikander
relates the metaphors of that tradition
to a form of Persian and Urdu poetry in
which the "beloved" can be simultane-
ously male or female, mortal or divine—
and thus universal. She tells the story
of reading the Koran as a child, unable
to understand Arabic, and "being acutely

over. When you finish [the paintings],
they transcend time."

Like Sikander, John Feodorov makes
use of devices from art of the past—in
his case, the hierarchical principles of
use of space in medieval painting or
living traditions he learned as a child
from his Navajo grandparents. "What's
interesting to me," says Feodorov, "is that
I have this Navajo background and this
sort of outsider Christian background of
the Jehovah's Witnesses which are com-
pletely opposed to each other, and I'm
in the middle still trying to make sense
of it." He is interested in the inherent
contradiction between a desire for the
sacred and our commercialized existence:
from his *Totem Teddy* (1989–98), series
of transformed, totem-enhanced teddy
bears that come with handbooks of ritual
dances and chants, to his paintings and
installations, he investigates the elusive
ambiguity of spirituality.

Shahzia Sikander
in her studio
Production stills,
2000

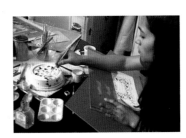
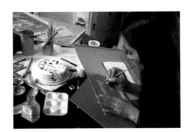
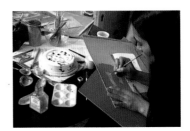

aware of that text and the power of
reciting and the experience that went
into delivering the works perfectly. The
recitation was very important; it was
almost this musical space, but you had
to be in practice every day to perfect it.
That, I personally find such an interesting
parallel to . . . miniature painting. I have
to be in practice to make the work
work. . . . The way it's delivered takes

Ann Hamilton and Beryl Korot share a
background in textiles and weaving; they
describe in similar terms the drawn line
and the thread, weaving, the computa-
tional structure of video, and non-narra-
tive works. Writing about her video work
from the 1970s (in *Leonardo*, 1988), Korot
(whose commissioned work introduces
the television segment that explores spiri-
tuality) says, "I became interested in the

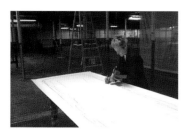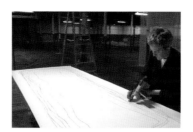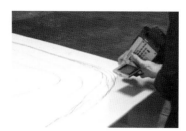

Ann Hamilton at work
on *ghost . . . a border
act,* 2000
Production stills, 2000

handloom as the first computer on earth, as the original grid and as a key to visual structuring. . . . To realize that the structure of woven cloth provided a firm basis for the ordering of video information and time in the creation of nonverbal narrative works satisfied my need to make technological works conform to precedent at a time when the limitlessness and newness of this medium were being extolled. In an age of such tremendous multiplicity of viewpoints, traditions, and beliefs as our own, it was a physical way for me as an artist, in an effort to heal my own inner striving for peace, to stretch my arms across millennia to join the ancient and the new in one long embrace." In a sense, for Korot the handloom becomes a stand-in for language and the thread, as for Hamilton, becomes a line; the line becomes the word, or the hand—the universal and the personal united. Hamilton says, and Korot would concur, "I don't know that I can articulate that relationship between the thread and the written line and the drawn line, but for me . . . it's about the origin of things, about a really fundamental act of making." Although Hamilton's process has shifted from time-consuming collaborative handwork (often realized in the past with groups that came together for a specific project) to reading, to less labor-intensive acts of art-making such as the mouth-camera photographic series, the time-honored Midwestern work ethic—that labor is its own redemption—plays an active role in her work and in understanding it. She believes that the making of art is a social act, and that "how one chooses to be social is an ethical act." So, for Hamilton, making art is an ethical

act. For viewers, to enter into her installations or to experience her new photographs is to participate in that ethical presence. She questions the nature of the installations and the experience of entering and viewing them, and asks, "Are they like sanctuaries [when] one enters the church or the mosque or the temple?" She answers herself, concluding that "to cross that threshold is . . . to enter a world where something else can occur. Perhaps, for some, that something else is spiritual."

During one of our interviews, Richard Serra said, "I think that what artists do is they invent strategies that allow themselves to see in a way that they haven't seen before—to extend their vision." It is

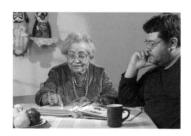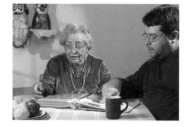

John Feodorov
with his mother,
Elaine Feoderov
Production
stills, 2000

my hope that the essays that follow will extend our collective vision and understanding of art. For those who have viewed the television series and explored its web site (through the link at www.pbs.org or www.art21.org), this book augments the experience, adding art-historical content and curatorial commentary. For those readers who come to this volume without having seen the filmed material, it stands alone as an introduction to the twenty-one artists whose work it discusses and as an invitation to new ways of thinking about, exploring, and viewing art.

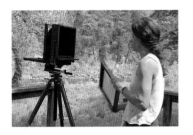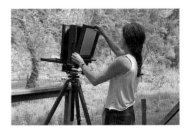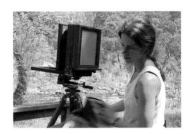

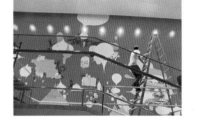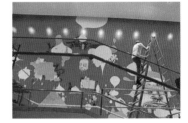

Here is a map of our country:
. . . here are the forests primeval the copper the silver lodes
These are the suburbs of acquiescence silence rising fumelike
 from the streets

Adrienne Rich
An Atlas of the Difficult World

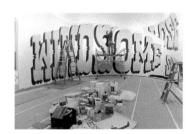

place

Place, Considered Thelma Golden

Inherent in the local is the concept of place—a portion of land/town/cityscape seen from the inside, the resonance of a specific location that is known and familiar. Most often place applies to our own "local"—entwined with personal memory, known and unknown histories, marks made in the land that provoke and evoke.

Lucy Lippard, *The Lure of the Local* (1997)

Some place. Any place. No place. What is a place? Is it geographical or psychological? Real or imagined? A sense of place vitally shapes our being, our identity, and yet we are often at pains to define it with anything like precision, partly because it is so inherently plural. It refers not simply to location but, at a deeper level, to home, departure, arrival, and destiny, even fate, our sense of mooring in the world, and our sense of displacement. It is what connects us to our community and what divides us from others.

Given this metaphorical richness, it is no surprise that American artists have found themselves attracted to place as a theme. After all, America is a country made of places—not just the places marked by road signs and maps, but also the less tangible but no less meaningful places forged in the crucible of memory, longing, and desire. "America" is the strange, beautiful mosaic of these places, reflecting the roots of its citizens, their origins as well as their wanderings. For wander they do: this is, above all, a country on the move, a country of immigrants, migrants, and transnationals. And the great movements of Americans— these comings and goings that perpetually reconfigure the country's identity— have been reflected in the works of the nation's artists.

The America depicted by painters and photographers at the beginning of the twentieth century is one of natural majesty and heroic urban expansion. Artists of the period adopted what today we would regard as a realist sense of place, emphasizing the sheerly physical aspects of the spectacles that stood before them: the vastness of America's wilderness, the glory and squalor of the metropolis. Thomas Hart Benton, Reginald Marsh, and Jacob Lawrence all created paintings that celebrated the diversity of America's distinct regions. Early photography also provided a glimpse of parts of the country that remained a mystery to most Americans. Photographers Walker Evans, Berenice Abbott (fig. 1), and Edward S. Curtis, among many others, made this vast country more imaginable. Of course, these artists were far from being mere documentarians; even the most bluntly realist of photographs often evoked the writings of Henry David Thoreau and Ralph Waldo Emerson, and carried, however obliquely, intimations of transcendence through reveries in nature.

In contemporary art, place has acquired an endlessly proliferating set of meanings: real, imaginary, material, conceptual, identity-based, cyber. In fact, place has even come to define the very

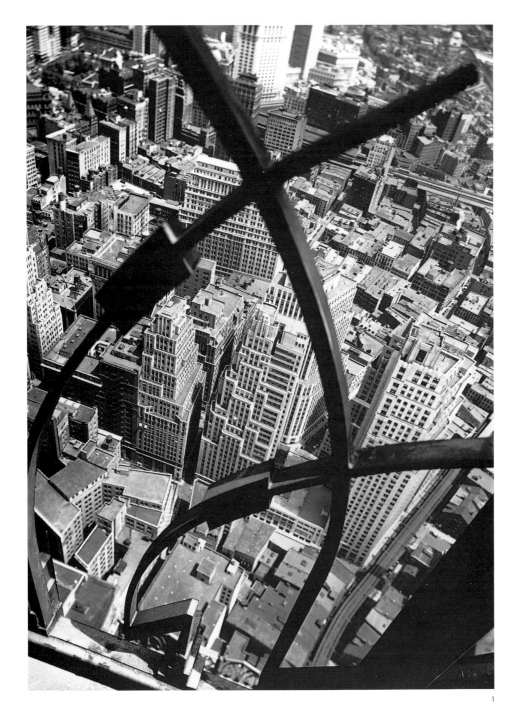

1
Berenice Abbott
City Arabesque, from Roof of 60 Wall Street Tower at 70 Pine Street, Looking Northeast, Manhattan, 1938
Gelatin silver print
Museum of the City of New York, Elon Hooker Acquisition Fund

1

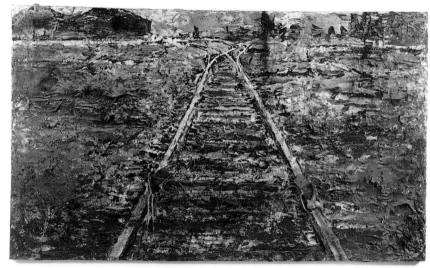

2

Sally Mann

3
Emmett, Jessie, and Virginia, 1989
Gelatin silver print, 20 x 24 inches
© Sally Mann

production of art in the case of "site-specific" works, which are made for, and hence partly defined, by a particular location. And then there is the larger question of America as a vast land of regions—and, as author James Baldwin might have said, regions of the mind—that has only grown vaster with the advent of globalism.

In Sally Mann's recent photographs of the American South, we find an artist who is not merely representing a place but reckoning with it. Eerie forests, scarred trees, architectural ruins, rivers in the mist: here are objects and scenes as charged with history and myth as one of William Faulkner's long, twisting sentences. Mann is a Southerner, born in Lexington, Virginia, where she now lives with her family. After her parents married—her father was a Texan, and her mother was from Boston—they settled in Virginia. The elder Mann was a doctor by profession but had many hobbies including, for a time, photography, and he gave Mann her first camera. It was not a new camera, and he gave it to her casually, she says, without expectation. She left the South as a young

woman to attend the Putney School and Bennington College in Vermont, and then she returned to Virginia to attend Hollins College and has remained ever since.

She approaches her subject with the love and the ambivalence of a native daughter. She embraces the romanticism of the old South, and she has the courage as a white Southerner to evoke it; yet she also recognizes the historic injustices that went hand in hand with Southern tradition. Like the German artist Anselm Kiefer's grand, tortured paintings of the tracks that led to the concentration camps (fig. 2), Mann's photographs evoke a disconcerting juxtaposition of horror and beauty.

Sally Mann is best known for "Immediate Family," a series of photographs she took of her children from 1985 through 1991 that were published in a volume of the same name (figs. 3–5). These are arresting black-and-white, sharp-focus photographs of her two daughters and son as they grew from childhood to early adolescence. The images existed along—and some critics felt they crossed—the border between intimacy and voyeurism. And though Mann intended her photographs as an exploration of portraiture, many

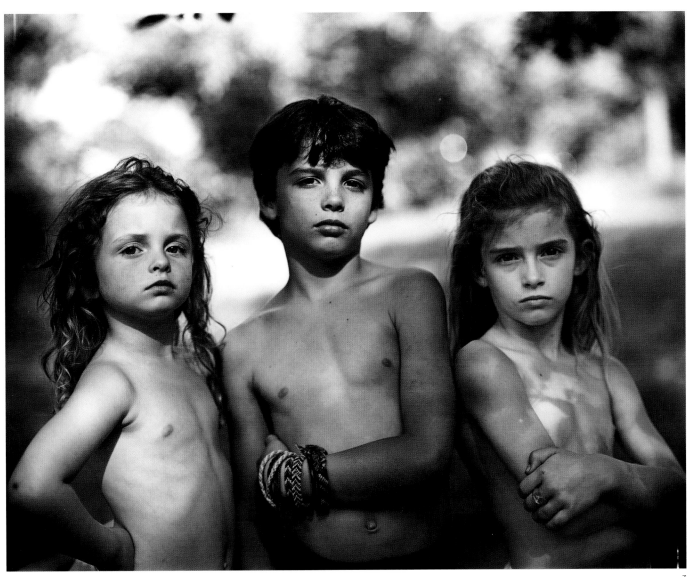

3

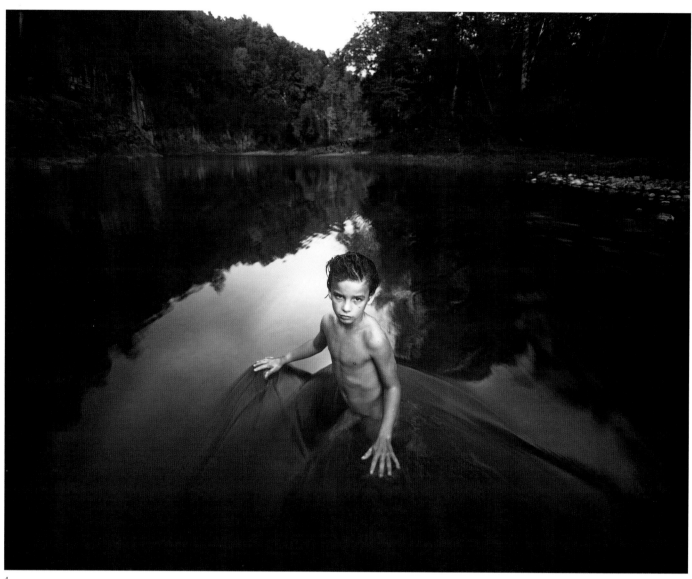

4

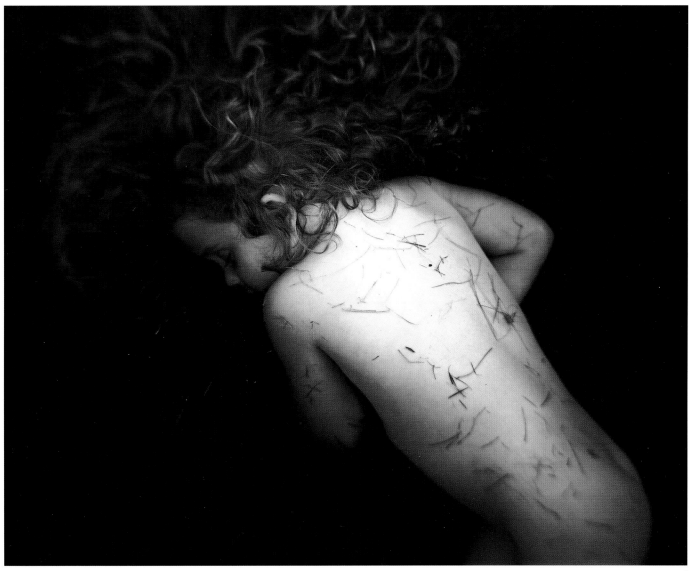

Sally Mann

4
The Last Time Emmett Modeled Nude, 1987
Gelatin silver print, 20 x 24 inches
© Sally Mann

5
Fallen Child, 1989
Gelatin silver print, 20 x 24 inches
© Sally Mann

times appropriating famous art historical images of children for her kids to act out, she found herself at the center of a growing controversy over sexual imagery in art. It was true that Mann was challenging the puritan taboos of American culture around the subject of childhood sexuality, with her erotically suggestive, often nude photographs.

But Mann's detractors conveniently overlooked the fact that her children were willing subjects who helped to choreograph the images. Undeterred by public scrutiny and criticism, Mann continued with these works until she and her children felt that the time, in her work and in their life, made it appropriate and natural to stop.

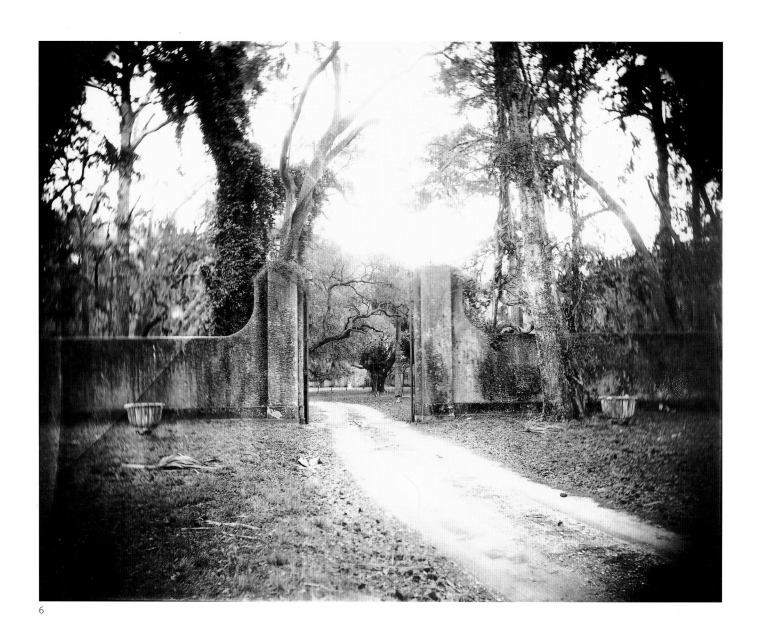

6

Sally Mann

6
Untitled (#18), 1996
From the "Mother Land" series
Tea-toned gelatin silver print, 38 x 48 inches
© Sally Mann

7
Untitled (#15), 1996
From the "Mother Land" series
Tea-toned gelatin silver print, 38 x 48 inches
© Sally Mann

Mann's later landscape work marks a dramatic shift from the biographical to the historical, and from the human to the inanimate: there are no people to be seen in her landscapes. Yet Mann describes her embrace of landscape as a natural progression. She says the landscapes were always there in the photographs of her children—she just couldn't see them due to her single-minded focus on her subjects. Still, it is plain enough that the landscapes are peopled—they are haunted by the dead—and that Mann, as a Southerner, is pursuing a self-investigation of the most rigorous kind by photographing them.

What is immediately striking about her landscapes is the shift in technique.

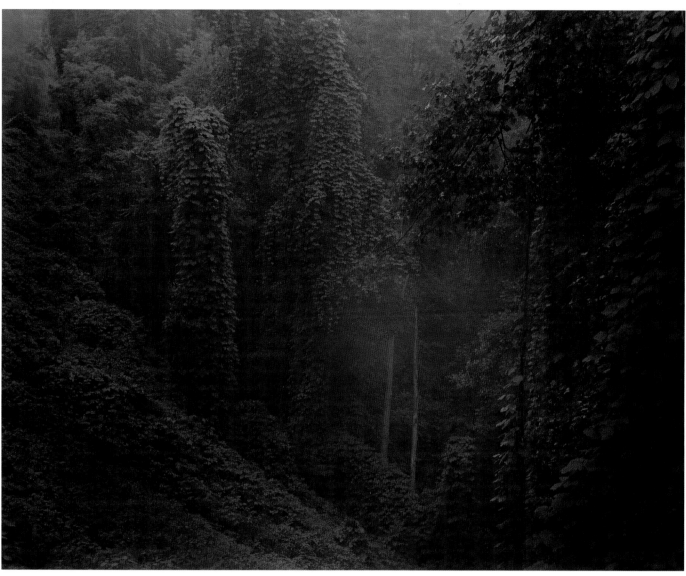

7

Using old cameras and lenses that Mann collects and prizes for their imperfections, she has forged a working method that combines the technical mastery and sophistication evidenced in her earlier works with chance effects. With this technique, Mann embraces both the science and the magic of photography. Unlike the photographs of her children, whose clarity made them all the more intense, Mann's landscapes seem to exist in a kind of blurred time-vacuum, a permanent haze that suggests the mediation of history and memory. Her series "Mother Land" was created in 1996 (figs. 6, 7). The photographs depict landscapes in Georgia and her home state, Virginia. In an introduction to the book that documents the

Sally Mann

series, Mann relates that in 1972 she had discovered a trove of negatives taken by Michael E. Miley, a Civil War veteran from her town. Miley is perhaps best known for his portrait of Robert E. Lee, but in this vast archive, Mann discovered many unknown portraits and landscapes. The landscapes she found especially striking, since they depicted subjects entirely familiar to her (some had been taken on the land where she lived) although they had been taken a century before. She attempts to evoke that same quality of timelessness and familiarity, but also of historical distance, in her "Mother Land." Mann's images of Georgia and Virginia are richly cinematic, resembling a movie set made to conjure the old South. Mann embraces the out-of-focus, under- or overexposed quality her lenses create and the imperfections in the negative that she allows to remain in the printing process. The photographs are luminous and at the same time somewhat sad for they seem to be disappearing before one's eyes.

"Deep South" (1998) takes off where "Mother Land" ends. For this recent work, Mann traveled on her own to Mississippi and Louisiana to continue her visual inquiry. The image of the tree in Woodville, Mississippi, provides a primary metaphor for the entire series. The image centers on a large and imposing tree trunk (fig. 8). A few feet up the trunk there is a ragged gash. Eternally scarred, the tree, which nevertheless continues to thrive, provides a symbol for the South that operates throughout this exploration.

In the most stirring work of the series, a photograph of the Tallahatchie River in Mississippi, Mann creates a monument. The photograph is shrouded at the very edges in darkness. At the middle of the image is the river, placid and luminous, the still water reflecting the trees on the other side of the bank. It is a bucolic reverie on the natural undisturbed beauty of that part of the country (fig. 9). Without identification it could be any river in any place. It might even be beautiful. But it isn't. It is in this unassuming body of water that the body of a young black man named Emmett Till was dumped after he was tragically and brutally murdered by a group of whites in 1955. On this unmarked stretch of river, there is no marker, no monument to Till, but Mann's camera wills us to see what James Baldwin called in his own exploration of the South "the evidence of things unseen." This is the power of the work.

History endures in the land and in the minds of those who live on it. In an introduction to a volume about "Deep South," Mann says of this part of the country: "It's the heart of the country, but it's such a flawed heart, a damaged heart, and when you've got a damaged heart, you got a place that will speak." And the photographs in the series do speak. They summon up all sorts of narratives. Several photographs capture the once-grand ruins of plantations with their architecture crumbling and vacant. Others simply show a view of the land lost, the small places that Mann sought out and discovered with her camera. One haunting image shows the floor of a forest, rendered almost primordial by the haze produced by Mann's technique. It shows a maze of gnarled and knotted branches of a forgotten secret place in the forest (fig. 10). With her photographs, Mann imbues landscape with the power of history.

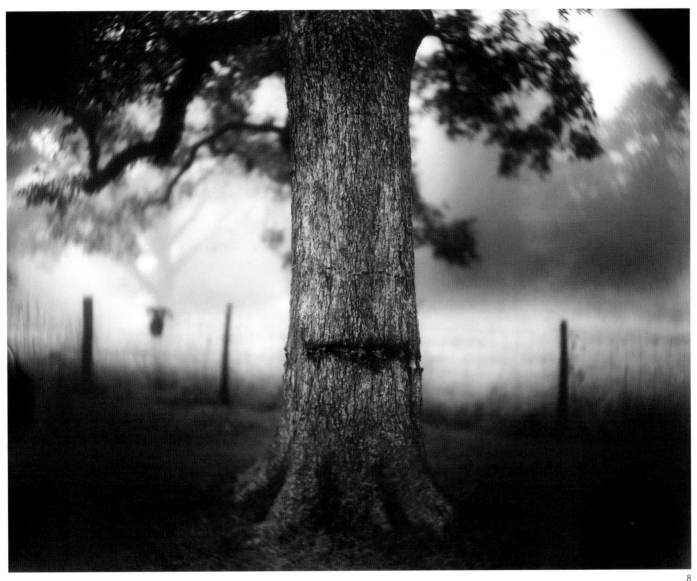

8

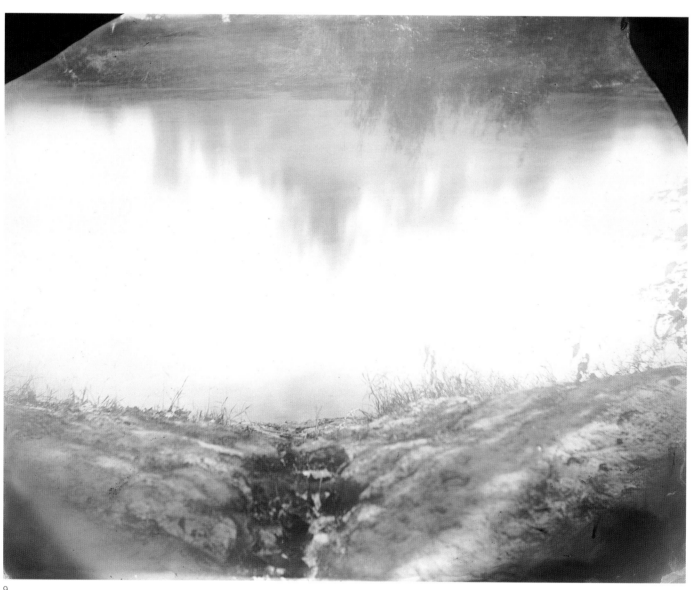

9

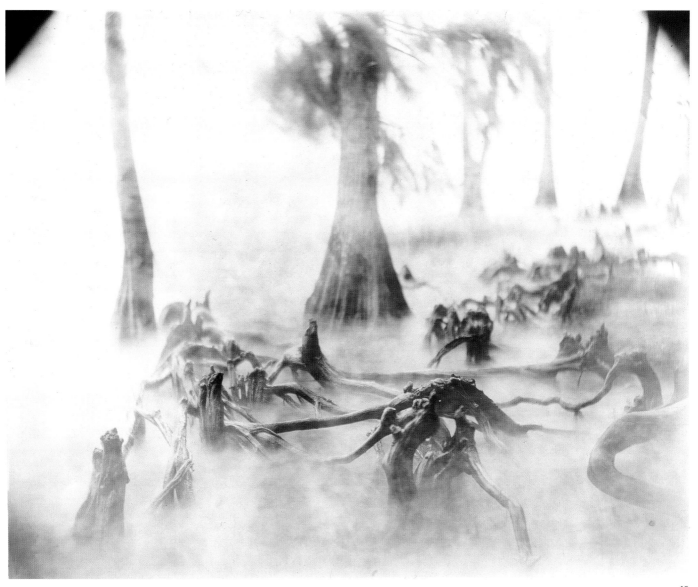

10

11
Keith Haring working on an untitled
drawing in the New York city subway, 1981

Barry McGee

12
Detail of wall installation from *The Buddy
System*, 1999, at Deitch Projects, New York
Mixed media, dimensions variable

11

While a sense of place—the countryside—
fills Mann's work, other artists turn to the
urban landscape around them. The city,
as the French philosopher Michel de
Certeau argues in *The Practice of Everyday
Life,* is a text, made of streets, buildings,
images, and signs. Rendering this space
intelligible—which is, after all, what living
in the city is about—is far from easy,
for the city is always in the process of
change. Each new element, whether
a skyscraper, a corner store, a community
garden, or, for that matter, a work of
freshly painted graffiti, alters the way
we experience and define the place.

Graffiti has been around forever, of
course. But in the early 1980s, the idiom
entered the contemporary art scene
as artists with roots in graffiti like Jean-
Michel Basquiat and Keith Haring pro-
duced sharp, edgy work that blurred
the boundaries between the street and
the gallery (fig. 11). Margaret Kilgallen
and Barry McGee, both based in San

Francisco, are the heirs to this tradition
of place-based, or site-specific, art. But,
unlike the New York City artists of the
1980s who willingly left the streets for the
more refined precincts of the art gallery,
Kilgallen and McGee have insisted on
simultaneously making work for both
spaces (figs. 12–14). (McGee continues
to work as a graffiti artist under the tag
"Twist," and Kilgallen creates work in the
street art context.) And by continuing to
produce unauthorized, legally question-
able work on the streets of San Francisco,
both artists have explored the distinctions
between public and private, sanctioned
and illegal, high and "low" art. Kilgallen
and McGee represent a new generation for
whom such distinctions seem increasingly
irrelevant. As they travel and exhibit, they
leave their marks as evidence. Their work
embodies a hybrid essence of site-speci-
ficity; it is specific to wherever they are.

Both McGee and Kilgallen view graffiti
as a means of contesting the creeping
privatization of public space in American
cities. They see all forms of street art as
an alternative to the visual barrage of
corporate advertising. It is a complicated
argument they put forth. Drawing inspira-
tion from the abundant local murals in
San Francisco, many of which are descen-
dants, in style and substance, of works
created during the Chicano mural move-
ment in the 1970s, Kilgallen and McGee
argue that advertising represents a violent
consumerist intrusion in the public sphere
that hardly serves the interests of the
community. Kilgallen says, "Other people
might want to put their own visuals in
their own neighborhood, something they
could relate to."

For these artists, place represents
territory and is something that is claimed
rather than inherited or assumed. It is

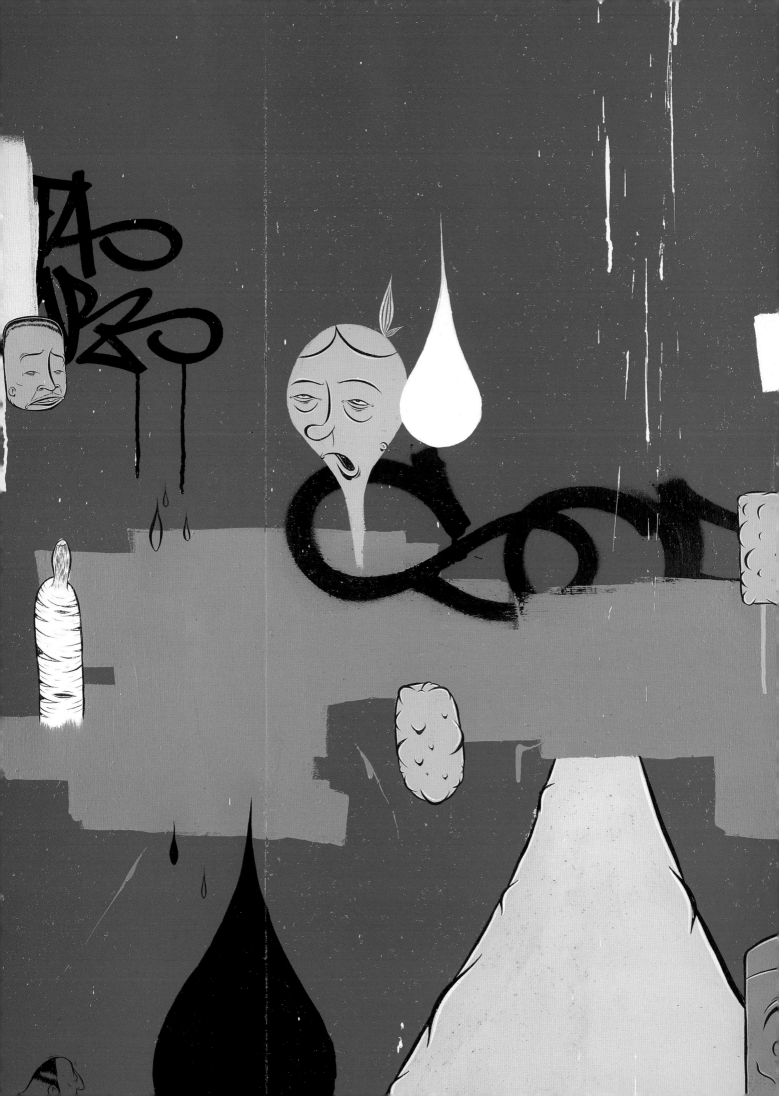

13

Margaret Kilgallen

13
Work on paper from installation, 2000,
at UCLA/Armand Hammer Museum,
Los Angeles

Barry McGee

14 FOLLOWING PAGES
Installation view of *The Buddy System*,
1999, at Deitch Projects, New York
Mixed media, dimensions variable

the space delineated by the presence
of one's mark. The name, the scrawl on
the wall, says "I was here." This approach
brings class and economic power to the
notion of place. In the urban environment,
the landscape creates an enormous sense
of anonymity; marking walls creates a
sense of specificity within that anonymity.
It also evokes a sense of ownership in
communities where there is little economic
power. One might not own a building or a
home, but through tagging one can claim
and "own" a wall. Graffiti, when read by
those within its culture, can define places
that would remain unnamed and unseen
to others. Marks can indicate the begin-
ning or end of gang territories. They can
alert to danger. Changes in the slang can
mark subtle ethnic/neighborhood shifts.
Street art can very literally create memo-
rial spaces, as one witnesses in the many
murals marking the spots of the violent
deaths of people that are found through-
out inner-city neighborhoods. These are
not places understood in official ways,
on maps or street signs, but through the
understanding of the various communities
from which they emerge.

Kilgallen and McGee are avid anthro-
pologists of this street art scene, keeping
a mental catalogue of writers and images
they've encountered and admired. Both
speak passionately about the audience
they reach with their graffiti works. They
intimate that this audience is perhaps
more important and far-reaching than the
rarified environments of the museum or
art gallery. Unlike their predecessors in
the graffiti movement of the 1980s, they
do not regard their private work as a step
up from and out of their public work; they
see the two distinct practices feeding off
one another.

Long before Barry McGee contem-
plated going to art school, he enjoyed
a huge cult reputation for the graffiti he
made and signed with the tag "Twist."
Born and raised in San Francisco, he
took part in the city's thriving under-
ground music and skateboarding scene.
San Francisco provided an unusually
hospitable environment for graffiti in
the 1980s: the city was full of places
that invited tagging, and there were
few crackdowns. Tags formed a private
language on the street, marking territo-
ries, claiming spaces, and making reputa-
tions for their authors. Twist became a
legend in this milieu for his originality
and his ability to spread his tag around
the city. His style, strikingly different
from that of East Coast graffiti artists
with their intricate lettering and subway-
car graphic murals relied on a personally
developed approach to the combination
of words and images that came to repre-
sent a West Coast ethos.

In 1994, in a gesture that was at once
ironic and prophetic, McGee drew over
the entire expanse of a construction wall
that was part of the Yerba Buena Center,
an institution that seeks to represent the
diversity of the San Francisco community
through the arts and which hopes to pro-
mote dialogues between the margins and
the mainstream. In a sincere effort to vali-
date the vernacular traditions in the city,
the center immediately invited McGee
inside to make a wall drawing—to do, in
other words, the very same thing he had
done outside the museum, as "Twist." The
Yerba Buena installation marked McGee's
emergence as an artist, as distinct from
his street identity.

McGee's wall drawings, created as
installations for museums and galleries,

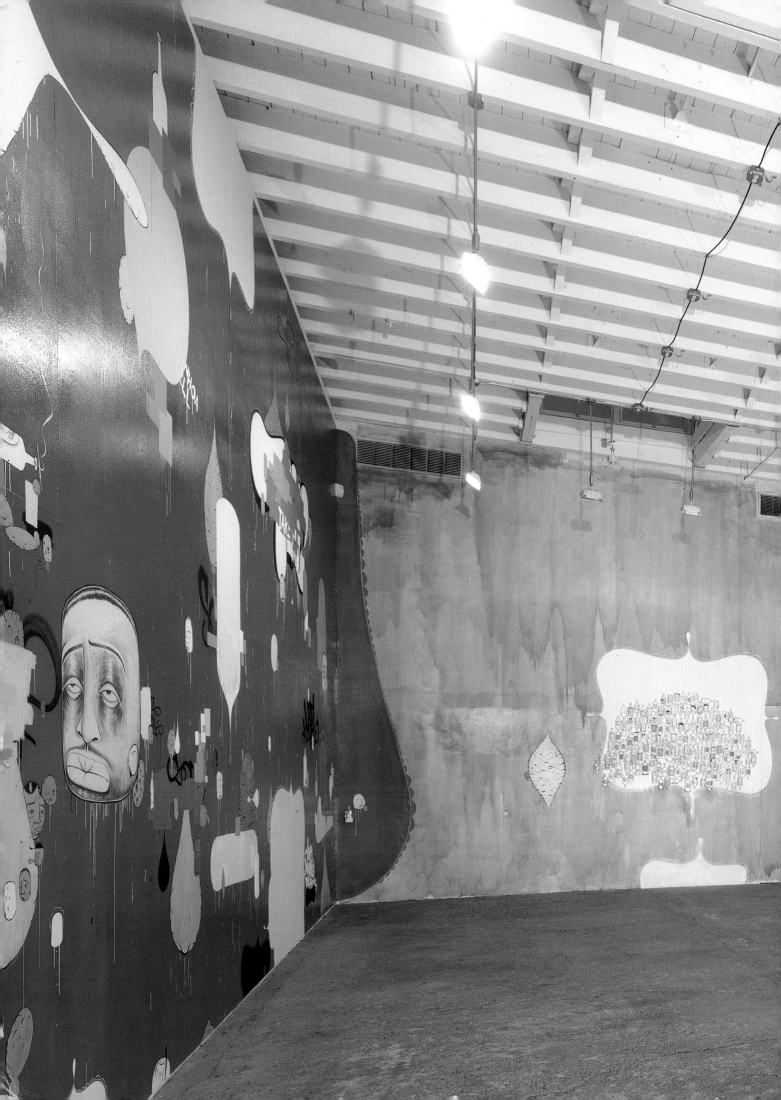

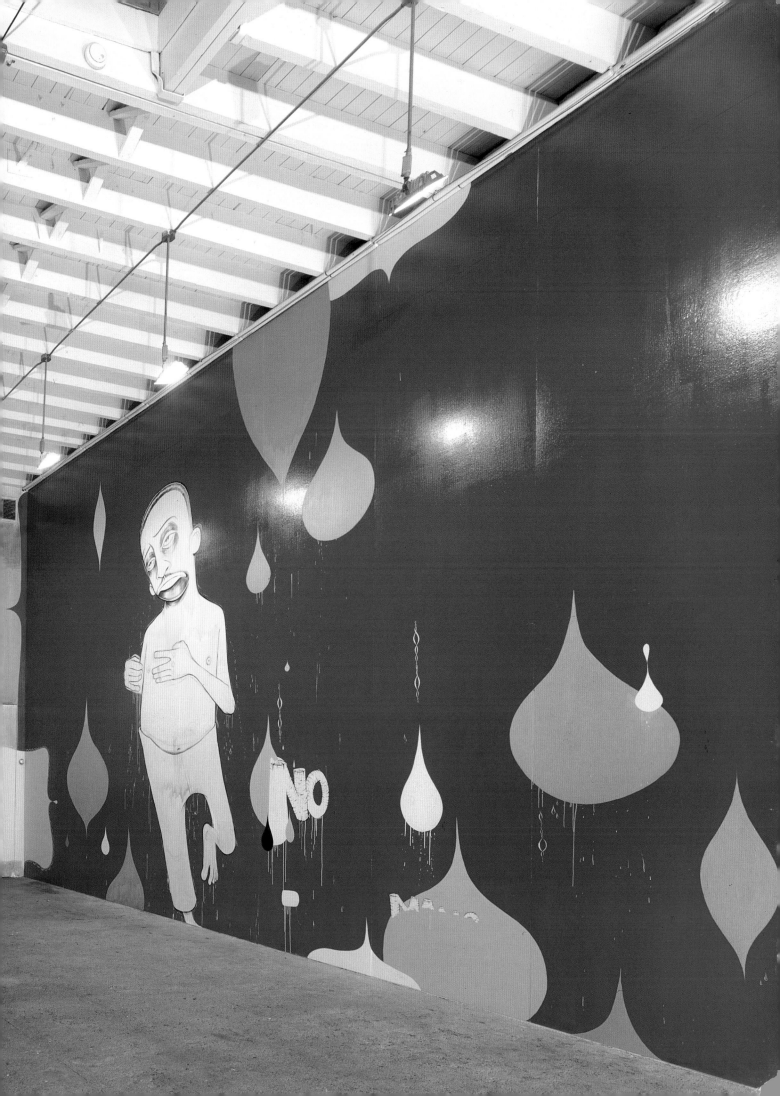

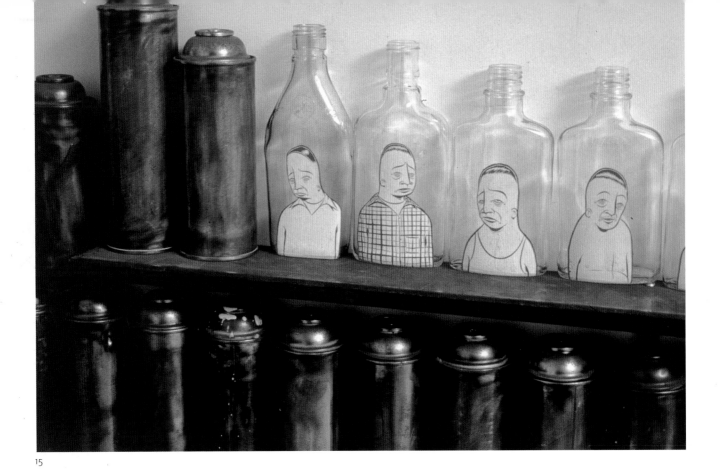

15

Barry McGee

encompass paintings, drawings, and found objects in arrangements that respond and react to their sites. At the core of his visual vocabulary are figurative images of old weary men, apparent street figures who display a range of expressions. His work has been compared to both the seminal American painter Philip Guston and the cartoonist R. Crumb, though he dislikes the comparisons with "high art" and their implicitly legitimizing effect. His murals are related to the expressionistic works of some of his peers, who invent visual vocabularies within site-specific wall works and combine the gravity of formal painting and the energy of the streets.

McGee's 2000 project for the UCLA/ Armand Hammer Museum, Hammer Projects series, is a raucous panoply of images (figs. 15–18). The installation draws on McGee's trademark characters, blockhead guys with their various expressions, from amused to dejected. In and around them, McGee fills the walls with the drips and spills inherent to the quick and furious style street writing demands.

He also layers the space with seemingly abstract swaths of paint. These swaths refer to the "no tolerance" approach many municipalities take to graffiti vandalism. When a wall is "bombed," the area is hastily painted over, leaving a mark that to some eyes is more artless, more unattractive than the graffiti itself. Like many of McGee's recent pieces, the Hammer project contains three-dimensional elements, including used paint cans and discarded liquor bottles. He removes the labels on the glass bottles and rebrands them with paintings of his characters. The installation also includes a collage of small, framed objects including his diaristic drawings and doodles, formal tags, snapshots, advertisements, flyers, and other assorted ephemera. McGee's inspiration for this display came when he traveled to Brazil on a residency in 1993 and visited a church in São Cristovão. He was struck by the devotional assemblages of photographs, carved hands and feet, and other personal effects created by the offerings of visitors. The images are

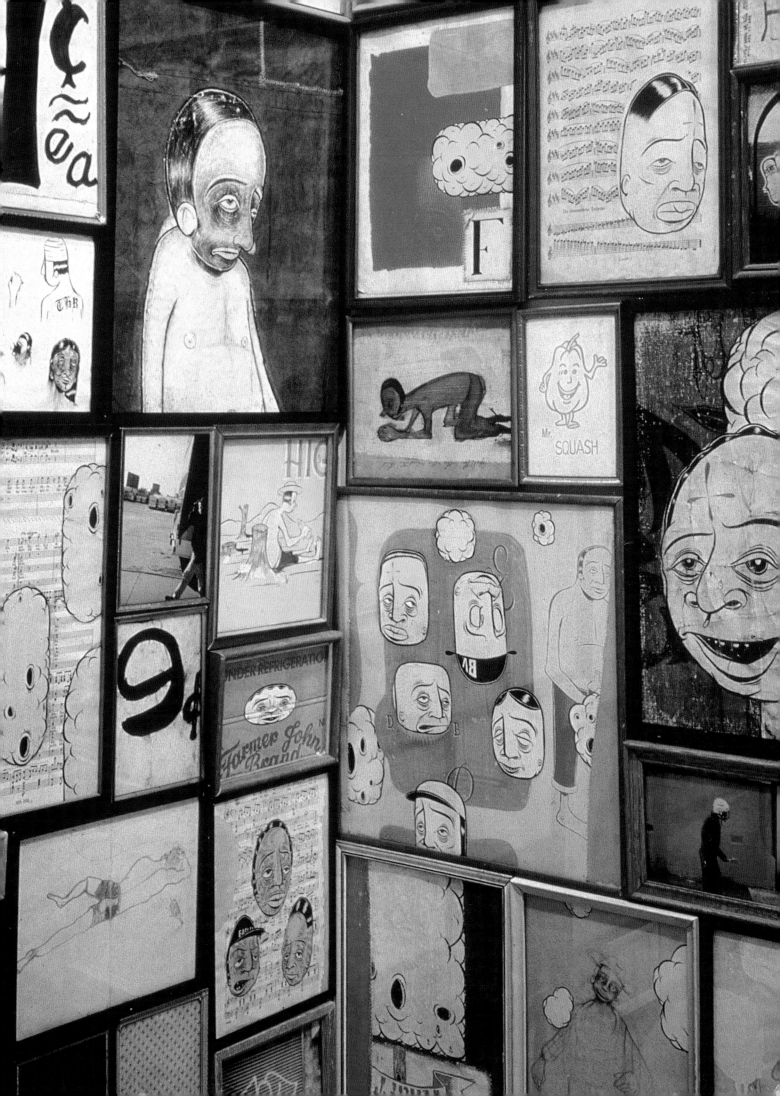

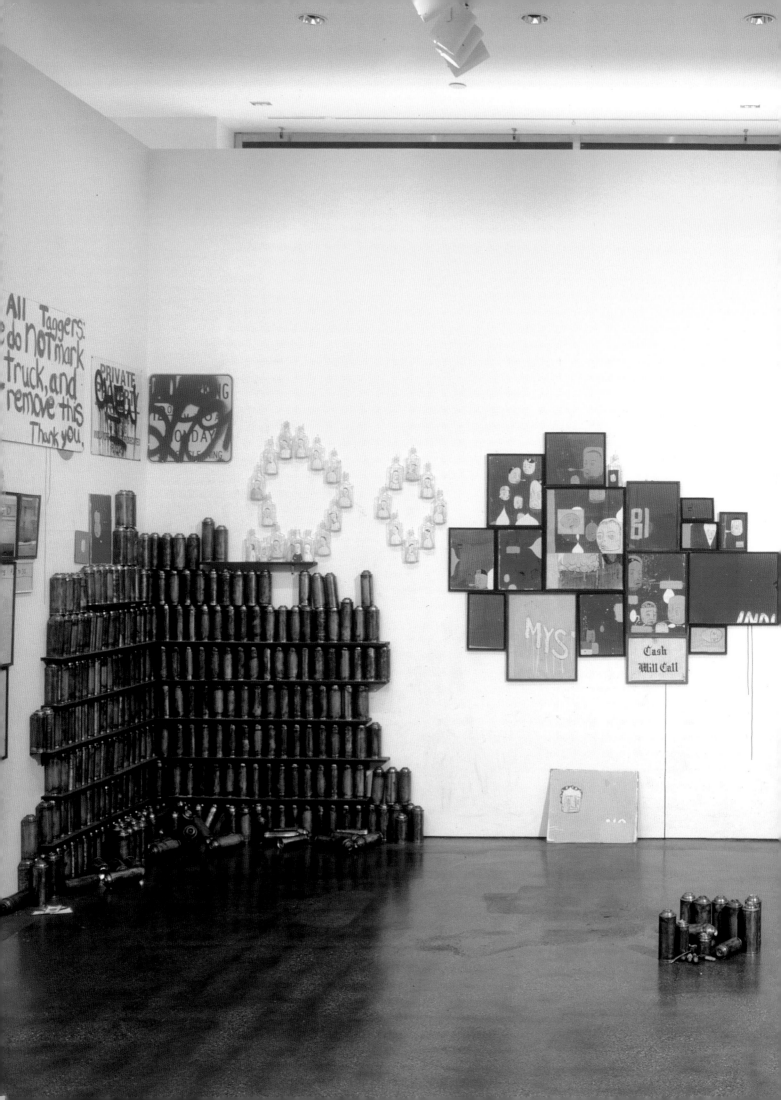

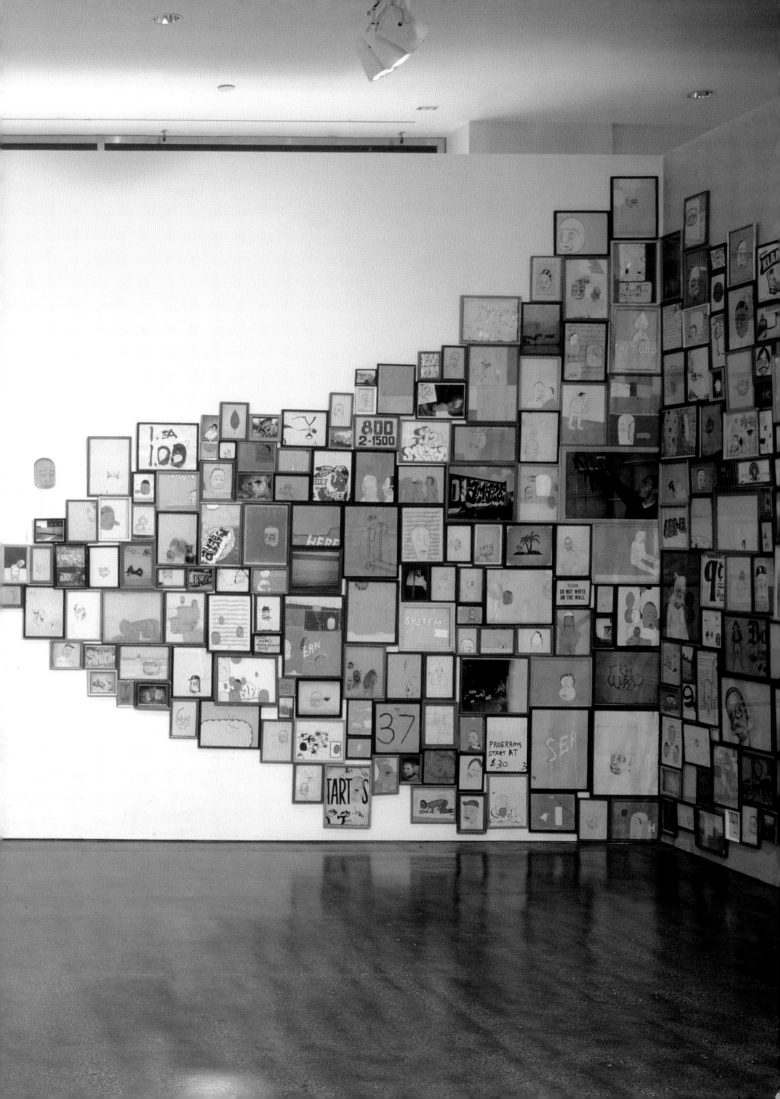

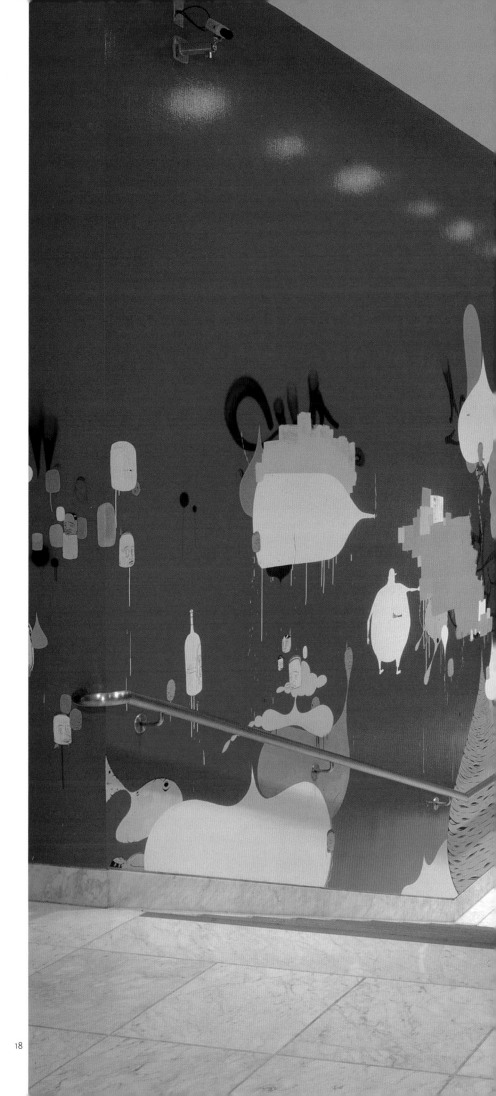

Barry McGee

18
Installation view, 2000, at UCLA/Armand
Hammer Museum, Los Angeles
Mixed media, dimensions variable

shown in old, used frames and create a
counternarrative to the large wall drawing
they are set against.

In the early twentieth century, region-
alism—the explication and celebration of
particular ideas and aesthetics of a partic-
ular place and time—was how place was
rendered and understood in art. Margaret
Kilgallen's work is powerfully influenced
by the many regional and ethnic vernacu-
lar art styles in America, which float,
sometimes unnoticed, around the edges
of the traditional art world. Place is mani-
fested not only through her interest in
site, but also through her nostalgia for the
places of the American past. Her work is
suffused with a longing and reverence for
the past; this can be seen in the signs
and symbols she collects and appropri-
ates and uses in her work. In the long
tradition of American documentary, her
view of a time filled with old honky-tonk
bars and picture shows, small towns and
down-and-out cities, blues shacks and
spicy characters is incredibly subjective
and therefore highly seductive. She
captures Depression-era America and its
sense of humor and strength in the face
of great adversity. She conjures through
her gatherings the flavor and the feeling
of that moment. She celebrates the small
creative statements that make up many
regional aesthetics that are increasingly
lost in an age of globalization. She honors
the artfulness that comes from necessity.

Kilgallen received a BA in printmaking
from Colorado College, where she also
solidified an interest in typography and
in classical styles of bookmaking. She

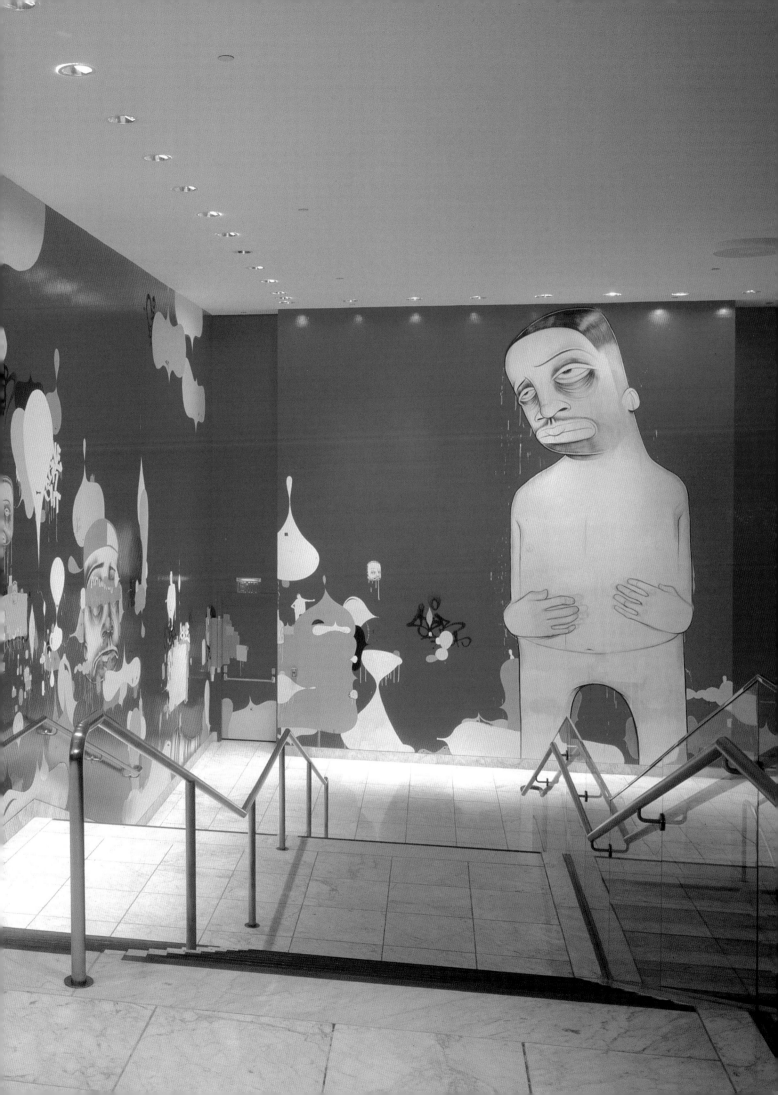

19

Margaret Kilgallen

19
Hand-painted trainyard photo (detail), 2000
Photograph by North Bank Fred with
hand-painted detail by Margaret Kilgallen.
With thanks from the artists to Bill Daniels

20
Work on paper from installation, 2000,
at UCLA/Armand Hammer Museum,
Los Angeles

relocated to the Bay Area in the early 1990s and found a job with book conservator Dan Flanagan at the San Francisco Public Library. From him, and from the direct experience of restoring books, she learned about letterpress, bookbinding, and typography. This apprenticeship significantly affected the work she began to make in her studio. She began exploring and combining principles of craft-making and the applied arts and began to insert some of that "handmade" aesthetic into her work.

Her deep interest in vernacular culture has made her a passionate authority on "hobo markings," a variation of street art that homeless men leave in and around freight train cars and train yards. Different from youth-oriented graffiti, hobo markings are the traces of indigent men who travel the country surreptitiously on freight trains. These markings indicate the men's presence and their various routes as they travel around just below the radar of everyday society (and the law).

Her interest in this subterranean form of communication and her love of type and signs led Kilgallen to the formation of her own unique graphic style. (Graffiti is, in part, an expansion and innovation of typographical styles.) Kilgallen is interested in these guerrilla markings in the public space, which indicate the presence of people in a city (and world) where mass advertising has increasingly effaced the individual. These influences are clear in her work. She cuts through the high/low, graphic art/fine art, street art/studio practice dichotomies by combining aspects of each of these arenas (fig. 19). At the heart of her work is an interest in storytelling. She combines free associative word drawings with clearly drawn images, mostly heroic images of women. Her sources for images are based in real life. She uses real people and events as her base and them renders them in her trademark style. These drawings, with their broad lines and flat planes of color, have the direct, readable qualities of graphic illustration.

Her work is also dependent on notions of reuse. Kilgallen is uninterested in bland, mass-produced ideals of perfection. She is intrigued by something she refers to as "imperfect perfection"; a wrongness in things that makes them right. She is the consummate recycler, using found images and resurrecting old type styles. She also makes inventive use of found objects.

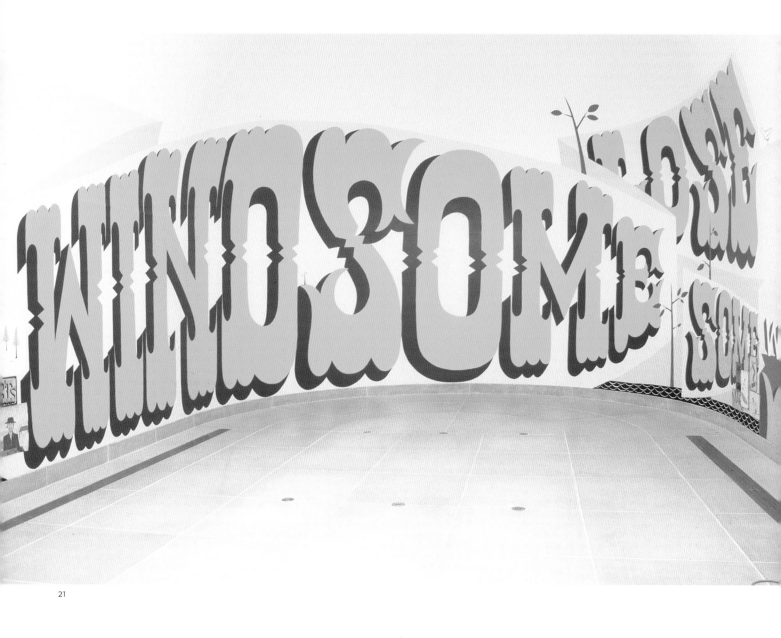

21

Margaret Kilgallen

21, 22
Iinstallation views, 2000, at UCLA/Armand
Hammer Museum, Los Angeles
Mixed media, dinemsions variable

Salvaged wood and other "junk" become
the supports for her paintings. This imper-
fection is seen in the work itself. Flaws in
her surface supports and paint application
all become integral parts of the images.

The 1999 mural installation Kilgallen
made for the UCLA/Armand Hammer
Museum Hammer projects series is an
impressive distillation of her vision (figs.
13, 20–22). She approached the gallery
space as a virtual cityscape; a collage of

images in a dizzying array of near- and
far-scale relationship, which wraps around
the room and even reaches off the wall
into the space with the inclusion of three-
dimensional sculptures. The installation
contains dozens of paintings that recount
snapshot vignettes arrested in time. Her
installation is built up incrementally, with
each work creating references to the next
along the walls. She mixes found and
imagined text of signs ("45cents," "Victor,"

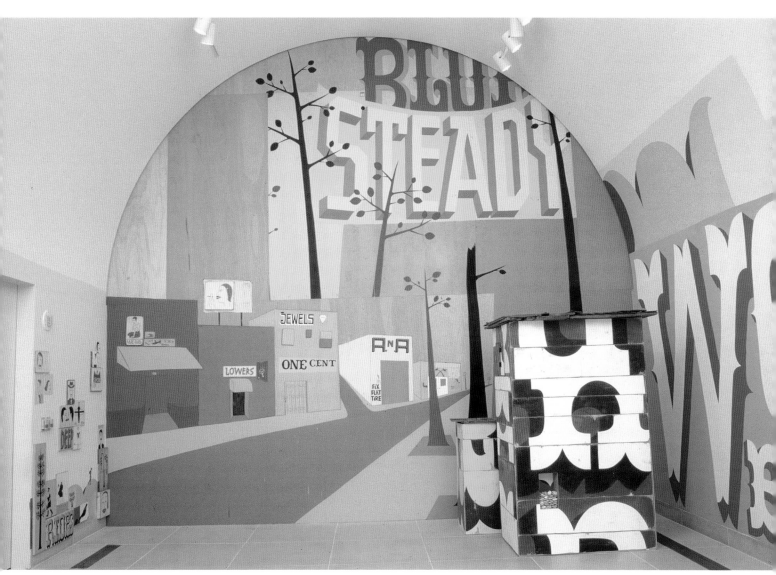

22

"No Loiteri..") with images of her kooky heroines and quirky characters. Small paintings that mimic folk art canvases are interspersed among the bigger expanses which mimic billboards appearing to have been salvaged from long-forgotten road shows and ghost towns.

Kilgallen seems to revel in the surrealist poetry that emerges from the random collage of words. Kilgallen's work is also suffused with a deadpan humor that hovers around the animated environment her installations create. In a large gesture in one corner of the installation, Kilgallen paints a scene of a road through a town. The road (to where?) continues out of the picture plane.

As with many other young women artists of her generation, the reimagining of women's lives in the past is paramount to Kilgallen's practice. She pays homage to fearless women and portrays them

Margaret Kilgallen

Installation view *of To Friend and Foe*,
1999, at Deitch Projects, New York
Mixed media, dimensions variable

with gravity and strength, realistic rounded figures, sly grins, and flat feet (fig. 23). Kilgallen is an enthusiastic and serious surfer, and she is conscious of her role as a woman in that world, as well as in the testosterone-fueled realm of street culture. Her works are full of images of early women surfers in their retro outfits, and of blues singers whose likenesses she imagines from their voices, which she hears on the radio. She depicts early women Olympians and working women, all women who defied the roles women have been offered throughout history.

Both Kilgallen and McGee work in a straightforward figurative style, in both their public and private works. This mode allows for a clear, easy address, something they both value, since audience connection is a major shared impetus. Place is manifested in the overwhelmingly site-specific nature of all their work. They both value it whether it is the place in this culture lost to mass media and mass production or the place found as it is claimed from the anonymity of the street by the mark of image and text. For both of these artists, place is not the site that you admire or memorialize through your art, but the one you claim and transform.

The question of place also informs Pepón Osorio's practice, to an unusual degree. Over the past two decades, he has sought to redefine his community's relationship to art, as well as the art world's relationship to community. During the twenty years that he lived in the South Bronx, Osorio produced art that held up a mirror to the culture of Puerto Rican New York. His early works were marked by a strong sense of cultural specificity that, when presented in the art world of the 1980s, forced viewers to reflect on

the vexed and ever-shifting relationship between center and periphery. Osorio's aesthetic—ornate, extravagant, exuberant, a kind of New World baroque—is derived not so much from Puerto Rico itself as from the artist's memories of the island, which he left at the age of twenty. Osorio's Puerto Rico is less a physical landscape than an "imagined community," to quote the cultural theorist Benedict Anderson. It is an expression of the longing and desire that go hand in hand with exile and displacement.

The son of an oil refinery worker, Osorio was born in 1955 in Puerto Rico. He grew up in a close-knit family. "Creating . . . represents for me the retrieval of experiences that have always been there," he said, citing as an early influence the elaborate cakes that his mother, Maria Luisa, used to bake for fiestas. After attending college for two years in Puerto Rico, Osorio moved to New York in 1975 to attend Lehman College in the Bronx, where he received a degree in social work. (For several years, Osorio was a social worker in New York City.) Like so many of his fellow island expatriates, he immersed himself in New York's thriving Nuyorican community. ("Nuyorican" is a combination of "New York" and "Puerto Rican," symbolizing the unique identity forged by New York's Puerto Ricans.) In 1978 he began making drawings and collage, mostly in what he describes as a "universalist" style. A year later, he met the choreographer Merian Soto. In Soto he found a kindred spirit, a fellow artist seeking to explore the materials of Puerto Rican culture. He designed a set for her, beginning a rich artistic collaboration that has lasted to this day; the couple married in 1987.

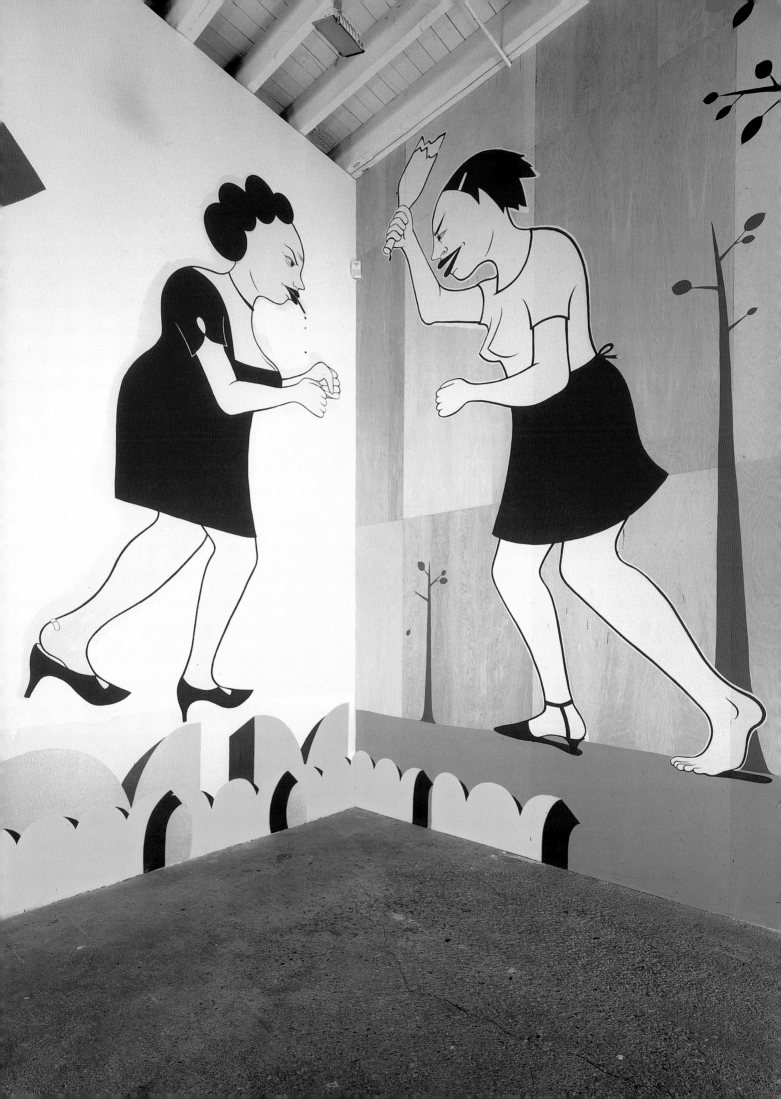

24

Pepón Osorio

24
La Bicicleta (The Bicycle), 1985
Mixed media, 42 x 60 x 24 inches

25
Installation view of *En la barbaria no se llora (No Crying Allowed in the Barbershop)*, 1994, at Real Art Ways, Hartford, Connecticut
Mixed media, dimensions variable

26 FOLLOWING PAGES
Installation view of *Badge of Honor* (detail, son's bedroom), 1995, at the Newark Museum, Newark, New Jersey
Mixed media, dimensions variable

Osorio established his mature aesthetic in the late 1980s with works like *La Bicicleta* (fig. 24), *La Cama,* and *The Chandelier,* sculptures made of the objects to which their titles refer—a bicycle, a bed, and a chandelier. Osorio's purpose was not to question the nature of art, as other artists have done, but rather to make art out of emblems of Latino community and culture. In a sense, he was repeating a gesture that he had observed among Latinos on Manhattan's Lower East Side of beautifying household objects in amazing and extravagant ways, and thereby affirming their humanity in environments that were often hostile. An avid collector of pop cultural knickknacks, Osorio festoons his sculptures with plastic dolls, miniature palm trees, beads, game pieces, and devotional figurines. In a modernist context, these objects might be disparaged as kitsch, but as cultural theorist Coco Fusco explains, they represent an alternative aesthetic for which embellishment and decoration are paramount. When Osorio's sculptures were first exhibited, their exuberance and decorative extravagance startled many viewers. Osorio had, in effect, introduced the art world to a culture and an aesthetic that had been virtually unseen, and the responses were at times confused. To viewers unfamiliar with Osorio's context, in which florid

embellishment is often an effort to shape and redeem one's environment, the works seemed oddly happy, if not innocent. But their complexities—their mingling of pride and pathos—were not lost on Latino viewers. This mixed response was no surprise to Osorio, who has often reflected on the culturally specific mode of his address to viewers. It is a reminder that "place" crucially informs our reception of works from other spaces, from other locations in American culture.

The early sets Osorio made for performances by Merian Soto informed his later works, which developed from sculptures into full-scale site-specific installations (fig. 25). The early sets involved the same elements as his later installations and made the connection between the theater, performance, real space, and art that has been so crucial to Osorio's work. The influence of his set design and the development of his sculptural aesthetic can be seen in several later installations. *Badge of Honor* (1995, fig. 26) is an installation that visually relates the story of a father and a son. The work was originally shown at the Newark Museum in New Jersey. The piece contains two side-by-side rooms, each of which visually describes the life of the person living in it. On the wall of each room there is a video projection of its inhabitant talking to the one in the

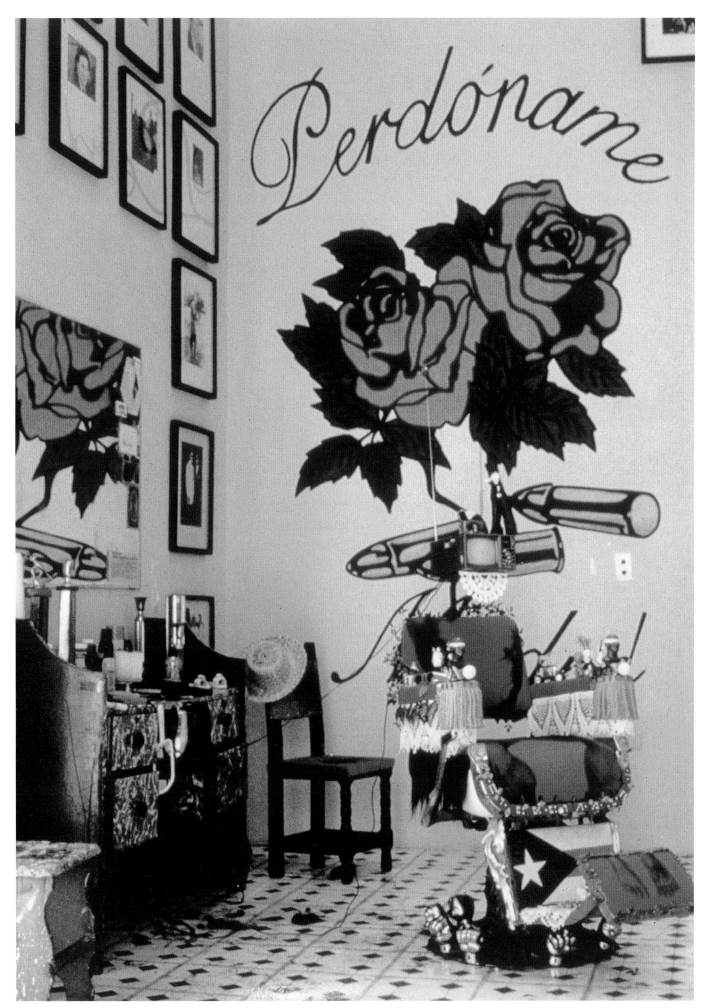

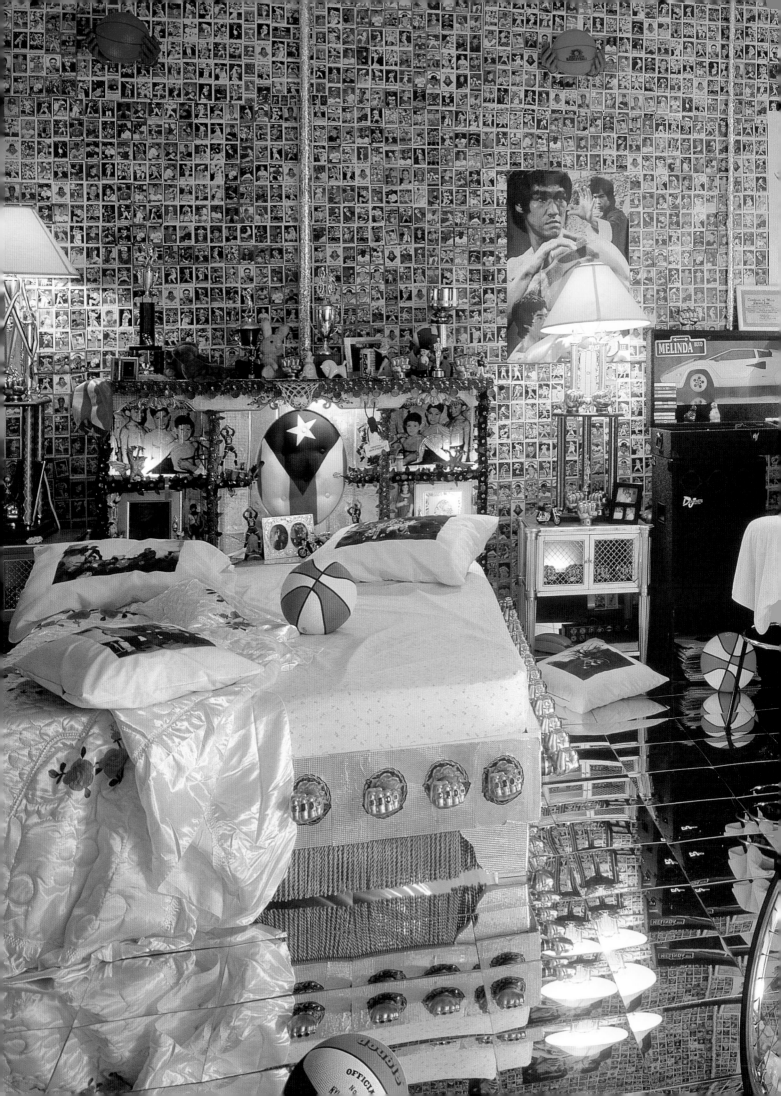

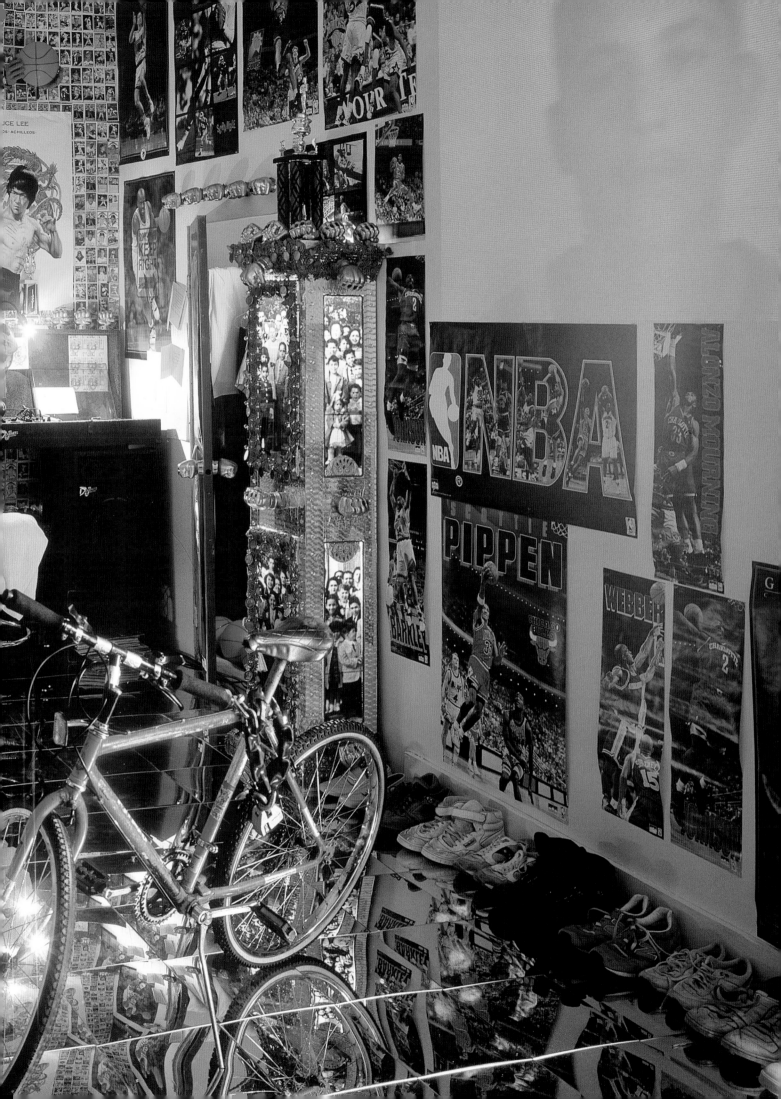

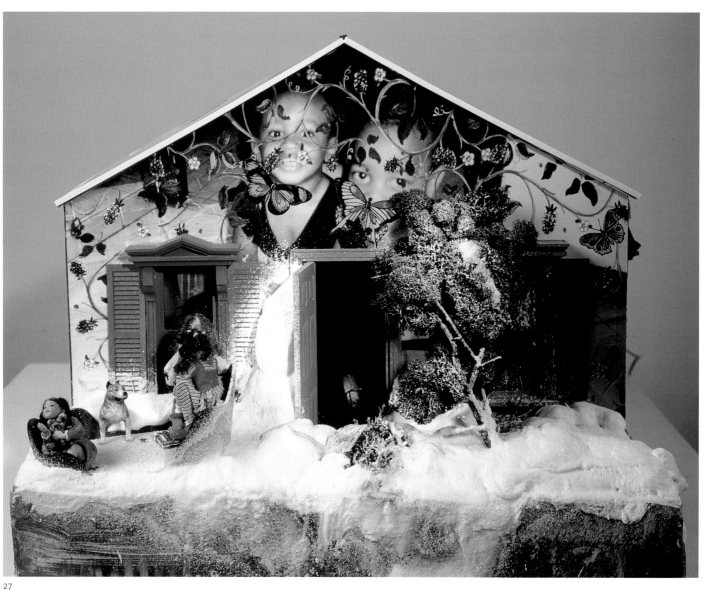

27

Pepón Osorio

27, 28
Home Visits, 1999–2000
Details of *Tina's House*
Mixed media, 20 x 28 x 17 inches

29
Home Visits, 1999–2000
Tina's House with Pepón Osorio,
Sasha Rosado, and Tina Rosado

other space. Osorio sets up an interesting collision of relations and oppositions. The father's room is almost bare, while the son's room is overflowing with boyhood paraphernalia. The son's room shows a sense of aspiration and promise; the father's indicates little hope. In the son's bedroom, sneakers and posters and action figures belie the boy's experience with the real world.

As in most of his work, by using the narrative, Osorio adds a layer that is missing from social and political debates about race and crime and even the American

family. This work is not a piece of conceptual art, imagined by the author. This is a real American family and he shows precisely where they live. Osorio cuts through the stereotypes and the expected pathologies to engage real lives. This piece is Osorio's work at its essence; it demonstrates his ability to heighten and deepen the understanding of experience in a way that fashions "art" from the real.

Tina's House (figs. 27, 28), part of his 1999–2000 "Home Visits" project, sees Osorio coming back to sculpture. It is a

conceptually large work based on a simple premise. He asks a real family—Tina Rosado and her two young daughters—who have lost their home to fire and flood, to recreate it with him in miniature. And as Osorio and the family (particularly the five-year-old Sasha) begin this task, it is immediately clear how complicated it is. In an exchange about the factual details of their residence, Osorio teases out peculiarities of memory and emotion. Rosado and her daughters discuss not simply what went where in the rooms, but who they were in those rooms. They recall what they were doing at the moment of the fire and flood and what they were able to salvage after the devastation took hold. After the artwork—which is a dollhouse—is completed, Osorio guides them through taking it apart. This process represents the devastation done to the house, first by the flood, then by the fire. The furniture is upended, household objects strewn all over. To Rosado and her daughters this house represents a truth. As they sit in their new home among their new things, they examine the replica of their old house and understand it both as artifact of their experience and also as art (fig. 29).

Watching Osorio work with his collaborators on this project makes clear how easily he inhabits a variety of different roles that defy specific categorization. He is at once a friend, a facilitator, a social worker, and an artist. As he guides the family through the exercise he has constructed, he speaks from a position of empathy and authority. He situates himself in their midst and shares their experience, their home, and their tragedy; together they make the art.

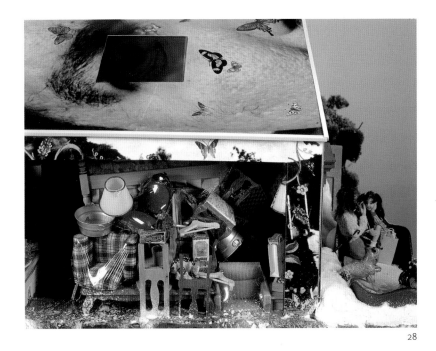

28

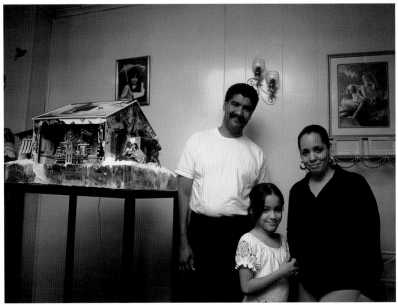

29

Richard Serra

30
One Ton Prop (House of Cards), 1969
Lead antimony, four plates,
each: 48 x 48 x 1 inch
The Museum of Modern Art, New York
Gift of the Grinstein Family

31
Tilted Arc, 1981
Weatherproof steel,
12 feet x 120 feet x 2½ inches
Collection General Services
Administration, Washington, D.C.
Installed Federal Plaza, New York
Destroyed by the U.S. Government,
March 1989

30

The work leaves the Rosados' new home and begins a tour of cities around the country, where it visits homes, offices, and community centers. At the first stop, across town from the Rosados' in Philadelphia, the piece clearly becomes "art." Shown on a pedestal, it is presented as a sculpture, a sculpture uniquely infused with its sense of origin. For Osorio, each place the work is shown adds to its meaning. This journey is emblematic of Osorio's work. In each place, both near and far from its origin, the work is redefined. It becomes, in essence, a site-specific piece, drawing meaning not only from its origin but from each place where it subsequently exists.

Richard Serra takes a completely different approach to place. His huge and massive steel sculptures are meant to be experienced by being walked around and through; they create a set of experiences for the viewer that are at once overwhelmingly visual and also spatial and tactile. Photographs can provide only a hint of their awesome scale and physical wonder. By a feat of engineering and the use of cutting-edge technologies, the artist has rendered

steel pliable enough to create his curved, twisted, and slanted structures. The effect is to draw the viewer into a place that is alternately uplifting, frightening, haunting, and exhilarating. Serra's work indicates how sculpture can commingle with architecture and the historic tradition of monument-making, not only to define space but also to create a place marked by the experience of engaging with the works. They are transformative, profoundly changing whatever space they might be in.

Born in San Francisco in 1939, Richard Serra drew copiously as a child and relates that as a young child his understanding of the way things worked came from looking at and drawing them. After receiving his master's in art from Yale, he spent two years traveling in Europe. In the late sixties he settled in New York City, where he has lived ever since. Serra was an important member of a critical generation of American sculptors who moved from working in minimalism, with its language of austerity and sculptural purity, to post-minimalism, also known as "process art," which emphasized the process of creation. Serra's prop pieces, made of lead sheets balanced very

precariously against one another or against walls, spoke to the spaces around them; they forced viewers to experience their delicate balancing act, which in turn became a part of the work (fig. 30). Serra worked through variations on this theme, while at the same time enlarging the scale of his sculptures. He also emerged as a theorist, in writings that are widely seen as laying out the framework of the monumental shifts in sculpture that have taken place over the past two decades.

Since the 1970s, Serra has produced a number of works, the most famous and controversial of which was *Tilted Arc* (fig. 31), commissioned in 1981 for the Jacob Javits Federal Building in lower Manhattan. *Tilted Arc* was a long, fencelike steel structure that cut across the building's plaza, where employees often congregated. Serra's intention was to create a dialogue between the sculpture and the space by inserting the work into the otherwise banal, straightforward setting. The sculpture infuriated many of the people who worked around and used the plaza, and after protests in the street and an acrimonious court battle, it was removed in 1989.

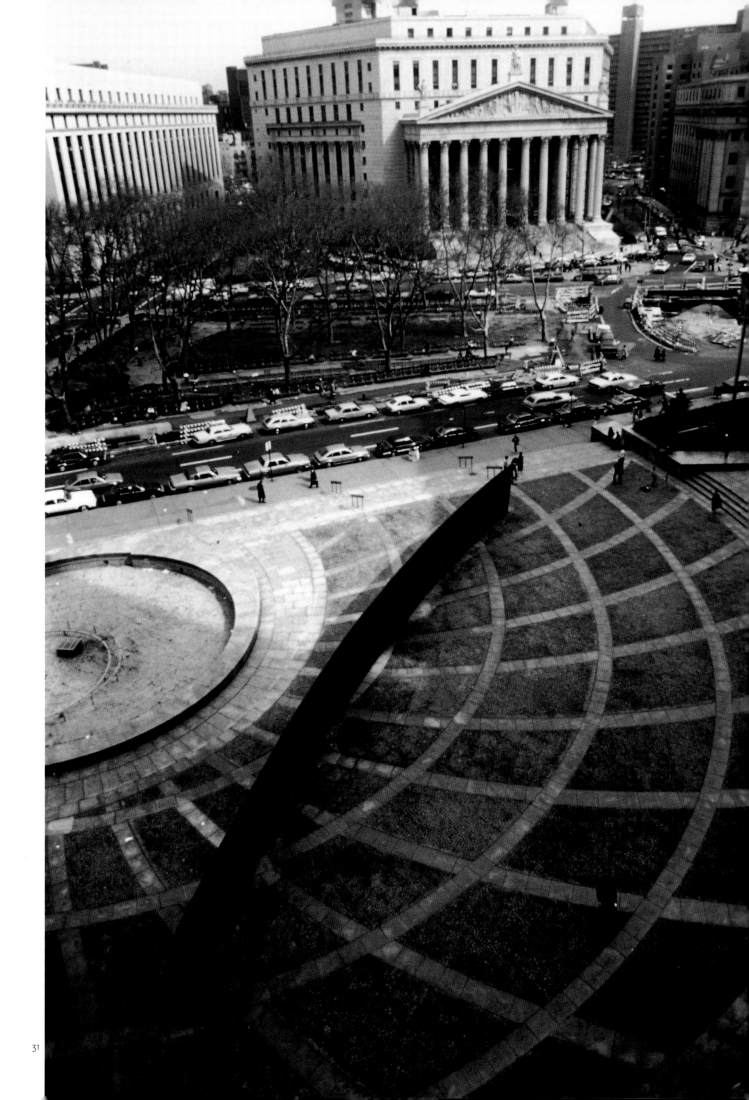

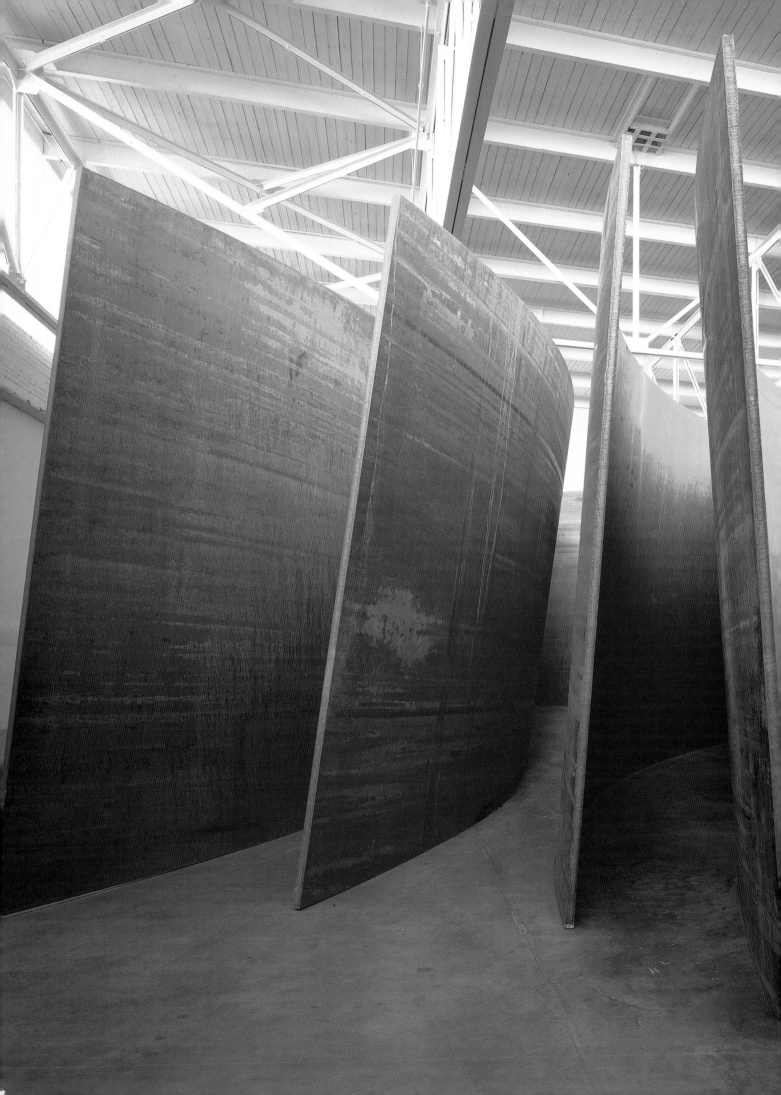

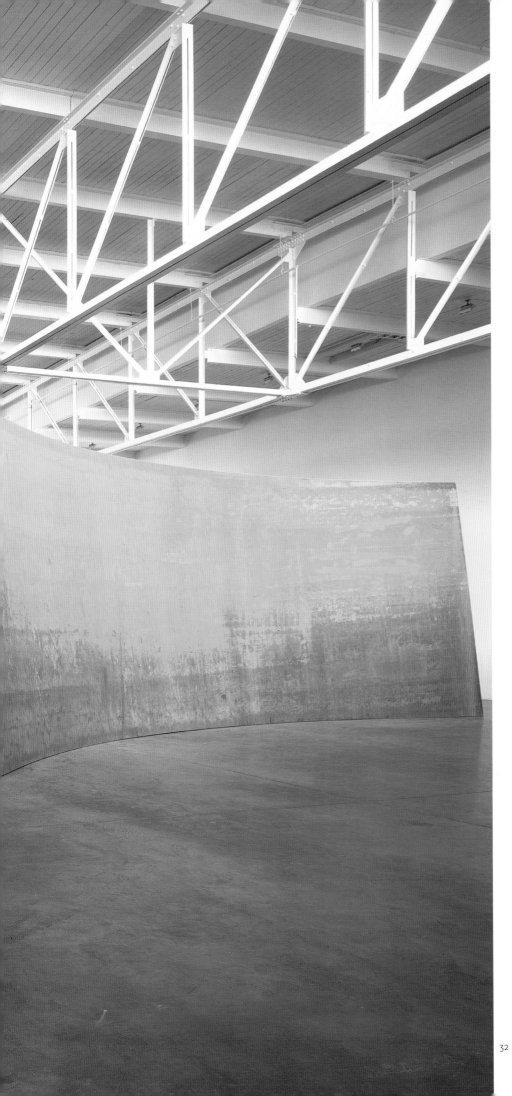

Richard Serra

32
Switch, 1999
Weatherproof steel, six plates,
each: 13 feet 6 inches x 52 feet x 2 inches
The Museum of Modern Art, New York

Richard Serra's sculpture has always been involved with an investigation of spatial play. The trajectory of his career has shown how sculpture can turn unmediated space into a place. Serra calls it "making space physical." The most recent passage in Serra's career has been taken up largely with the production of his torqued ellipses. These sculptures are made from 40-ton, 16-foot Cor-ten steel plates that are bent and manipulated to Serra's specifications to make these massive round and oval enclosures. Serra starts with a cone, which he manipulates into an ellipse. This makes possible a structure that both leans toward and away from the viewer. With this equation in mind, Serra challenges both the properties of his materials and the available technology to turn his idea into a three-dimensional form.

His sculpture *Switch* (1999, fig. 32) was a perfect introduction to the increasing creation of places within the spaces where his sculptures are viewed. *Switch* seems to stretch to bring the ceiling and the floor together in a contradictory state of compression and expansion of size, scale, and mass. Another work, *Torqued Ellipse VI* (1999, figs. 33–35), was to be viewed in the natural light existent in the space where it was first exhibited. This created sensual effects of light and shadow in the maze-like structure.

In 1999 the Guggenheim Museum Bilbao presented these and other works in a survey exhibition that powerfully illustrated Serra's long engagement with creating sculpture in dialogue with architecture. Frank Gehry's fantastic building

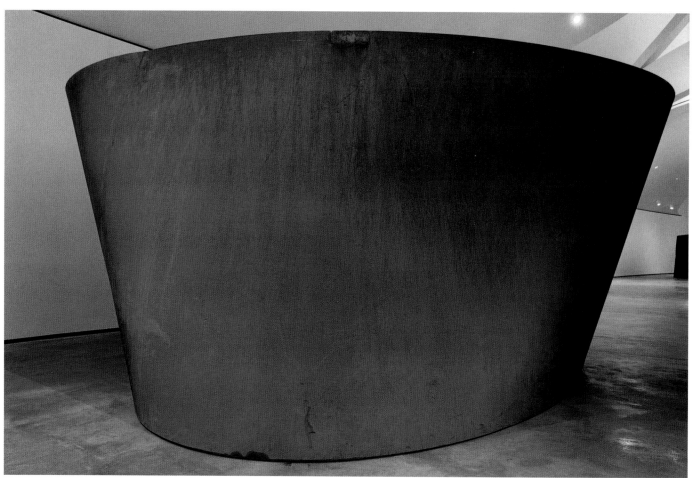

33

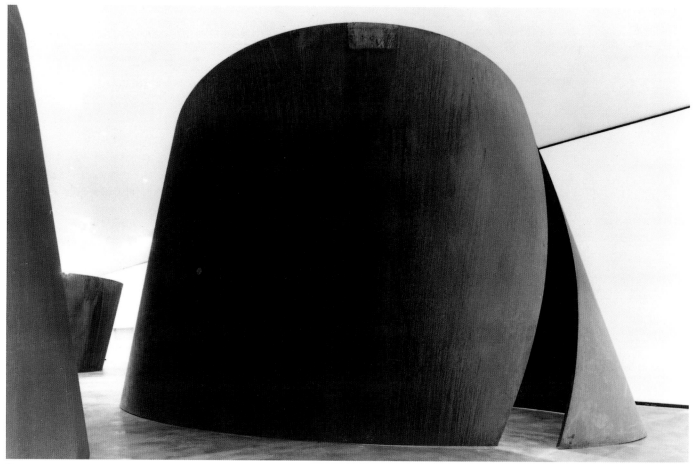

34

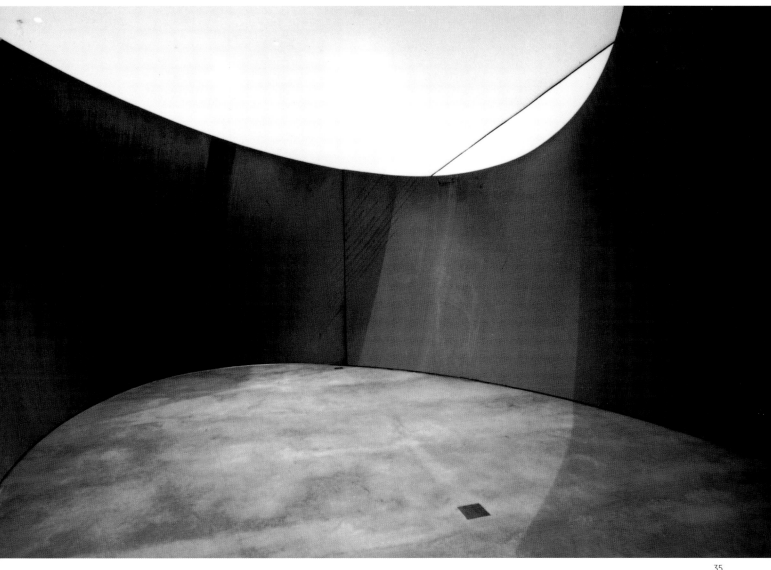

35

Richard Serra

33–35
Installation views of *Torqued Ellipse VI*,
1999, at the Guggenheim Museum,
Bilbao, Spain
Weatherproof steel, 13 feet 8½ inches
x 33 feet 5½ inches x 19 feet 8¼ inches
Metropolitan Museum of Art, Gift of
Jerry Leiber, 1985

was an ideal setting for Serra's work (fig. 36), not only because the museum afforded enough space for these extraordinary sculptures, but because the architect is a dear friend and kindred spirit of the artist. Indeed, when the museum was built, Serra was commissioned to create a torqued ellipsis, *Snake* (1996, fig. 37), in one of the building's major spaces. Seldom has architecture provided such a sublime foil for sculpture. (As art critic Peter Schjeldahl remarked in the *New Yorker,* "The sculpture felt affectionately understood.") The galleries created by Gehry, almost unfathomably large, cry out for grandiose statement, which Serra duly provides. Meanwhile,

Snake seems to echo the vibrations and curves of Bilbao's exterior, as if Serra were paying tribute to his friend's signature forms. The Bilbao exhibition featured eight ellipses, some weighing over 100 tons, some as long as 433 feet. Their effect is inseparable from their weight and size. Solid and seemingly impenetrable, the sculptures all have openings at different places, leaving viewers to figure out where and how to enter them. Once inside, a range of feelings, intellectual and physical, immediately confronts the viewer. Some of the sculptures induce an acute sense of claustrophobia, with walls that seem to close in and around you. Others embrace

Richard Serra

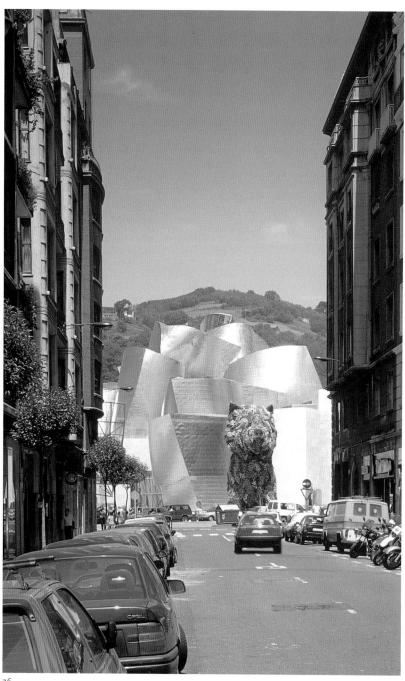

36

you with a womb-like sense of enclosure and provide an aperture onto the outside that changes as you make your way through. Still others provoke an intense sense of danger and foreboding by suggesting what Serra himself describes as a "gravitational pull." They all produce a sense of awe, as their visual appearance of weightlessness is tempered by the knowledge of their sheer, unbelievable mass.

By producing such a rich set of contrapuntal variations on the single theme of the torqued ellipse, Serra has created an almost fuguelike structure for the series. And he has succeeded, through his sculpture-as-architecture, in making art that is felt and experienced rather than passively observed. Serra's work does not represent a place, or even (*Tilted Arc* notwithstanding) mark a place; it simply is a place, a joyous site composed of geometry, mass, touch, and sensation. And therein lies Serra's distinctive contribution to American art.

If, in the next hundred years, artists continue the endless exploration of the beauty and mysteries of place, some of their work no doubt will be heir to Laurie Anderson. In her career, which spans three decades so far, Anderson has redefined contemporary art by her consistently innovative approach to the explication of word and image in multimedia. Her work includes pictures, sounds, music, video, performance, dance, technology, animation, and more. Anderson synthesizes a broad and disparate range of mediums and ideas, and through her vision she creates something brand new.

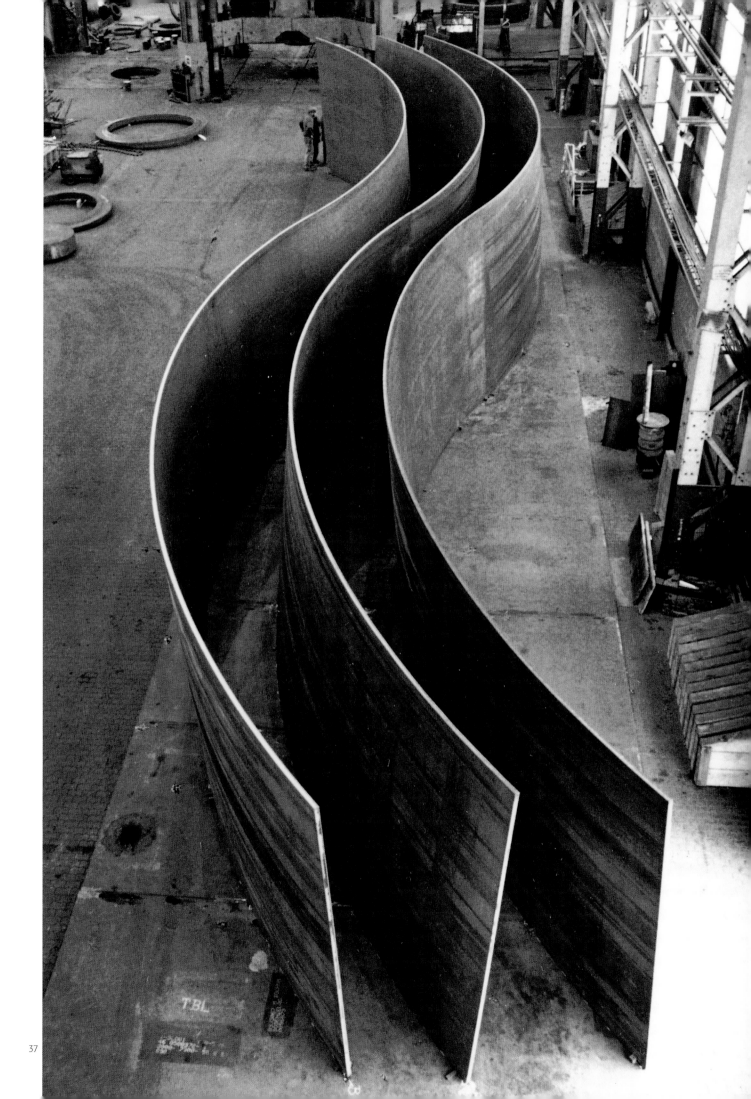

38

Place, in Anderson's work, has to be understood through a future-inspired sense of time and space as infinite and elastic, and of the world as one minor portion of a never-ending universe. In Anderson's work the notion of place retreats from the physical to the mental— a literalization of James Baldwin's "regions of the mind." Her evolution as an artist is as complex as her work. RoseLee Goldberg, the premier historian of Anderson's work, marks her journey by characterizing the eras: she says Anderson was "an innovator in the seventies, a leader in the eighties and a beacon in the nineties."

Anderson came to New York City in 1966 to attend Barnard College. She entered the downtown scene in the early 1970s and began making sculpture, film, and music, as well as writing and creating performances. She was deeply involved in the community of artists who were rethinking the practice of contemporary art and defining new forms with their work. She was part of the generation of artists who made video and experimental film, sound, and technology as valid as the more traditional mediums of oil paint, marble, and bronze. Performance is the center of her practice. Her presence, through her body and her voice, has always been the intellectual core of her works. She has performed often with a violin, calling it her alter ego. She said "for me, the violin is the perfect alter

ego (fig. 38). It's the instrument closest to the human female voice. It's a siren." Additionally, Anderson has pioneered the understanding of technology through her art and given a sense of the future in the present in her productions.

In 1983 Anderson created a groundbreaking work titled *United States* (fig. 39), perhaps one of the most stirring contemporary visions of this country ever created by an artist. She began writing *United States* in 1979 when she was living abroad and from that distance began to question the nature of being American. She returned to the U.S. at the dawn of the Reagan era, and the political climate she encountered also fed the creation of this monumental work.

United States is a multimedia theater work on a grand scale. The work confronts

the audience with a tidal wave of words, images, song, and spectacle. Anderson creates a metatext that describes the country. It includes original songs, texts, thousands of still images, and film clips in a cogent visual frenzy that has the effect of being a journey to visit a million different people at once. The set for the piece includes a huge map of the United States as a backdrop, literalizing her attempt to convey the grand scale of the country. The final work was eight hours long and ran over the course of two nights. She termed it a portrait in the form of an opera. Over time she revised and reworked the piece, increasing its already massive scale. She says of the work, "When I began to write *United States* I thought of it as a portrait of a country. Gradually I realized that it was really a description of

38
"Walking Solo for Tape Bow Violin" from
Americans on the Move, 1979 (Part 1 of *United
States 79–80,* New York version

39
Performance of *United States Part II* at the
Orpheum, New York, 1980

39

any technological society and of people's attempt to live in an electronic world." The work created a notion of place, of America, as a conglomeration of personal memory and mass media fabrication, of subjective fact, and seductive fictions. The work's enormity, not just in length, but also in content, provides a potent metaphor for the overwhelming inability to find one's place within this version of the cacophonous image world she describes. Technology renders the physicality of place obsolete, in Anderson's view of the present and near future as presented in the piece. Goldberg describes this work as having transformed Anderson into a "new kind of artist," emblematic of the fluidity and fluency that will no doubt be the hallmarks of twenty-first-century artistic practice.

At the beginning of the twentieth century, artists challenged themselves with the task of trying to picture and understand this growing nation, to come to terms with its vastness and diversity. One hundred years ago, artists provided their fellow citizens, through landscape and photographs, the opportunity to begin to understand this country by engaging with their images. Now, at the dawn of a new century, with these six artists it is clear that the concept of place is being redefined. History and region, home and community, site and space, geography and psychology all confront the challenge of trying to render the real intangible. As technology makes everything seem inherently closer and more familiar, these artists tease out meaning and help people see places that might be near—home, street, region, town—as

wholly unfamiliar. Within the frenzied movement of time, Mann, McGee, Kilgallen, Osorio, Serra, and Anderson work within the many sets of meanings that define place in contemporary society and offer anyone who encounters these works the experience of place by seeing, hearing, and ultimately, feeling their work.

Place is latitudinal and longitudinal within the map of a person's life. It is temporal and spatial, personal and political. A layered location replete with human histories and memories, place has width as well as depth. It is about connections, what surrounds it, what formed it, what happened there, what will happen there.

Lucy Lippard, *The Lure of the Local* (1997)

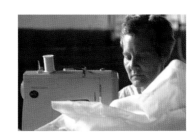

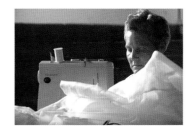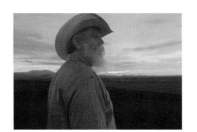

The cardinal has no red name like fire or crown.

Henry Dumas
Knees of a Natural Man

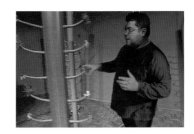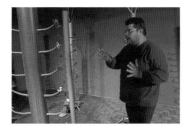

spirituality

Regarding Spirituality Lynn M. Herbert

The realm of the spiritual is mysterious and inviting. It is a place where we are encouraged to explore the unknown; to search, ponder, and reflect. It is a place where we can gain a greater knowledge of self and sometimes, sometimes, even find illumination. And yet it is a realm shrouded in mystery. We do not always know how to get there and never know what we might find when we arrive. There is no definitive map or designated entrance to this state of mind—we are each on our own when it comes to accessing the spiritual. As such, it sometimes surprises us, sneaking up on us in unexpected places.

For many of us, art can open a door into the spiritual realm. And if we look back through the history of civilization, we discover that art and spirituality have always been inextricably linked, that they have had a long and fruitful partnership. Much of what we know of ancient cultures we have learned from the artifacts that have survived them. As we journey through the history of art, we discover breathtakingly grand testimonies to spirituality. We find the Great Pyramids of Giza and their labyrinths of ritual chambers, Stonehenge's monolithic circle of stones on England's Salisbury Plain, and the Nazca Indian lines found in southern Peru that only become visible when seen from high above in an airplane—all large-scale manifestations of collective beliefs and dreams. We also find more intimate and personal expressions of spirituality. The intricate illuminated manuscripts of

1

medieval Europe, the Islamic miniatures of Persia, and the tenth-century Chinese landscape paintings of a sublime nature all suggest a more private, individual meditation on spirituality. Artists, it would seem, have long been our interpreters, our shamans, and our guides.

Looking through the millennia, we also discover that at certain times the link between art and spirituality has been vital and rich, and at other times issues of the day have pulled artists toward more secular subjects. Such has been our era. In art historical parlance of the twentieth century, the word *spirituality* has been branded persona non grata, and unfairly so. However, with the twenty-first century upon us, we finally seem ready to remove the restrictive cloak of political correctness that has obfuscated spirituality in matters of art. This is as it should be: it was a fool's errand to try to muffle humanity's vital breath, its essential being and very soul.

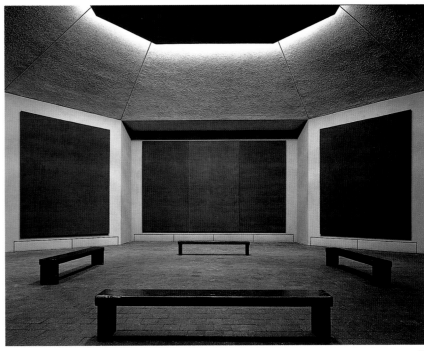

2

This is not to say that spirituality was totally absent in American art of the 1900s. Toward the end of the century, two artists in particular, both born in the first decade of the century, gained increasing recognition as quiet and enduring keepers of the flame: Agnes Martin and Mark Rothko.

From her relative seclusion in the mountains of New Mexico, Agnes Martin has created a body of deceptively simple minimalist paintings that speak worlds to those who choose to take an extended look and open themselves up to them. Her paintings manifest a meditative effort on the part of the artist and invite viewers to respond in kind. With a relative modicum of line and color, and everpresent traces of the human hand, Martin's paintings invite quiet contemplation. Rigid though they may seem, their perfection lies in their imperfection; as in nature, there are no perfectly straight lines in a Martin painting. One enjoys looking at a Martin painting in the same way that one enjoys gazing at the ocean.

Martin has written extensively about making art, and the term *inspiration* features prominently; she writes, "The great and fatal pitfall in the art field and in life is dependence on the intellect rather than inspiration." She writes of perfection and of ideals; about truth, beauty, and the sublime; and of being open to self-discovery and fully aware of everything around you, both large and small. *Happiness* is another word that recurs in Martin's writings (fig. 1). For her, *happiness* is the result of being fully open and receptive to what life offers us, or in her own words: "Happiness is being on the beam with life—to feel the pull of life."

We can find Martin's feeling of connectedness or "happiness" in the paintings of Mark Rothko. Rothko sought the sublime in a form of purity through a fundamental use of color, line, and shape. He is best known for his paintings in which mysterious rectangles of color appear to hover over a colored ground. Their rich and varied coloration engulfs viewers, drawing them into an otherworldly realm.

In 1964, when Rothko was sixty years old, art patrons Jean and Dominique de Menil commissioned him to create a series of paintings for a chapel in Houston, Texas (fig. 2). Art historian Sheldon Nodelman writes that Rothko, who more than once had described his work as religious, had longed for years to find a chapel-like space for his paintings. He set aside all other projects and focused all his efforts on the chapel paintings, for which he chose an uncharacteristically dark and brooding palette. Dominique de Menil wrote (in the foreword to Nodelman's *The Rothko Chapel Paintings,* 1997) about seeing the paintings in Rothko's studio for the first time:

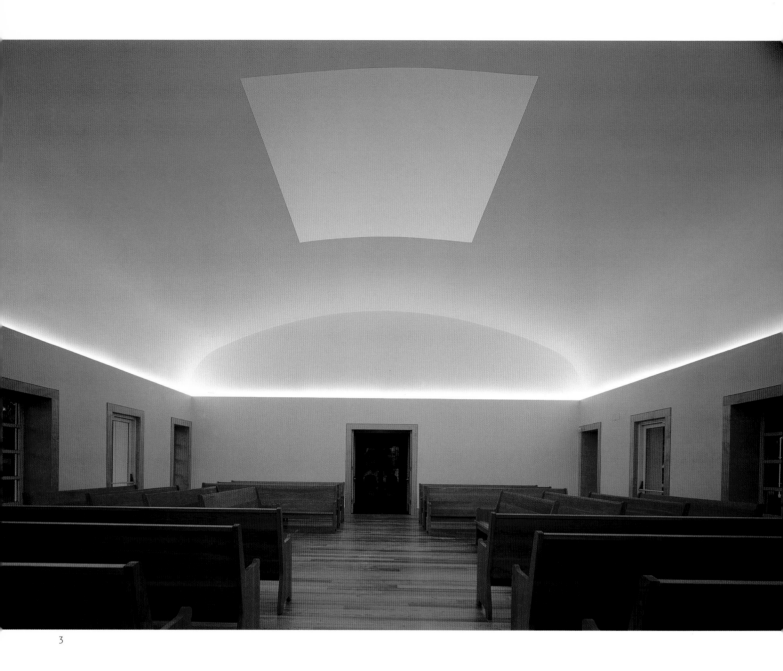

3

James Turrell

3, 4
Views of skyspace at Live Oak
Friends Meeting House, 2000,
Houston Texas
Retracted skyspace shows
light changing as sun sets

Finally the day arrived and I went to his studio. It was empty except for one painting, one of the four large, dark purplish monochromes. He had placed a chair for me about twenty feet in front of it and another chair for himself between the painting and me. He did not utter a word. He just looked at me. I felt instantly that not one muscle of my face should betray a surprise. I had expected bright colors! So I just looked. O miracle, peace invaded me. I felt held up, embraced, and free. Nothing was stopping my gaze. There was a beyond.

Rothko collaborated with architect Philip Johnson on the ecumenical chapel's design, and the building was finally dedicated in 1971, a year after Rothko's death. Though he never saw his paintings installed, the commission was a formative one for the artist. As he wrote to the de Menils in 1966, "The magnitude, on every level of experience and meaning, of the task in which you have involved me exceeds all my pre-conceptions. And it is teaching me to extend myself beyond what I thought possible for me."

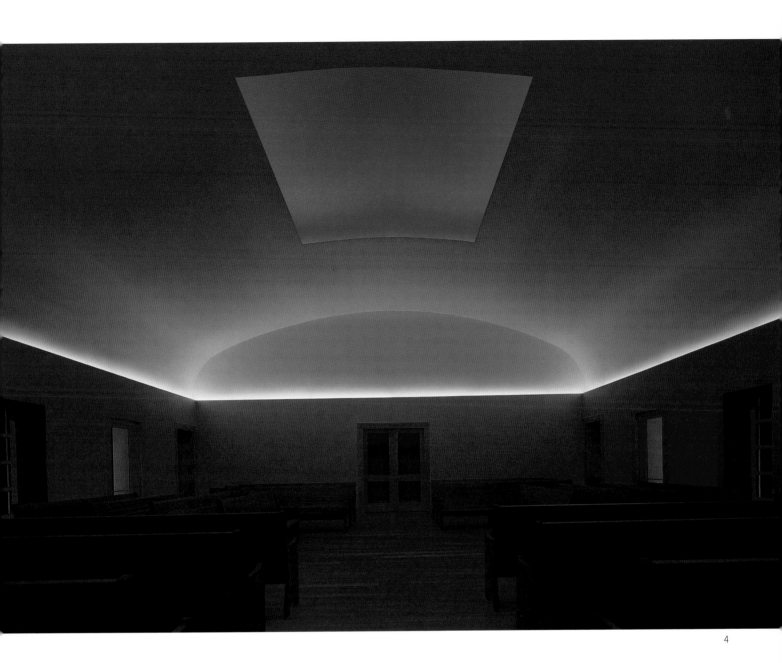

4

The flame that artists like Martin and Rothko fueled is now flourishing and burning brightly in the United States. More and more contemporary artists are venturing into the spiritual realm, and critical discourse in the field is beginning to acknowledge spirituality's role and impact. James Turrell, Ann Hamilton, John Feodorov, Shahzia Sikander, and Beryl Korot are five such turn-of-the-century artists who have chosen to incorporate spirituality in their art.

Only a few miles away from the Rothko Chapel, James Turrell has recently completed a work for the Live Oak

Friends Meeting House (figs. 3, 4). Turrell is an artist whose medium is light—not paintings that depict light, not sculpture that incorporates light, but light itself. For his works, Turrell taps into the light that greets us when we flip an electrical switch or turn on a television, the light from headlights and neon signs all around us at night, the light that each day comes with dawn and leaves at dusk, and the light that glimmers in faraway stars. Turrell's particular gift is in allowing us to have a unique and intimate experience with light and to feel its transcendent power.

Turrell grew up in a Quaker family. In a Quaker meeting, or service, the individual seeks greater awareness by looking inward in silence (as opposed to, say, listening to a sermon). Turrell has described this as "going into meditation and waiting for the light to come." The characteristics of the Quaker tradition are reflected in Turrell's work, which is pared down, direct, and quiet, and the artist acknowledges being influenced by the Quakers' "straightforward, strict presentation of the sublime." His work at the Live Oak Friends Meeting House is what he calls a "skyspace," an

5

opening in the ceiling designed to create the illusion of bringing the sky right down to the ceiling's edge, seemingly within reach, like a breathtakingly palpable and chromatic painting directly overhead. The work is most spectacular at sunset, when the roof retracts to reveal the sky's vivid and ever-changing color as the sun sets and darkness slowly envelops the earth.

We hope for transcendent experiences when we go into places earmarked for worship, and at the Live Oak Friends Meeting House, Turrell certainly delivers. But for years Turrell has made it abundantly clear that such experiences can be had in any number of places using various kinds of light. Can you imagine having a transcendent experience in, of all places, a hotel elevator lobby? Guests walking out of the elevator on each floor of the Mondrian, a hotel in West Hollywood, California, are greeted by Turrell's almost tactile light. In *Hi Test* (1998, fig. 5), the gentle, subtly changing light, the light of whispers rather than a full chorus, comes from a cut in the wall the size and shape of a small television screen. A small television set is placed on the floor beneath the opening, projecting light into an all-white closet-size space and transforming what we see on television into a diffuse array of wondrous quiet light. On each of the hotel's floors, the inset television is tuned to a different station, making each work different. A marvelous irony emerges that something so serene and beautiful can be created from the riot of images ordinarily found in television programming.

5
Site-specific permanent installation of *Hi Test*,
1997, at Mondrian Hotel, West Hollywood,
California

6
Installation view of *Heavy Water*, 1991,
at Le Confort Moderne, Poitiers, France

7, 8 FOLLOWING PAGES
Views of site-specific permanent installation of
The Light Inside, 1999, at The Museum of Fine
Arts, Houston, Texas (Main Street tunnel passage)
Electric lights, wires, metal, and paint

In *Heavy Water* (1991, fig. 6), Turrell
used both natural and artificial light to
create an extraordinary work in a public
swimming pool in Poitiers, France. Wear-
ing the artist's specially designed swim-
wear, participants could swim underwater
through an illuminated pool to a light-
filled skyspace chamber at its center. The
experience of all-consuming immersion
and surfacing elicited profound feelings
associated with baptism and rebirth, all in
a municipal setting. (The Poitiers facility
was destroyed, but the French government
plans to rebuild the work in Crest, in
the south of France.) In *The Light Inside*
(1999, figs. 7, 8), a similar empyreal jour-
ney is available to all who use an other-
wise utilitarian tunnel connecting two
buildings at the Museum of Fine Arts,
Houston. Between two monumental walls
of light runs a black pathway that seems
to float like one of Rothko's rectangles
over a bottomless, color-filled pool of
light. Visitors who venture onto that path-
way are rewarded with the sensation of
floating in an ethereal chamber of chang-
ing light and color.

Perhaps Turrell's most numinous work
will be his *Roden Crater* (fig. 9), which he
has worked on since the 1970s. In a natu-
ral crater near Flagstaff, Arizona, on a vol-
canic field situated between the Grand
Canyon and the Painted Desert, Turrell is
creating an observatory so grand and so
visionary that one inevitably associates it
with the likes of Stonehenge and other
ancient observatories. The sky at the crater
site presents particularly theatrical and

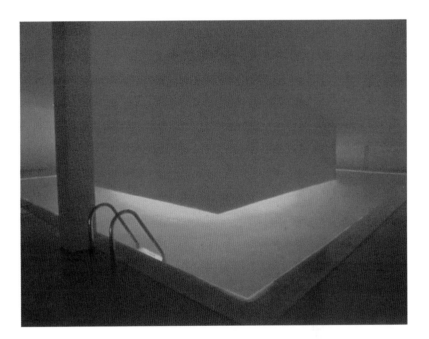

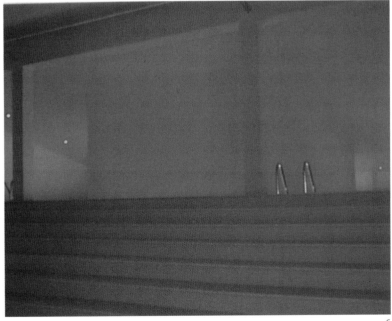

6

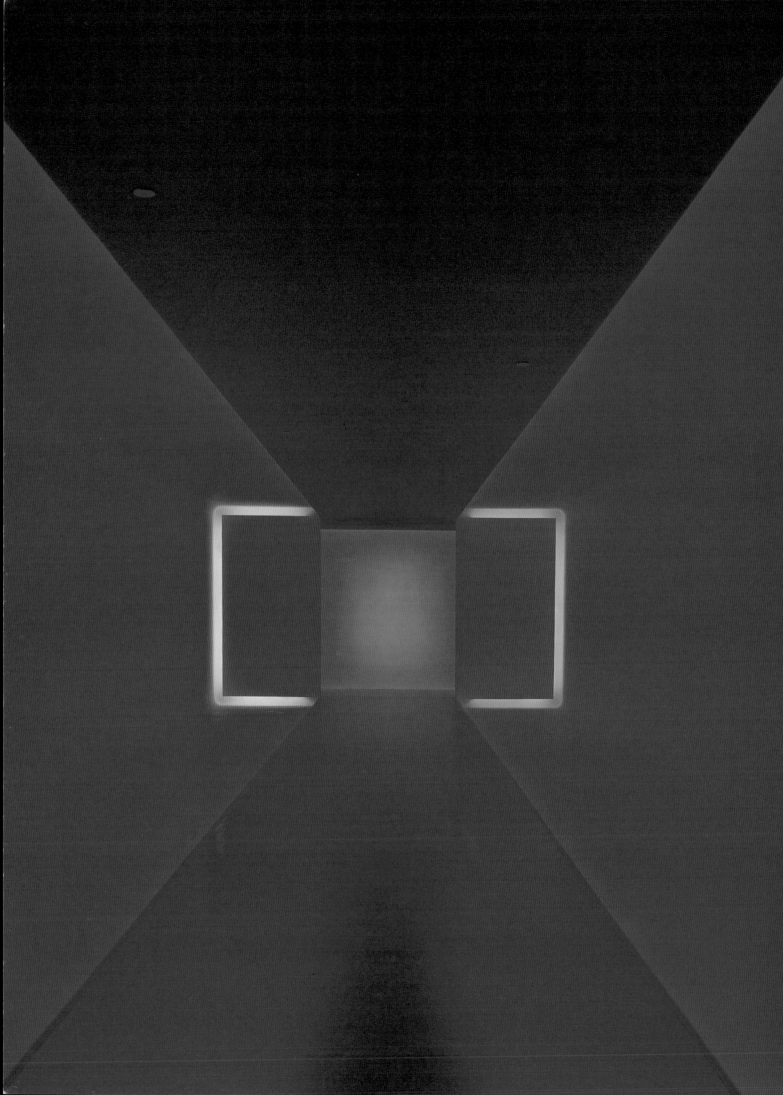

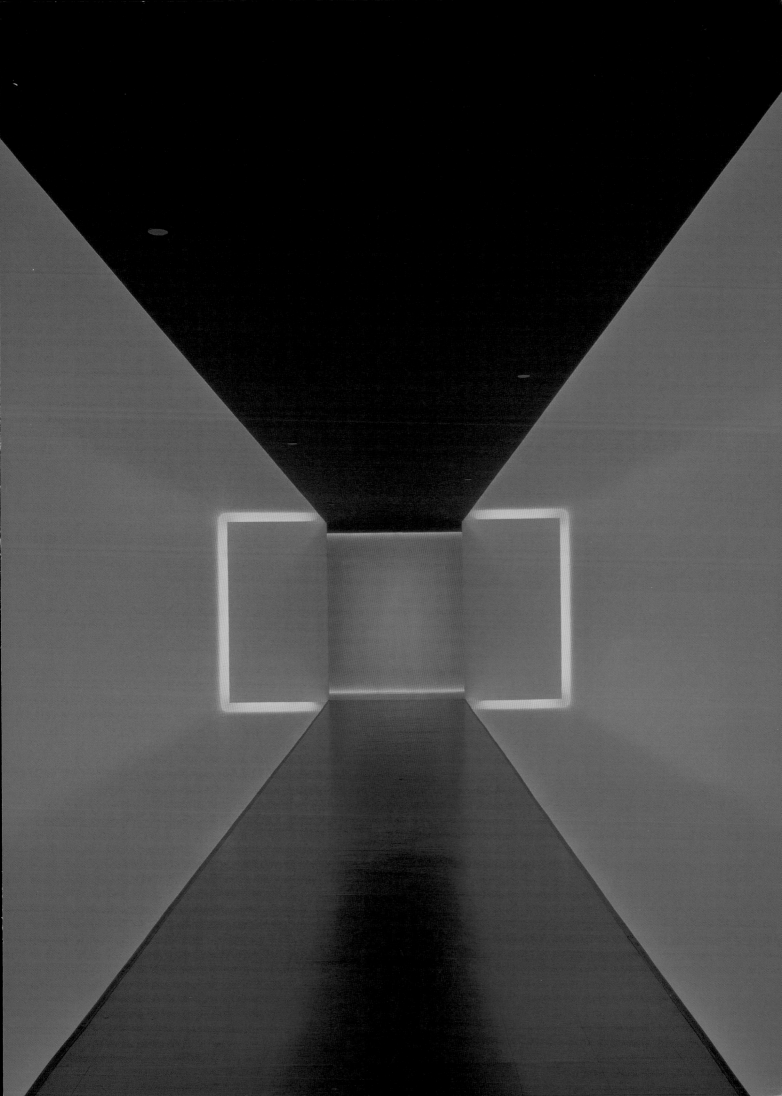

James Turrell

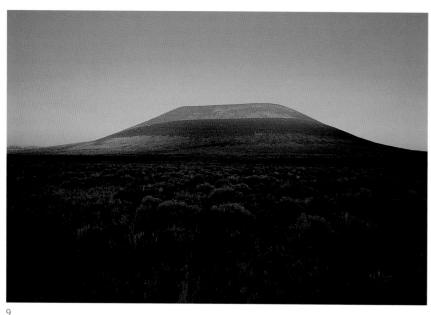

9

vivid shows. Sunrises and sunsets include ranges of color unimaginable to the uninitiated, and the clear night sky is resplendent with stars and planets. Turrell's observatory will include a series of tunnels and chambers that look to different portions of the sky, presenting different events (fig. 10). Among the phenomena visitors will be able to observe are the movement of the North Star, the details of the moon via a pinhole camera, and even the light of Jupiter. The music of the spheres, sounds from deep space, will be heard via a pool of water that picks up signals from quasars and distant galaxies. The *Roden Crater* will emphatically underscore what Turrell's other works have taught us: not only does light reveal what is around us, it also makes known what is inside us. Through light, we can discover the immensity within.

Ann Hamilton is another artist whose works have a way of getting right inside us before we know what to make of them. Describing the Rothko Chapel, art historian Sheldon Nodelman has written: "A strong component in the visitor's initial impression of the chapel is likely to be a sense of bafflement, of the inadequacy of one's available discursive apparatus to the experience one is confronting." Viewers experience this same kind of bafflement upon encountering Hamilton's works. Though they have no direct religious ties, they are as spiritual as Turrell's play with light or Rothko's somber chapel paintings in that they engage our whole being, eliciting the most personal of revelations.

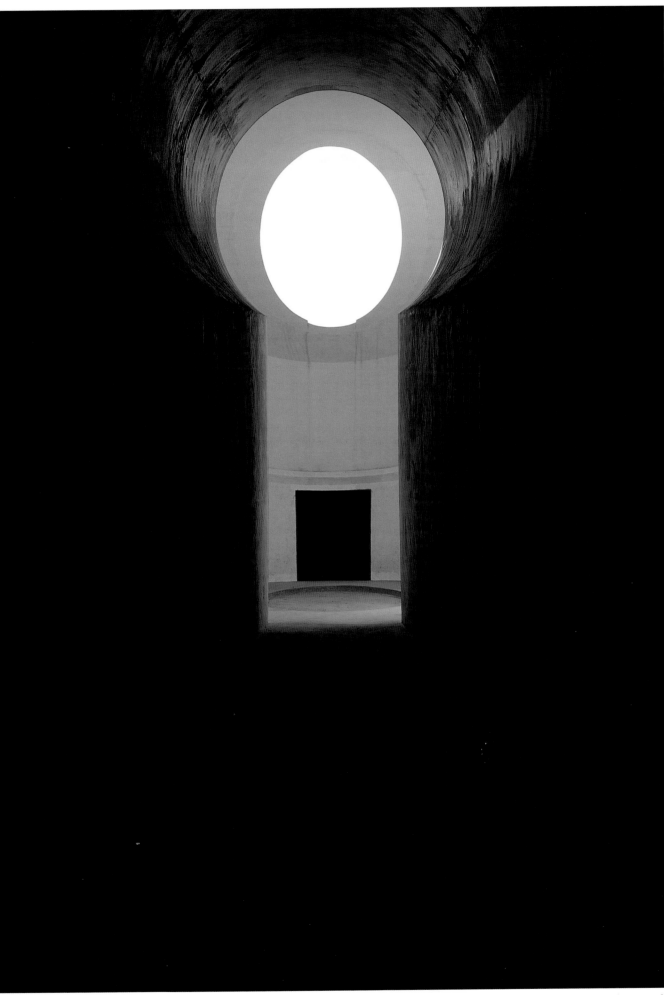

11

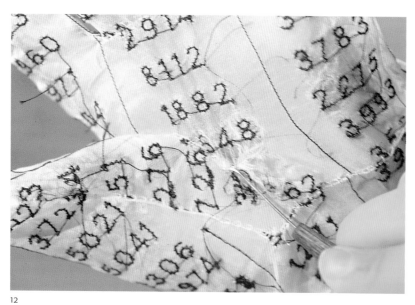

12

Hamilton does this by bringing her viewers into the realm of the unconscious, that complex and unmarked territory that is the provocative province of dreams. In psychoanalytic theory, this domain of thought is called "primary process." Hamilton's works challenge us to follow her into this world of pre-linguistic perception (where we "feel" something before we know or can say what it is), bypassing the smoothly paved routes of received knowledge and taking us instead down those rarely traveled, but scenic back roads of our minds.

In *kaph* (1997), a dramatic all-encompassing installation, Hamilton beckoned viewers across a threshold into a cryptic realm where the walls of an enormous white canyon wept, where a trapeze swung back and forth unattended, where a silent figure assiduously picked stitched numbers off a silk organza glove and let them drop to the floor (figs. 11, 12), and where four monumental tables covered in white sheets bore a massive and mysterious load. In *(bearings)* (1996, fig. 13), viewers are confronted with a different kind of threshold. Two circular forms made of fourteen-foot curtains spin randomly, clockwise and counterclockwise, like immense dancing skirts hanging off the floor at knee height. Openings in each skirt invite viewers to step inside and experience an otherworldly euphoria, a feeling of weightlessness in an ethereal vacuum.

Ann Hamilton

11, 12
Detail views of *kaph*, 1997, at the
Contemporary Arts Museum, Houston, Texas
Curved tearing walls, mounded dirt covered
with cloth on tables, mechanized trapeze,
seated figure, silk gloves embroidered with
numbers, dimensions variable

13
(bearings), 1996
Two black silk organza curtains, mechanical
devices, dimensions variable
Musée d'Art Contemporain de Montréal,
Montreal, Canada

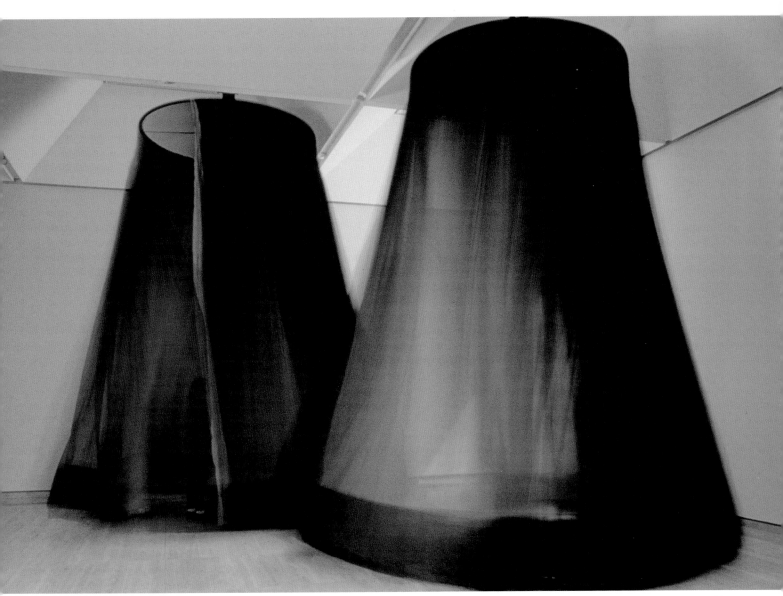

13

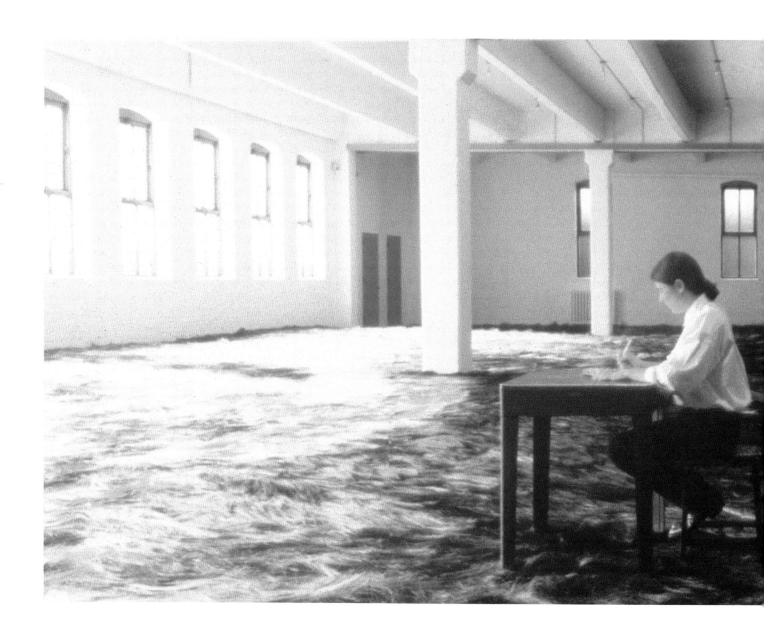

Ann Hamilton

14
Installation view of *tropos*, 1993–94, at
Dia Center for the Arts, New York
Undulating floor of horsehair, translucent
window glass, voice, table, book, seated
figure, lines of the book singed with a tool
as it is read, dimensions variable

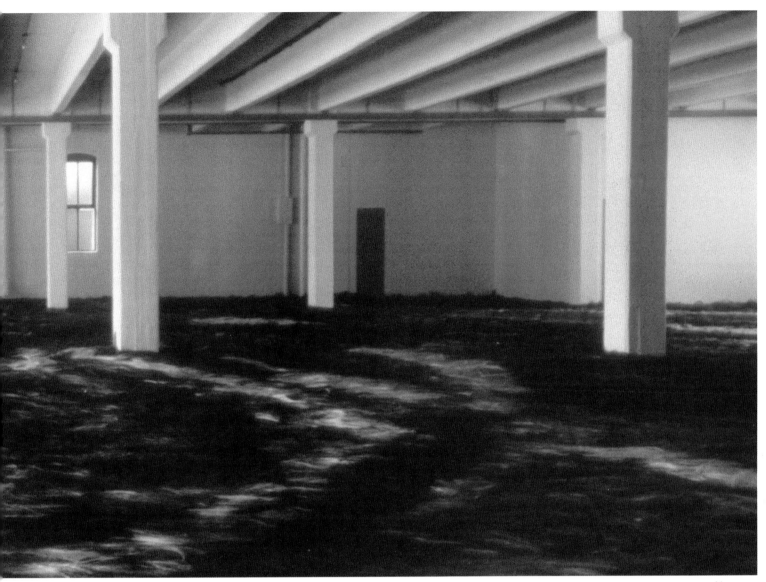

14

In *tropos* (1993, fig. 14), a lone person sat in an undulating gossamer sea of horsehair, meditatively burning away the words in a book with an electric instrument (like a heating coil), eradicating a few words at a time. Here, as in other works, language plays a vital role, but always in the background: it never pulls her out of the realm of primary process, always leaving her mind as free as a poet's. Although words could actually be heard in *myein* (1999), they were whispered almost inaudibly. Surrounded by white walls bearing a poem by Charles Reznikoff in large Braille characters, viewers heard the poem while a magenta powder intermittently wafted down from the ceiling, accumulating on top of the Braille characters and on the floor.

In *ghost. . . a border act* (2000, figs. 15, 16), installed in an old textile mill in Charlotte, North Carolina, Hamilton reduced the written word to its most fundamental tactile form—a handwritten line. Using a video image projected onto the translucent silk walls of a room erected on the factory floor, Hamilton showed a pencil both drawing lines and seemingly

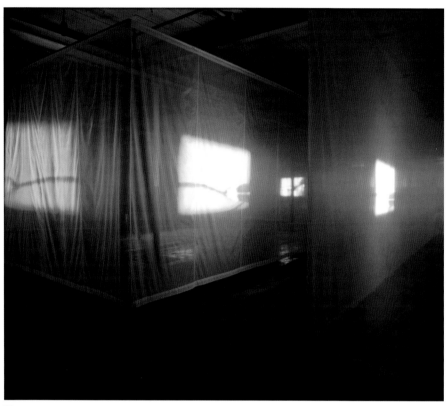

15

eating or removing each line (when the projection ran in reverse). She projected this drawn line to overlap a painted "horizon line" on the surrounding walls of the mill, a line that had been placed there for utilitarian reasons relating to the textile machinery.

In a project begun in 2000, Hamilton transposed the roles of the eyes and the voice by taking photographic portraits with her mouth (figs. 17, 18). Holding a specially adapted film canister in her mouth, she essentially becomes a human camera. Her sitters must stand totally still, very close to her mouth, during the long exposure period. One sitter described the experience: "The exposure took about 45 seconds. During that time she opened her mouth and looked at me as I looked at her. . . . It was an amazing and interesting experience . . . very intimate. Ann is a very trusting soul and I felt like I was going inside her and letting her inside me. I found myself crying, which completely surprised me." Looking at these photographs and seeing the sitter through the outline of Hamilton's mouth—from within—is like witnessing the ineffable moment when one person's breath or spirit connects with another's.

Hamilton's and Turrell's works take us into the realm of the spiritual by engaging the sensorium, by making us hyperaware of that which is around us. Even though their works are very much of this world, they still manage to take us elsewhere—

Ann Hamilton

15, 16
Installation views of *ghost . . . a border act*,
2000, at the former Ix Factory,
Charlottesville, Virginia
Silk organza, tables, video projection,
and sound, dimensions variable

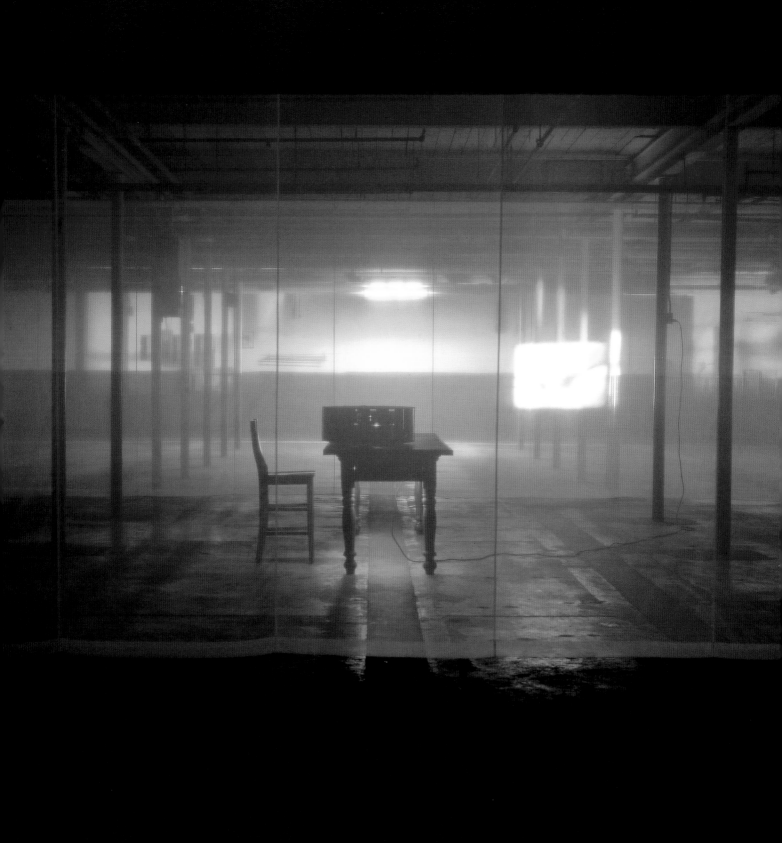

Ann Hamilton

17
Untitled, 2000
Pin-hole mouth photograph
from the series "face to face"

18
Ann Hamilton photographing
Jean Noel Herzlin with her mouth.
Production still, 2000

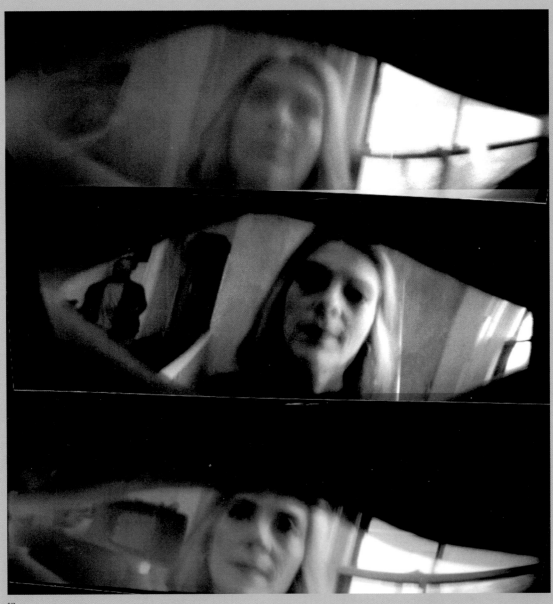

17

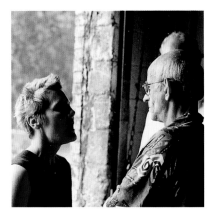

18

John Feodorov

19
Totem Teddy, 1989–98
Mixed media, 11 x 8 x 8 inches

to the mysterious, primitive, and unmediated land of primary process. Hamilton says her works often ask of their viewers, "Can you trust it without naming?" The spirituality that we discover in these artists' works catches us a bit by surprise: no outward signs or indications forewarn us that a spiritual experience is to be had.

Other contemporary artists have chosen a different path to spirituality, one that uses existing idioms and frameworks associated with matters of the spirit. Two such artists working this way are John Feodorov and Shahzia Sikander.

John Feodorov explores issues of identity as he probes the potential for spirituality in our times. His heritage gives him a unique vantage point: he grew up in southern California, the son of a Navajo mother and a Russian father. As someone who is neither one nor the other, who feels intimately what it is to be in between, Feodorov touches upon the human yearning to belong that lurks behind today's seemingly endemic spiritual alienation. This exploration has taken many forms, from painting to sculpture and installation.

In *Totem Teddy* (1989–98, fig. 19), Feodorov pits Navajo traditions against consumer society, throwing in some humor for good measure. Today's stuffed teddy bear is a far cry from the majestic animal that is its source, and Feodorov restores some of the bear's power to it, so to speak, by turning a series of teddy bears into totems. Each comes with a booklet ("*Totem Teddies* are specifically designed to meet the spiritual needs of

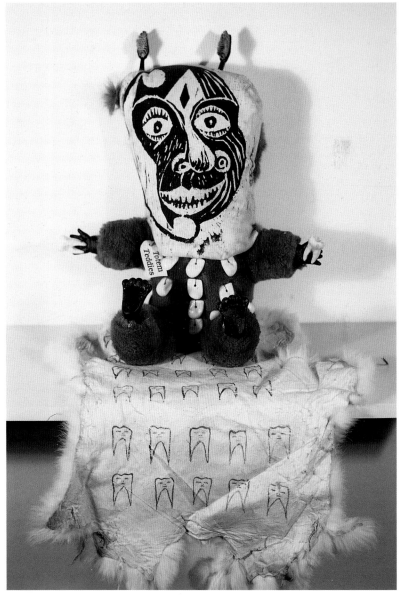

19

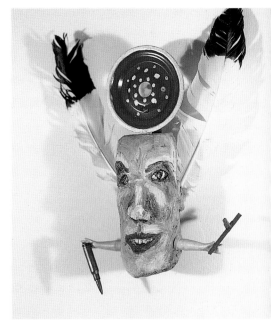

21

22

consumers of all ages") that explains how
Navajo deities are not all good or all bad,
but more like Hellenic deities—powerful,
scheming, and manipulative. If something
evil should befall you, the trick is not to
ask forgiveness, but instead to strategize
about how to get back into that deity's
good graces. Each bear's booklet urges
viewers to "use the handy spinning oracle
to determine what you must do in order
to appease your offended Totem Teddy
and re-harmonize yourself with the uni-
verse" (fig. 20).

Feodorov's fascination with medieval
European art is evident in his series,
Angels with Crosses and Bullets (1990–98,
figs. 21, 22) in which he counters the easy
charm of later cherubic Renaissance angels
by "putting the scare back in." Using found
materials, he creates apocalyptic characters
in Native American guise, a multicultural
reminder that while one hand giveth, the
other taketh away. Feodorov's "reminders"
also extend to warnings about the precari-
ous state of our natural environment
(figs. 23, 24). On the occasion of the 100th
anniversary of Mt. Rainier National Park,
both a popular recreation site near Seattle
and the home of a mountain sacred to the

John Feodorov

20
*Animal Spirit Channeling Device for
the Contemporary Shaman*, 1997
Mixed media, 15 x 12 x 3 inches

21, 22
Angels from the installation *Angels
with Crosses and Bullets*, 1990–97
Mixed media (found objects),
dimensions variable

John Feodorov

23, 24 (detail)
Installation views of *Forest at Night*, 1996–97
Mixed media with video and sound,
dimensions variable
Sacred Circle Gallery of American Indian Art,
Seattle, Washington

25
Office Myth, 1995
Oil on canvas with fluorescent light, 73 x 66½ inches

26, 27 FOLLOWING PAGES
Two views of doll from the installation
The Office Shaman, 2000–01
Mixed media installation, dimensions variable

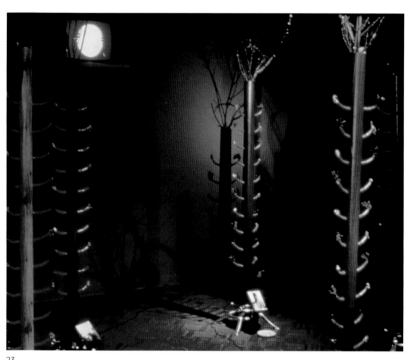

23

24

local Indian people, Feodorov created
Sacred Mountain (1999). The installation
included beer cans, sawdust, cigarette
butts, feathers, a plastic Virgin Mary, faux
pine branches, lights, and the sounds of
sawing and jets flying overhead.

Continuing to examine the relationship
between spirituality and capitalistic society,
Feodorov has reenvisioned the workplace,
where we spend so much of our time,
as a potential spot for spiritual encounters.
The fact that it is one of the last places one
would think to look for inspiration makes
it all the more appealing to Feodorov.
In *Office Myth* (1995, fig. 25), a female
worker is shown transfixed by a divine
light of fluorescent variety, the height of
her ecstasy measured against the depth of
her co-worker's despair. And in *The Office
Shaman* (2000–01, figs. 26, 27), Feodorov
transforms the office cubicle into a quasi-
sacred space complete with sound, video,
"divine" fluorescents, and ceremonial
costumes (business suits adorned with
beads, feathers, and other elements
associated with shamanic rituals). The
chants audible inside this sanctuary sound
traditional—they have the right tone, the
right ring—but as you listen, you realize
that they are repeating motivational
slogans often found posted in the work-
place. Underneath the playful veneer of
Feodorov's works runs an earnest desire
to reflect our shared human vulnerability
and yearning.

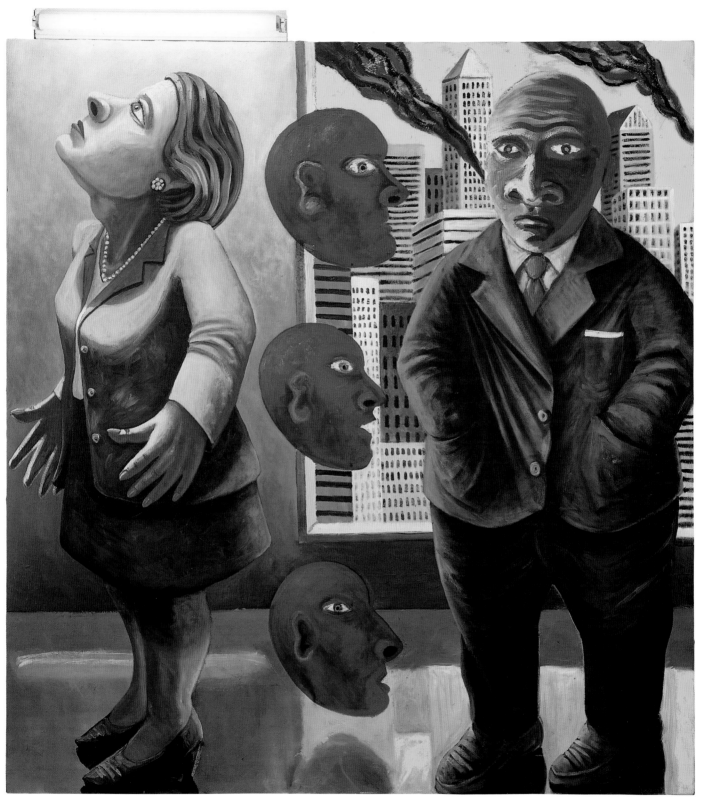

25

28

Shahzia Sikander

28 (detail), 29
The Scroll, 1991–92
Vegetable color, dry pigment, watercolor, tea on
hand-prepared Wasli paper, 13⅛ x 63⅞ inches
Collection the artist

29

As in Feodorov's work, the visual idioms related to spirituality that Shahzia Sikander uses in her art reflect her own heritage. Sikander was born in Lahore, Pakistan, and while in college she began training in the rigorous and painstaking art of miniature painting. Although miniature painting was considered outmoded, the stuff of souvenir shops, by her fellow students, Sikander responded to the challenge of mastering this difficult art— learning how to make her own paper and pigments and even catching squirrels to use their fur to make special brushes— having been seduced by its arduous refinement. As Sikander explored the technique, she also delved into the intellectual side of the miniature, including its conceptual nature, with all of its religious symbols, narratives, and formal structure, and its varied history as differences emerged in the Hindu, Persian, Muslim, and Indian styles. When she moved to the United States to attend graduate school, Sikander began to make the miniature her own, taking what the tradition had to offer and infusing her own life experience—a personal spirituality—into the works.

The Scroll (1991–92, figs. 28, 29) was a breakthrough for Sikander in which the artist took the architectural geometries of sixteenth-century Persian miniatures and laid them out on a five-foot Chinese-inspired scroll. The work is full of the play of patterns—the contrast of inside and outside that leads to the windows, spirituality, and divinity suggested in historic miniatures. But rather than depicting the court of, say, a Persian king, *The Scroll* reveals a contemporary home in Pakistan, complete with kitchen and patio and Sikander herself in white, drifting from room to room.

Perilous Order (1994–97, figs. 30, 31) began with the challenge of depicting marbleized borders but eventually evolved into a meditation on intolerance and hypocrisy. Sikander portrays a gay friend living in a society that doesn't tolerate homosexuality as Aurangzeb, the Mughal emperor of India from 1658 to 1707 who was an avid enforcer of Islamic orthodoxy though he himself was reputed to have been homosexual. He is surrounded by Hindu *apsaras*, or nymphs, one of whom has her finger in

30

Shahzia Sikander

30, 31 (detail)
Perilous Order, 1994–97
Vegetable color, dry pigment, watercolor, tea
on hand-prepared Wasli paper, 10½ x 8 inches
Whitney Museum of American Art, New York
Purchase, with funds from the Drawing Committee

32
Fleshy Weapons, 1997
Acrylic, dry pigment watercolor, tea wash
on linen, 96 x 70 inches
Collection the artist

33
Hood's Red Rider #2, 1997
Vegetable color, dry pigment, watercolor, tea on
hand-prepared Wasli paper, 10⅛ x 7⅛ inches
Collection Susan and Lewis Manilow, Chicago

her mouth, a traditional symbol of amazement in Persian miniatures.

In works like *Fleshy Weapons* (1997, fig. 32), we see again how Sikander brings past and present with their many different religious traditions together in one work. The voluptuous abstract female form present in this work emerged in some of the artist's early watercolors and soon evolved into a goddess figure. The idea of a goddess is blasphemous in Muslim belief, but integral to Hindu mythology. Sikander addresses this opposition by cloaking her goddess in a Muslim veil that partially covers the many arms traditionally present in a Hindu goddess. This interweaving of traditions stems in part from Sikander's personal history as a Muslim growing up in Pakistan, next door to primarily Hindu India. The goddess' looped feet keep her off the ground, floating and independent like Sikander herself.

We find Sikander's goddess again in *Hood's Red Rider #2* (1997, fig. 33). Here Sikander's faceless icon is surrounded by others, including a griffin, or *Chillava*—a creature part lion and part eagle, incorporated from Greek mythology into Punjabi tradition. Here it symbolizes the artist's own status as a cultural hybrid. Sikander has explained: "The *Chillava* has multiple identities, and it reflects the sort of rhetoric or categories that I am confronted with. Are you Muslim, Pakistani, artist, painter, Asian, Asian-American, or what?" The

31

33

34

Shahzia Sikander

34
Installation view of *Chaman*, 2000, at the
Whitney Museum of American Art, New York
Mixed media, dimensions variable

35
Riding the Written, 2000
Vegetable color, dry pigment, watercolor, tea,
on hand-prepared Wasli paper, 8 x 5½ inches
Collection the artist

calligraphic border in *Riding the Written*
(2000, fig. 35) is equally personal for
Sikander. As a child, before she could
read Arabic, she "read" the Koran simply
for the formal beauty of the letters.

Given her heritage and chosen mode
of expression, Sikander's works (fig. 34)
are as political and concerned with iden-
tity as Feodorov's Native American state-
ments. But both artists have chosen to
chart a course as well in the realm of
personal expression and toward personal
discovery. We can easily lose ourselves in
Sikander's expansive miniatures, moving
through their technical mastery to their

marriage of cultures and religions until
they become as meditative for us as
they were for the artist creating them.

If one looks at Turrell's and Hamilton's
work as celebrating the mystery of spiritu-
ality and its ability to catch us unaware,
and Feodorov's and Sikander's work as
celebrating traditional rituals and spiritual
idioms by breathing new life into them,
then artist Beryl Korot's work would lie
somewhere in between.

Writing about video during its early
years as an art form led Korot herself to
experiment with the medium, and she
went on to become a pioneer in the field;

35

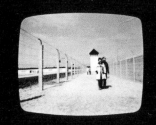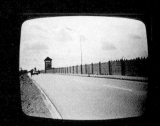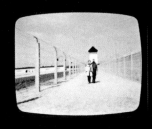

Beryl Korot

in 1970 she cofounded *Radical Software*, the first magazine to explore the concept of alternative communication systems and video in particular. In *Dachau 1974* (1974, figs. 36, 37), Korot broke ground for video art on several levels. It was one of the earliest multichannel works, liberating our television mindset by presenting successive images on several monitors at once. This opened up a whole new world of possibilities for putting narrative together in a more complex manner, introducing both rhythm and pattern.

In *Dachau 1974*, Korot used four monitors to revisit an unforgettable place in history, a Nazi death camp. In this work, Korot creates a kind of visual music. Her camera follows tourists as they walk through the camp, and it periodically dwells on specific buildings and sites. As such, Korot allows the present (in the form of the site itself) to confront the past: we recognize these buildings and are reminded of why they were built. Present and past further intermingle as we hear such sounds as gravel crunching underfoot, trucks driving by, and church bells ringing in the distance; sounds from the present that we can assume were also heard in the past. It is a carefully choreographed and emotional journey in which much is left to the imagination of the viewer, in this case a powerful supposition. Systems became an underlying theme of the work: from the Holocaust as a system for destroying people to the system of information encoded in the electronic lines that create video to the systematic weaving together of imagery

37

Beryl Korot

38
Videotape notation for minutes
13 to 18 from *Text and
Commentary*, 1976

39
Installation view of *Text and
Commentary*, 1976
Five channel video with textile,
dimensions variable

38

on four monitors to tell a story. All come together to create a very moving and haunting meditation on man's inhumanity to man.

Korot's "video tapestry" would lead her to explore tapestry itself in various woven works. She sees the hand loom as an archaic force, "the first computer on earth, as the original grid and as a key to visual structuring." She explains: "In an age of such tremendous multiplicity of viewpoints, traditions, and beliefs as our own, [using the handloom] was a physical way for me as an artist, in an effort to heal my own inner striving for peace, to stretch my arms across millennia to join the ancient and the new in one long embrace." In *Text and Commentary* (1976, figs. 38, 39), Korot expressed this idea of a spiritual embrace both literally and figuratively by bringing together drawings, weavings, and video in one work.

Much formal religion is inextricable from language ("In the beginning was the Word . . ." [John 1:1]), and Korot's interest in systems of language led to a later series of paintings on handwoven canvas for which she developed her own analogue to the Roman alphabet; in many of the paintings, the text centers on the story of the Tower of Babel. In the calligraphic *Anordnung* (1986, fig. 40)—German for "in order"—a small human figure is our point of entry into the mesmerizing world of letters and mark-making in much the same spirit as Sikander's *Riding the Written*.

Since the late 1980s, Korot has collaborated with minimalist composer Steve Reich, combining her video with yet

39

Beryl Korot

40
Anordnung, 1986
Oil on canvas, 90 x 56 inches
Private collection

Beryl Korot
and Steve Reich

41
The Cave, 1993
Performance with interviewees
and musicians

another medium—music. Together they have created a new genre of musical theater, a kind of video opera. *The Cave* (1993, fig. 41) is an exploration of the story of Abraham, a visionary iconoclast important in Judaism and Islam. The title refers to the Cave of Machpelah in the West Bank city of Hebron, a site that both Jews and Muslims celebrate as the burial place of Abraham and Sarah; it is the only sacred ground where members of both faiths worship. Using a gridlike staging reminiscent of Korot's weaving and early multichannel work, *The Cave* is presented in three acts: first Israelis, then Palestinian Muslims, and then Americans talk about Abraham and his family today. Their very words, including every inflection, inspired

Beryl Korot

and Steve Reich

42
Production stills from the opera
Three Tales—Act 1—Hindenburg, 1998
Color and black-and-white video

43
Production stills from the opera
Three Tales—Act 2—Bikini, 2000
Color and black-and-white video

42

Reich's score—he transformed their speech with a sampler—creating a kind of musical portrait of each interviewee. Korot's multichannel video presents details of the interviewees' images that were abstracted and redesigned in the computer and transported back to tape on several of the large screens. Each interviewee is thus embedded in an aural and visual portrait of him- or herself. The screen design itself functions as a way for live musicians and singers to be placed on a set alongside the prerecorded images. Three sets of characters—the interviewees, the performers, and the biblical subjects to whom they refer—side by side with Biblical and Koranic texts, bring together the different beliefs linking the past to the present.

Korot and Reich's epic video opera titled *Three Tales* (2002) explores humankind's increasingly complex relationship to technology in the twentieth century. The prologue sets the stage, beginning with the book of Genesis and humankind's purported mission on earth. Act I focuses on the *Hindenburg* (fig 42), the presumably indestructible zeppelin that exploded in 1937; Act II examines the destruction wrought by the atom bomb testing at Bikini Atoll in 1946 (fig. 43); and Act III takes on Dolly the cloned sheep and the advent of genetic engineering.

For this project, which includes a strikingly rich array of documentary footage, Korot developed a new video technique,

Beryl Korot

44
Production still from *Untitled*, 2001
Color video

43

the effect of which almost defies description. Technically, she treats each frame as if it were a still photograph, creating a new type of slow motion as she manipulates and varies the number of frames per second. As this unusual moving image unfolds, viewers feel as if they are being pulled into an altogether other dimension or realm. This sensation is both exciting and unsettling as Korot is allowing us to see as we've never seen before. Interspersed with this new and wondrous visual experience is contemporary commentary from the religious and scientific communities and Reich's music derived from those voices. With all of these elements combined, *Three Tales* gives new meaning to the term "all-encompassing experience." The piece transports us to an unforgettable state of being and invites us to explore the consequences of blind faith in science, and demonstrates how spirituality offers one way to deal with the challenging questions that science has placed before humanity.

On the occasion of this series on spirituality, Korot, was invited to create a new work—in effect, a personal response. For *Untitled* (2001, fig. 44), Korot has altered existing video footage of James Turrell, Ann Hamilton, John Feodorov, and Shahzia Sikander using her newly developed video technique of suspension. Transformed in this way, each of the artists' gestures takes on a

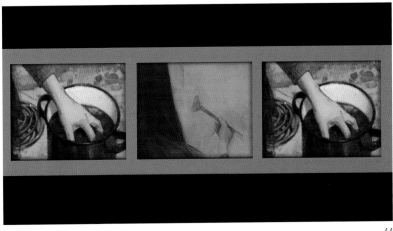

44

45
Ernesto Neto
Installation view of *Nhó Nhó Navé,* 1999, at
the Contemporary Arts Museum, Houston
Stockings and sand, dimensions variable

46
Shirin Neshat
Untitled from *Rapture series—Women
Pushing Boat,* 1999
Gelatin silver print, 44 x 68 ¼ inches
Edition of 5 and 2

47
Christian Boltanski
Installation view of *Les Ombres*
(The Shadows), 1996, at the Institute
of Contemporary Art, Nagoya, Japan
Electric fan, light bulb, and wire,
dimensions variable

48
Sol LeWitt
Wall Drawing #913, 1999
Acrylic
Ceretto Chapel, Alba, Italy
First drawn by Anthony Sansolta, Ciro
Scarpetta, and Ivano Tagetto, August 1999
Collection Bruno Ceretto, Alba, Italy

45

46

heightened importance and meaning. As Agnes Martin has written: "Every infinitesimal thought and action is part and parcel of a wonderful victory." We are transported and reminded anew of the role of the artist as interpreter, shaman, and guide. In *Untitled* (2001) we feel the spiritual power of light, of the word, and of tradition and memory; of ritual, mystery, and shared truths found in unexpected places. One of humankind's greatest gifts stands revealed: our ability to communicate profoundly through art.

It is important to note that Korot, Turrell, Hamilton, Feodorov, and Sikander are not alone in their pursuits. Recent years have brought us such works as Ernesto Neto's wondrous *Naves* (fig. 45), Shirin Neshat's compelling video fables (fig. 46), Christian Boltanski's haunting shadows (fig. 47), and Sol LeWitt's playful *Ceretto Chapel* (fig. 48). Such compelling works lead one to hope that the new century might bring with it a revitalized union of art and spirituality. That would be for the greater good because in these fast and technological times, we all too often lose touch with the spirit within. Art, as we have seen, has that rare ability to make us pause, reflect, and explore our innermost being. It is a key that can unlock countless doors, opening our eyes, our minds, and our hearts. As Thomas Merton, one of the twentieth century's great theologians, has written:

In art we find ourselves and lose ourselves at the same time.

from *A Thomas Merton Reader* (1974)

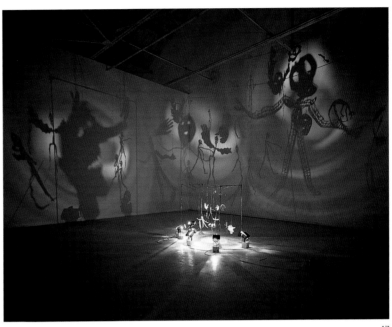

47

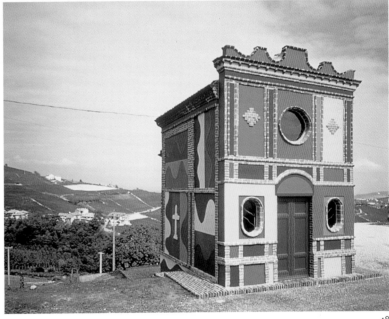

48

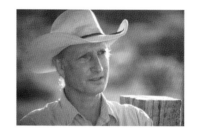

I am I because my little dog knows me.

Getrude Stein

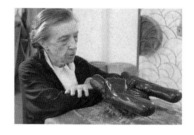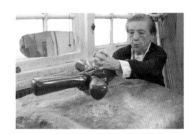

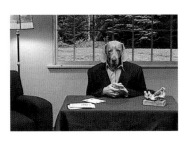
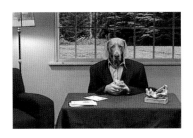

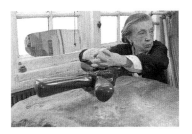
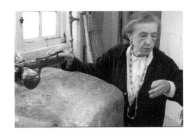
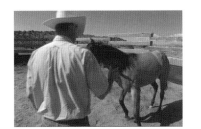

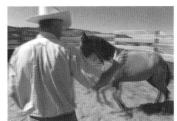

I Am I Because . . . Robert Storr

William Wegman

1
On Set, 1994
Color Polaroid, 24 x 20 inches
© 2001 William Wegman

2
Front Façade, 1993
Color Polaroid, 24 x 20 inches
© 2001 William Wegman

3
Patriotic Poodle, 1994
Color Polaroid, 24 x 20 inches
© 2001 William Wegman

"I am I because my little dog knows me." So said the American writer Gertrude Stein. Stein's whimsical regard for the elusiveness of being extended to her writing an "autobiography" of her companion Alice B. Toklas, though the book was more about Stein herself than about Toklas. Indeed, her ventriloquism might just as well have given her reason for saying, "I am I because Alice Toklas knows me," but mean that "I know myself because I know Alice Toklas, and Alice Toklas knows me." In theory at least, these displaced perspectives are multiplied by the number of dogs or companions one has had. Thus the simplest of phrases may lead us into a hall of mirrors in which our identity is reflected back on us from so many angles and with so many distortions that the self that is projected onto the mirrors is lost in a crowd of alter egos.

As far as thinking you have a hold on your identity because your dog recognizes you is concerned, Stein added, "That does not prove anything about you it only proves something about the dog." If, like Stein, you credit dogs with the ability to distinguish among humans in all their protean facets, then the question arises of how many sides the personality of a given dog might encompass, followed by the question of how those different aspects might be revealed, and under what circumstances, and to whom. In short order, our hall of mirrors becomes a sparkling labyrinth peopled with a kaleidoscopic display of women and men and their best canine friends.

Stein's appreciation of animal perspicacity is akin to that of the contemporary artist William Wegman. If anyone has fully grasped the myriad moods and demeanors of dogs, it is Wegman, ably assisted by his cast of weimaraners, Man Ray, Fay Ray, Chundo, and Batty. One way of looking at Wegman's photographs and films of this theatrical dynasty is to think of them as exercises in wry anthropomorphism: dogs doing people things—cooking, playing musical instruments, posing for posterity in their Sunday best—all with a slightly bemused air. The other, perhaps more appropriate, way of thinking about them is to say that they depict people "doggified"—with no offense intended: that is, people who just happen to look like weimaraners, doing what they are in the habit of doing. After all, in spite of the higher social and psychological complexities of human nature, it is sometimes useful to be reminded of the basic instinctual component of our makeup. "Why must I be like that?/Why must I chase the cat?/Something 'bout the dog in me," Funkmaster George Clinton sings. Although Wegman's dogs sit preternaturally still for the camera, ignoring ambient cats, Clinton's matter-of-fact statement would not be lost on Wegman. And, as the visual artist Bruce Nauman would be quick to see, Clinton isn't just joking.

In Wegman's world, clothes make the dog (figs. 1–6). It's the choice of suit or dress or wig that gives his players their overall character; framed by strawberry blonde curls, a frilly collar, or a feather stole, their long, normally doleful faces

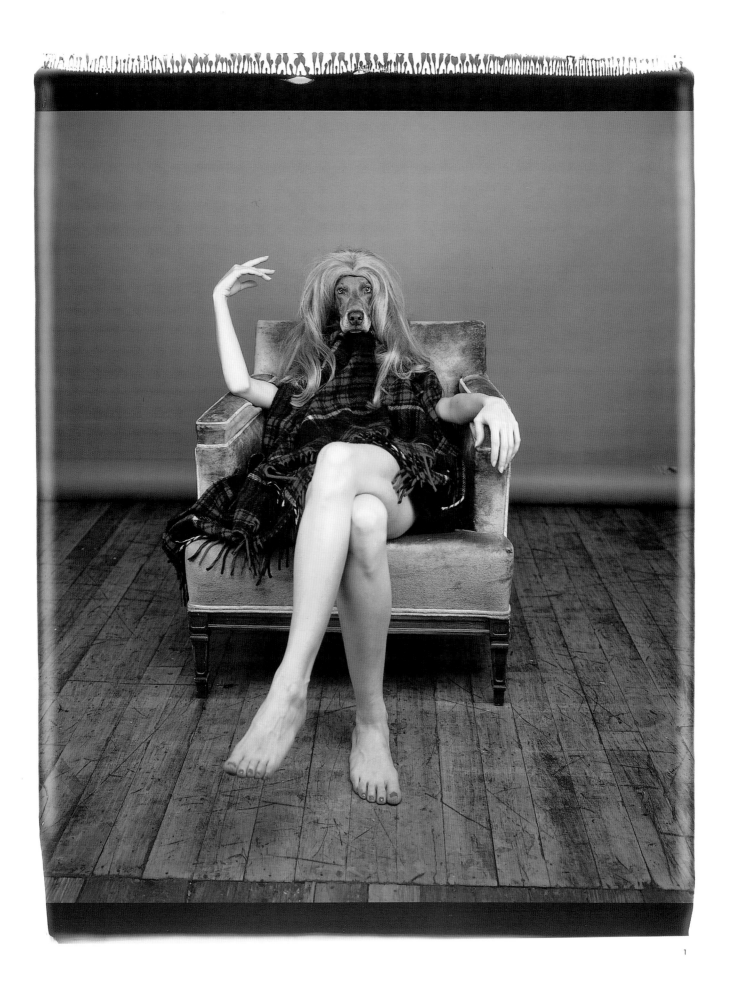

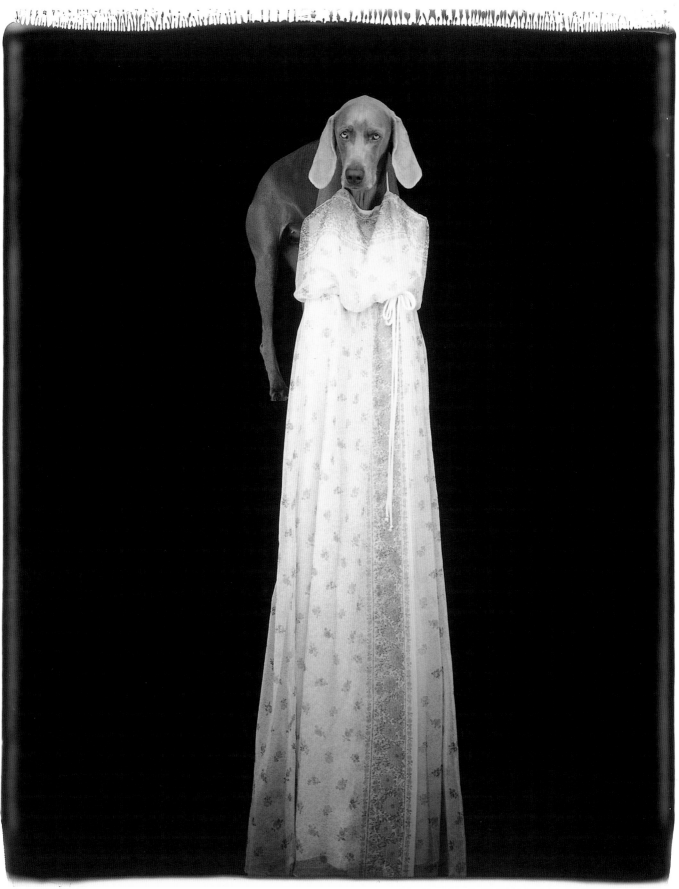

2

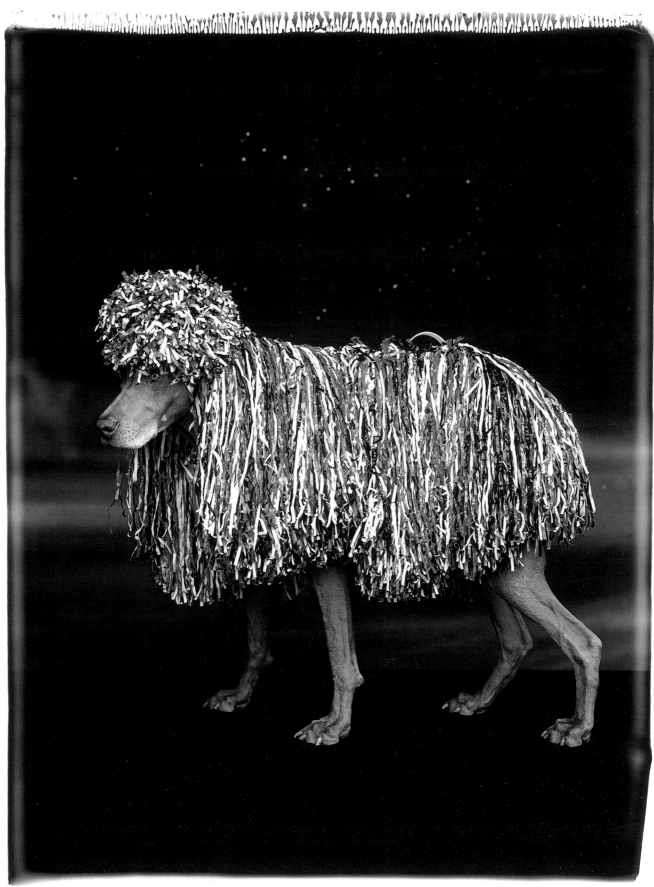

3

William Wegman

4
Canon Aside (diptych), 2000
Color Polaroid, 24 x 20 inches each
Top image of vertical diptych
© 2001 William Wegman

5
Miss Mit, 1993
Color Polaroid, 24 x 20 inches
© 2001 William Wegman

6
Stepmother, 1992
Color Polaroid, 24 x 20 inches
© 2001 William Wegman

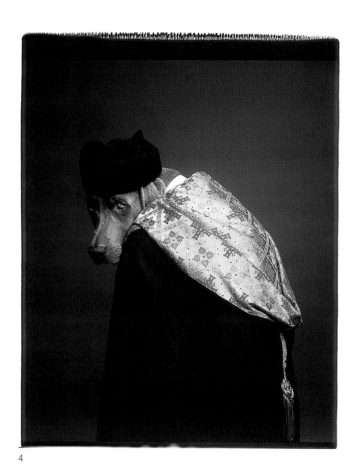

4

assume an engaging expressiveness, and we begin to ascribe to them traits and emotions akin to our own. Ingratiating humor and a trace of sentimentality inform these pictures, but insofar as both qualities are disarming, both predispose the viewer to accept a level of absurdity that has broader ramifications. Identity, in Wegman's gently subversive mode, is a matter of striking attitudes that tease our desire to identify with what we see despite our awareness of its fundamental artificiality. Superficial effects thus tap into deeply submerged assumptions with offhand wit serving the function of icebreaker.

Integrity is the virtue of being ethically consistent. An admirable ideal, it is based on the assumption that all the pieces of our personality fit, or could be made to fit, if only we exercised our will. Too much history, too much literature, too much psychology tells us that this is an impossible goal; impossible not just because we are morally weak—though we very well may be—but because the wholeness needed to achieve that goal is denied us. Whether original sin is thought to be the cause, or class conflict, or Oedipal tensions, or an imbalance in the humors, or disruptions in the exquisite circuitry of the brain, our fundamental instability and dividedness are the true facts of life. Human nature, such as it is, is the sum of human contradictions with this important qualification; add up those contradictions two or more times in a row according to the experiences of two or more people,

or even the same person on two or more days, and the sum will never be the same.

Bruce Nauman's subject is "human nature," the quotation marks having been added to remind us not only that Nauman uses it as a term yet to be defined, but that the concept itself is disputed by many for whom it smacks of false universals. Nauman's primary resource is himself, though he does not presume to be anything other than an ordinarily conflicted example of a larger community. Nauman's method is empirical, which in practice means that he frames hypotheses about what the human condition is or might be and tests their resonance against his own intellect and nervous system and against the responses of others. "I force myself into contradiction," he once declared. Of course, the contradictions were already in place, but the force involved is a matter of discipline, the cranking up of preexisting tensions that most people try to alleviate, or crank down by planned distraction or simple inattention. But paying attention is what Nauman's art is all about. Actually doing that means monitoring with the maximum possible intensity the inner disturbances of the peace as well as the strife around one. This takes stamina—Nauman's work can be as much of an ordeal for the viewer to witness as it was for the artist to make—and it can take one to the edge of what might be called a state of spiritual hypochondria, except that over and over again Nauman demonstrates that the malaise he suspects might be afflicting us really is.

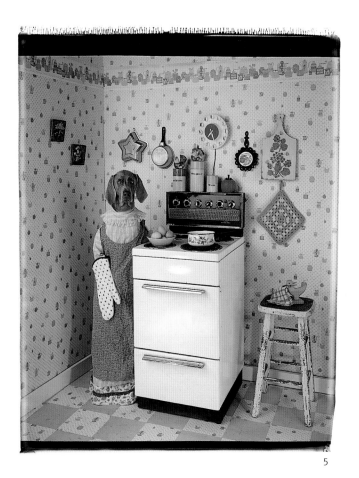

5

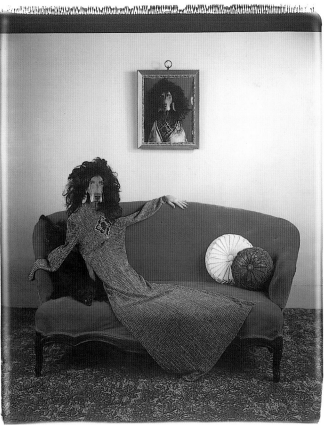

6

Bruce Nauman

7
Still from *Slow Angle Walk (Beckett Walk)*, 1968
Videotape, black-and-white, sound, 60 minutes, repeated continuously

8
Self-Portrait as a Fountain, 1966–67
Color photograph, 19¾ x 23¾ inches
Edition of eight

9
One Hundred Live and Die, 1984
Neon tubing mounted on four metal monoliths, 118 x 132¼ x 21 inches
Collection Fukake Publishing Co., Ltd., Naoshima Contemporary Art Museum, Kagawa, Japan

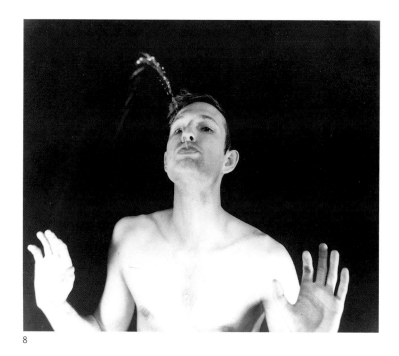

8

7

These fevers and chills of the soul are not detectable—much less treatable—by conventional scientific or social-scientific means, though Nauman's experiments sometimes resemble those of behavioral psychology, which he briefly studied before becoming an artist. Indeed, Nauman is deeply mistrustful of the claims made by science, which he views as being just as likely to hurt us as to help us. Nevertheless, the strict regimens he sets himself—choreographing difficult physical movements (fig. 7), performing difficult tasks (fig. 8), or repeating tongue-twisting, mind-bending texts (fig. 10)—and the controlled and controlling environments he creates (fig. 11)—narrow, overlit corridors through which the public is invited to pass; barren, claustrophobia-inducing spaces; and small cells in which a disembodied voice growls from loudspeakers: "Get out of this room! Get out of my mind"—are all crucibles in which to render our basic instinctual, emotional, and intellectual attributes, our needs, desires, vulnerabilities, and fears.

The aim of Nauman's multimedia analysis of human behavior is not to improve upon the ways in which these characteristics naturally mix. On the contrary, he seems to believe that any real improvement is impossible. In his artistic laboratory, the emphasis is placed instead on the isolation and examination of such habits, yearnings, and anxieties. At times, indeed, his procedures amount to a kind of mental vivisection. Meanwhile, rather than holding out the hope that we might overcome our limitations and retrain ourselves to do the right thing, repetition, a key—element of his aesthetic—tends to reinforce the "givenness" of our traits and to increase the pressure on the binds and double binds that our dichotomous compulsions produce.

One Hundred Live and Die (1984, fig. 9) addresses the problem in the starkest but most dazzling manner. Splitting a huge neon signboard into four columns, two ending with LIVE and two ending with DIE, Nauman then completes the phrases with a list of verbs—SPEAK, LIE, CRY, KISS, RAGE, LAUGH, TOUCH, FEEL. The result is illuminated one sentence at a time, then in columns of sentences, then all at once like a Las Vegas marquee, enumerating the states of being—dignified and undignified—that in varying measure compose our identity. Again using neon, Nauman has listed the seven

LIVE AND DIE	LIVE AND LIVE	SING AND DIE	SING AND LIVE
DIE AND DIE	DIE AND LIVE	SCREAM AND DIE	SCREAM AND LIVE
SHIT AND DIE	SHIT AND LIVE	YOUNG AND DIE	YOUNG AND LIVE
PISS AND DIE	PISS AND LIVE	OLD AND DIE	OLD AND LIVE
EAT AND DIE	EAT AND LIVE	CUT AND DIE	CUT AND LIVE
SLEEP AND DIE	SLEEP AND LIVE	RUN AND DIE	RUN AND LIVE
LOVE AND DIE	LOVE AND LIVE	STAY AND DIE	STAY AND LIVE
HATE AND DIE	HATE AND LIVE	PLAY AND DIE	PLAY AND LIVE
FUCK AND DIE	FUCK AND LIVE	KILL AND DIE	KILL AND LIVE
SPEAK AND DIE	SPEAK AND LIVE	SUCK AND DIE	SUCK AND LIVE
LIE AND DIE	LIE AND LIVE	COME AND DIE	COME AND LIVE
HEAR AND DIE	HEAR AND LIVE	GO AND DIE	GO AND LIVE
CRY AND DIE	CRY AND LIVE	KNOW AND DIE	KNOW AND LIVE
KISS AND DIE	KISS AND LIVE	TELL AND DIE	TELL AND LIVE
RAGE AND DIE	RAGE AND LIVE	SMELL AND DIE	SMELL AND LIVE
LAUGH AND DIE	LAUGH AND LIVE	FALL AND DIE	FALL AND LIVE
TOUCH AND DIE	TOUCH AND LIVE	RISE AND DIE	RISE AND LIVE
FEEL AND DIE	FEEL AND LIVE	STAND AND DIE	STAND AND LIVE
FEAR AND DIE	FEAR AND LIVE	SIT AND DIE	SIT AND LIVE
SICK AND DIE	SICK AND LIVE	SHIT AND DIE	SHIT AND LIVE
WELL AND DIE	WELL AND LIVE	TRY AND DIE	TRY AND LIVE
BLACK AND DIE	BLACK AND LIVE	FAIL AND DIE	FAIL AND LIVE
WHITE AND DIE	WHITE AND LIVE	SMILE AND DIE	SMILE AND LIVE
RED AND DIE	RED AND LIVE	THINK AND DIE	THINK AND LIVE
YELLOW AND DIE	YELLOW AND LIVE	PAY AND DIE	PAY AND LIVE

11

cardinal virtues and the seven cardinal vices around the cornice of a building in the middle of the campus at the University of California at San Diego, taking care to superimpose them in such a way that when they light up, one first sees the virtues one by one, then the vices, then all simultaneously with the letters overlaid so that the concepts are visually conflated and the choices they represent are confounded, underscoring how hard it is to distinguish the good and evil in our conduct (fig 12). In the video piece *Good Boy, Bad Boy* (1985, fig. 13), a man and a woman on side-by-side monitors recite the same litany of simple propositions that begins with "I am a good boy. You are a good boy. We are good boys. This is good," continues on through "I am a bad boy. You are a bad boy. . . ," and ends with "I don't want to die. You don't want to die. . . , " thus conjugating the verbs of existence with all their incompatible options and ethical polarities.

In this context, Nauman's formal ingenuity has led him to use mediums, such

Bruce Nauman

10
Violins Violence Silence, 1981–82
Neon tubing with clear glass tubing suspension frame,
60½ x 66½ x 6 inches
Oliver-Hoffmann Family Collection, Chicago

11
Room with My Soul Left Out, Room That Does Not Care, 1984
Celotex, steel grate, yellow lights,
408 x 576 x 366 inches
Flick Collection

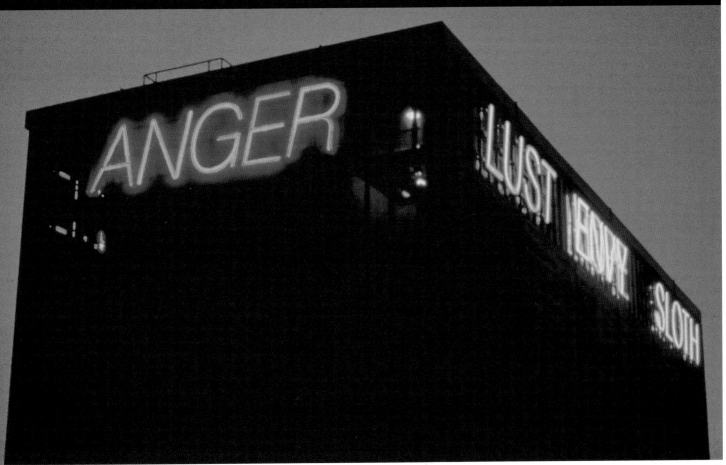

Bruce Nauman

12 PREVIOUS PAGES
Installation views of *Vices and
Virtues,* 1983–88, at the University
of California, San Diego
Neon tubing and clear glass tubing
mounted on aluminum support grid,
height 84 inches
The Stuart Collection, University
of California, San Diego
Purchase with funds from the
Stuart Foundation and the National
Endowment for the Arts

13
Good Boy, Bad Boy (details), 1985
Two color video monitors, two video-
tape players, two videotapes
(color, sound), dimensions variable
Edition of forty

14
Installation view of *Clown Torture,* 1987
Four color video monitors, four speak-
ers, four videotape players, two video
projectors, four videotapes (color,
sound), dimensions variable

15
Still from *Clown Torture* (Tape 1, Reel
A, *Clown Taking a Shit*), 1987

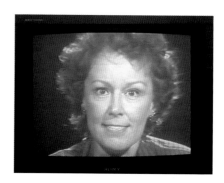

13

as television and neon, that are habitually associated with entertainment and advertising—just the sort of assaultive image technology that prevents us from paying attention to our inner voices—to send messages of an altogether unexpected kind. Because we are highly literate in these media languages, we immediately seize upon differences between the usual fare and the jarring words and pictures Nauman injects into the information system. That his are mixed messages also deviates from the norm, which overwhelmingly consists of one-dimensional slogans and two-dimensional "personalities." The insistent uncertainties of Nauman's work

not only amplify its effect, but change the dynamic between the active source and the supposedly passive recipient of those messages, transferring to the viewer a heightened consciousness of and responsibility for the unresolved feelings and irreconcilable thoughts Nauman has stimulated.

Although frequently severe, Nauman's work is not without humor, which may take the form of sight gags, bad puns, or woebegone, Buster Keaton-like clowning (figs. 14, 15). Nauman knows the power of the grotesque and uses it to trigger incommensurable responses: the smile and the grimace, the spasm of laughter and the spasm of pain. And what does

all this say about identity? That identity is the knot in the belly that either spasm may tie, and that, when the two spasms occur simultaneously, the knot is pulled so tight it can never be undone.

"You've got to watch that woman!" Nauman once said of Louise Bourgeois. And you do. The occasion of his remark was a preliminary tour of the exhibition spaces at the Museum of Modern Art in New York City, where, in the early 1990s, he and she had been allocated adjacent galleries in a group show. Hers was dominated by a huge pistonlike construction that ran on rails, with its flashing red light casting shadows on the walls of the darkened room. This infernal contraption had been created out of two large, round, steel storage tanks, dug up from underneath a gas station on orders from the Environmental Protection Agency. Bourgeois spotted the discarded tanks by the roadside and arranged for them to be hauled to a nearby vacant lot she owned. There she had windows and doors cut into the sides and tracks welded into the larger of the pair—which was the size of a sedan—so that the other—which was the size of a compact car—could roll in and out. When the nesting enamel-black tanks were finally installed, she named the work *Twosome* (1991, fig 16). The mischievousness of Bourgeois's sensibility is evident from the title, which, on the most obvious level, transforms this massive mechanical device into a metaphor for sexual union. In the 1920s, Marcel Duchamp, the father of Dada, was among the first to depict erotic love as a diabolical machine;

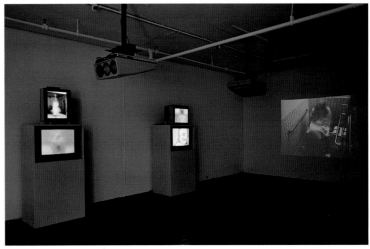

14

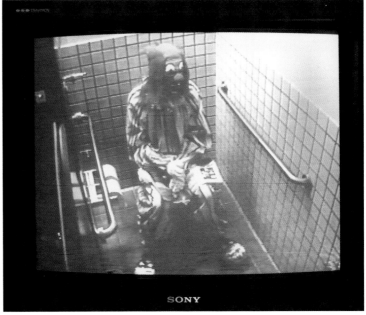

15

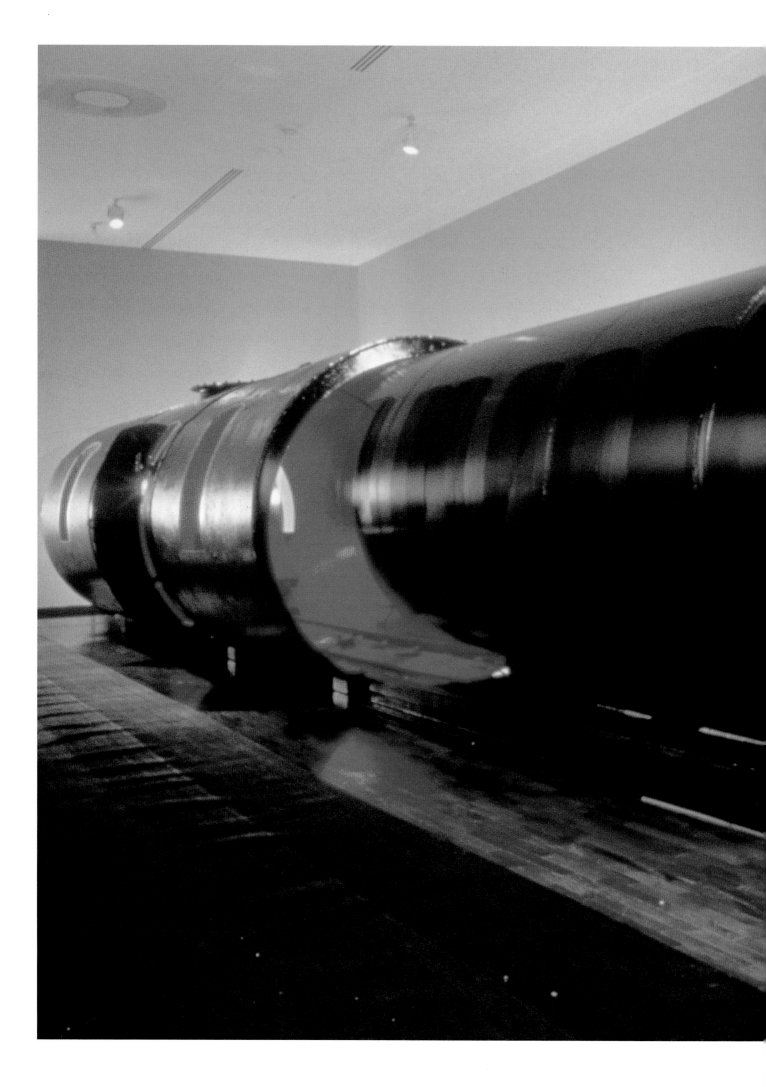

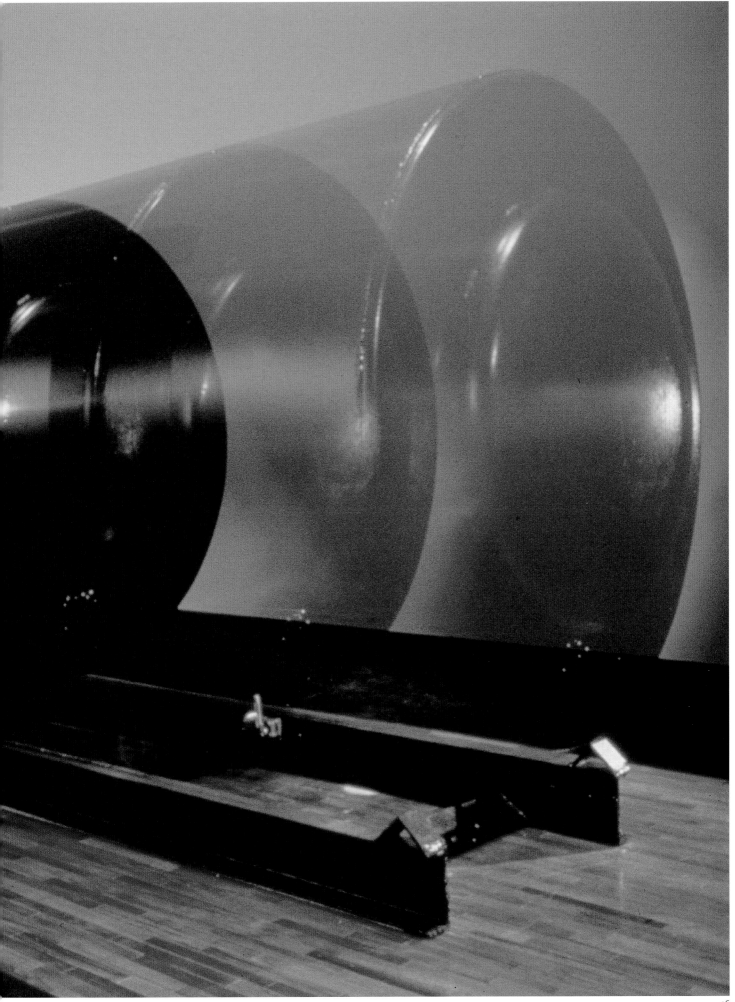

16 PREVIOUS PAGES
Twosome, 1991
Steel, paint, and electric light,
80 x 456 x 80 inches

18
Cell (Eyes and Mirrors), 1989–93
Marble, mirrors, steel, and glass,
93 x 83 x 86 inches
Collection Tate Gallery, London

17
Marcel Duchamp
La Mariée (The Bride), 1912
Oil on canvas, 35¼ x 21⅝ inches
Philadelphia Museum of Art, Louise
and Walter Arensberg Collection

17

but his version of science-fiction desire was as delicate as a Swiss watch (fig. 17). Bourgeois's late-twentieth-century reconfiguration of this basic idea is earthy, overpowering, absurd, and a little scary.

Some of the change in tone may have to do with changing times. Artistic decorum is not what it used to be, and in any case, Bourgeois has never been shy about sexual matters. More significant, however, is the fact of gender. Duchamp's various versions of futuristic lovemaking are the fantasies of a male seducer; Bourgeois's are those of a mature woman who has long since outgrown romanticism. Meanwhile, Bourgeois has suggested, the concept of a "twosome" can be interpreted in another way that would never have occurred to Duchamp, namely the relationship between mother and child. From this perspective, Bourgeois's sculpture describes the expulsion of the child from the mother's body and the longing of the child to return to the safety of the womb, in which case the flashing red light and the heavy movement back and forth along the rails come to symbolize the blood and violence of birth. Put them all together—amorous fusion, routine procreation, arduous labor combined with the longing to be one with another body, and the trauma and inevitability of separation, and you have the kind of compound image typical of Bourgeois's work overall.

Unlike Nauman's multifarious output, the "I" that speaks through Bourgeois's art is, avowedly, that of the artist herself. Virtually everything she makes connects in one way or another with the basic narrative to which she constantly returns:

the story of an unhappy childhood in which she, as a small girl, was forced to play go-between in the marriage between a strong-willed but long-suffering mother who died of a lung ailment while in her daughter's care and a charming but unfaithful father who flirted with and unwittingly tormented her during her passage from adolescence to womanhood. It is, in sum, a tale of confused identities and ambiguous roles, of vulnerability and aggression, of the loss of self and its painful, always tenuous recovery. Having said that, however, Bourgeois's representations are never literal, nor is her part in the drama fixed. Thus, in *Twosome*, she may associate herself at any moment with the mother or the child, the active sexual partner or the passive one, and the viewer, following her example, may do likewise. In Bourgeois's metamorphic world, males and females, adults and children are simultaneously antagonistic and dependent, and, in their oscillation between strength and weakness, violence and tenderness, they are also interchangeable. Who Bourgeois is in her work is therefore less a matter of simple, one-to-one symbolic matchups than of shifting emotions in response to fluid relations among plural identities (fig. 18).

Fillette (1968) pushes this ambiguity further still. An oversized and, so it would seem, unequivocally phallic object, its title means in French "little girl." This may strike one as perverse or preposterous, but in other Bourgeois sculptures one can clearly see the gradual transformation of a long-necked woman with small breasts into this epitome of masculinity. That transformation also tells a story, a

19

sculptural fable of how a young girl became the thing she feared, so that it could not do her harm. Yet, as always with Bourgeois, once they start, the tables never stop turning; and so in a famous photograph of the artist by the late Robert Mapplethorpe (fig. 19), Bourgeois is seen carrying *Fillette* under her arm like a grocery bag or purse, with a Cheshire cat grin on her face. In fact, her original plan was for viewers to cradle the sculpture in their arms like a baby, because after all, she said, the aroused male is, despite all appearances, as helpless as a young girl. Thus we again come full circle in the psychological labyrinth that Bourgeois entices us to enter with her strange but somehow primordial images.

Bourgeois's forms are not always as recognizable as they are in *Fillette*. Clusters of modular abstract forms and simple geometric motifs are, if anything, more common than are recognizable depictions. The spiral, for example, is a recurrent symbol of the anxiety felt by an individual who desperately searches for his or her center and is simultaneously spun away from it. In *Femme Volage (Fickle Woman)* (1951, figs. 20, 21), Bourgeois mounted thin scraps of wood on a central shaft to show the ways in which a body pivoting on itself can be scattered to the winds as it desperately seeks attachment to another body. In *Spiral Woman* (1984, figs. 22, 23), the small whirling motion is captured by the fleshy coils that seem at once to cocoon and smother a woman perilously suspended in midair. And in spare linear drawings the spiral becomes a gyrating vortex surrounded by emptiness (fig. 24). It is an image of flux and disorientation, of all-consuming vertigo, of an emotional vacuum, and of a being that cannot locate itself and therefore cannot come to rest.

Louise Bourgeois

19
Robert Mapplethorpe portrait of the artist holding *Fillette*, 1982
Gelatin silver print, 20 x 16 inches
© 1982 the Estate of Robert Mapplethorpe
Used with permission

20, 21 (detail)
Femme Volage (Fickle Woman), 1951
Painted wood, 72 x 17½ x 13 inches
Guggenheim Museum, New York

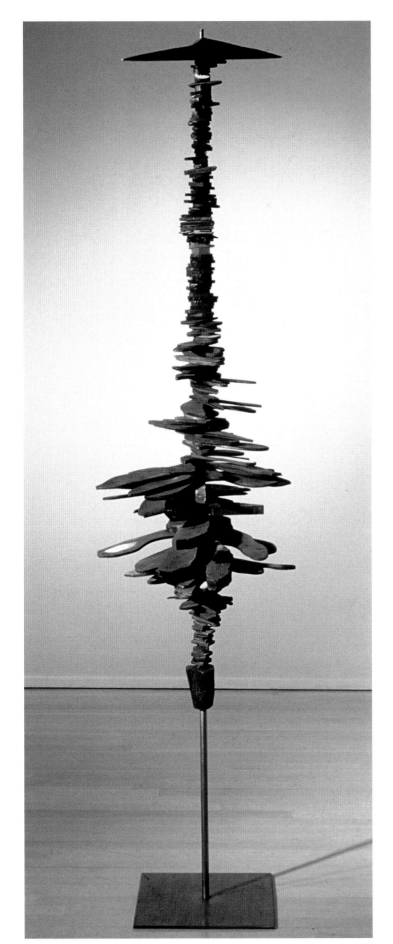

20

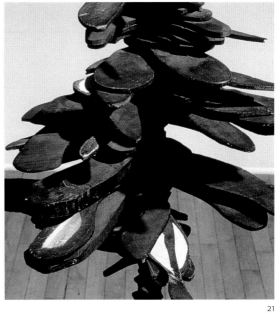

21

Louise Bourgeois

22 (detail), 23
Spiral Woman, 1984
Bronze and slate disc,
bronze: 11½ x 3½ x 4½ inches,
disc: diameter 1 x 34¾ inches
Collection Elaine Dannheiser,
New York

24
Spiral, 1994
Watercolor, ink, and color pencil
on paper, 13¼ x 9½ inches

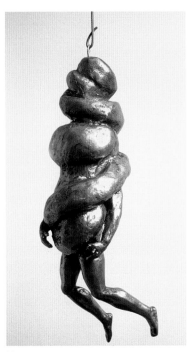

22

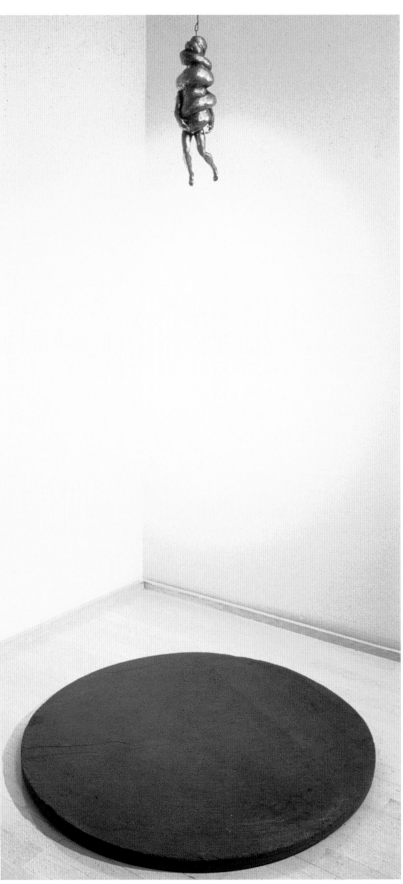

23

24

Louise Bourgeois

25
The Nest, 1994
Steel, 101 x 189 x 158 inches
Museum of Modern Art, San Francisco

26
One and Others, 1955
Painted wood, 18¼ x 20 x 16¾ inches
Whitney Museum of American Art, New York

25

Bourgeois often treats the theme of the restlessness of groups as well. In *One and Others* (1955, fig. 26), pod-shaped totems are crammed together on a small base like people huddled together in a public square. Some are relatively tall; others are short. All stand precariously on tiptoes and are kept from falling over by those standing next to them. At first glance, this would seem to be the most intimate and mutually supportive of communities, yet the ambivalence that is characteristic of Bourgeois's work is also present here. For inasmuch as these anthropomorphic modules touch, they chafe, and inasmuch as they protect one another, they hem their neighbors in. And insofar as each man, woman, or child, dreading loneliness, yearns to belong to this microcosm, each of them, craving solitude, at the same time yearns to escape from it. With its overall semblance of cohesion and its subtle frictions and instabilities, *One and Others* effectively summarizes the coincidence of social attraction to friends or family and the antisocial rejection of them.

Defiance (1994) treats the same theme as *One and Others* but emphasizes the fragility of human relations and the potentially drastic consequences of upsetting them. Composed of dozens of glass bottles, jars, vases, and beakers densely packed on a wooden shelf balanced on

26

27

Louise Bourgeois

27
Articulated Lair, 1986
Painted steel, rubber, and stool,
132 x 132 x 132 inches
The Museum of Modern Art, New York
Gift of Lily Auchincloss and of the
artist in honor of Deborah Wye

a central wheel, the sculpture is, in effect, an accident waiting to happen. So long as they remain in equilibrium, the vessels sparkle in orderly ranks, but ever so slightly tipped this way or that, they would fall off and break or crash into each other and shatter. Bourgeois's version of playwright Tennessee Williams's "glass menagerie," *Defiance*, suggests that the maintenance of such order runs counter to the laws of nature, as it literally entails the defiance of gravity. It is a vision of society simultaneously at peace with itself and hovering on the brink of catastrophe. Whereas Nauman conjugates the verbs of being in diverse mediums, so too Bourgeois juxta-

poses existential antonyms in arresting images and disconcertingly tactile forms.

The smile she cracks in the Mapplethorpe photograph and the over-the-top oddity of some of her works demonstrate that for her, as for Nauman, wit is both an expressive means and a palliative. Still the fundamental truth of Bourgeois's experience is that she sees herself as having been cast adrift in a sea of conflicting emotions, with art as her only anchor. It is her identity as an artist, then, and her corresponding capacity to sublimate anger, anguish, and the destructive impulses they prompt in the creative process that allows her to survive (figs.

28

29

25, 27). Projecting herself with equal intensity into images of the mother, the father, the child, the lover or the hater, the victimizer or the victim, Bourgeois is first and last a maker; the ability to create and the insatiable need to do so are the axis around which her polymorphous selves and her multifarious work rotate.

The concept of community is central to Kerry James Marshall's work, too, but the stress he places on it is very different from Bourgeois's, reflecting both Marshall's status as an African American and his sense that art can be an agent of change. Growing up first in Birmingham, Alabama, and then in the South Central section of Los Angeles, Marshall came of age at a time when the positive momentum of the civil rights era had run up against the backlash of the 1970s and 1980s. Marshall was lucky that his parents gave him the freedom to explore his artistic intuitions and fortunate that mentors at school gave him the outlet for that growing sense of vocation. Almost from the first, Marshall was inspired by artists and mediums that sought the most direct possible communication with their potential audience: the great masters of the Renaissance, Baroque-period painters such as Goya and Rembrandt (fig. 28), modern draftsmen, illustrators and graphic artists such as Charles White (fig. 29), Rockwell Kent,

and Fritz Eichenberg, and, like most young Americans, the comics. Much of modern art has been distinguished by its hard-to-follow syntax and symbolic codes (some just plays hard to get). By contrast, Marshall's monumental paintings and woodblock prints, photographic filmstrips, and tabloid comic books offer pictorial alternatives characterized by clear, forceful narratives, complex but always legible compositions, sharply defined shapes and harmonious colors, and, finally, an overall sense of vitality. Blocking in figures and backgrounds in rich flat tones and tints, Marshall works on large expanses of unstretched canvas that he hangs loosely from the wall, as if the pictures were banners more than conventional paintings (figs 30–33).

The settings for many of his paintings have been the housing projects and domestic interiors in which many poor and working-class African Americans lead their lives and on which they leave their mark. Among white middle-Americans who never venture far from home, the mention of such places tends to conjure up words like "ghetto" and the specter of buildings disfigured by graffiti and blighted by general abuse. The world we see in Marshall's pictures is nothing of the kind. Rather, it is meticulously tended by its inhabitants, who have made

Kerry James Marshall

30
*Better Homes,
Better Gardens,* 1994
Acrylic, collage on
unstretched canvas,
100 x 142 inches
Denver Museum of Art

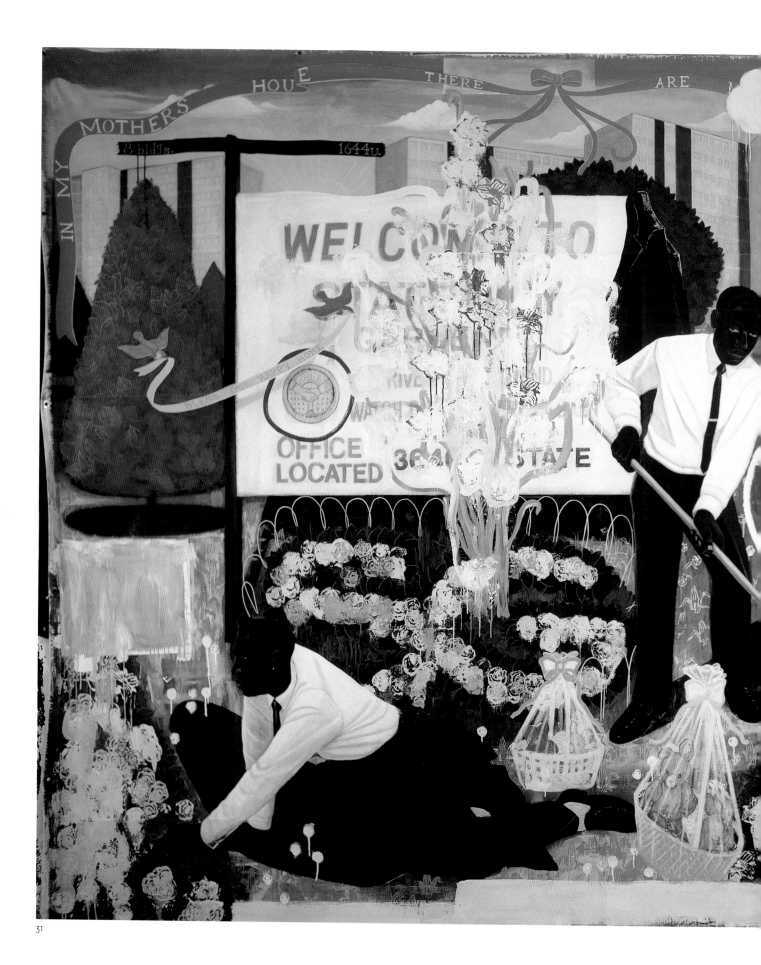

31

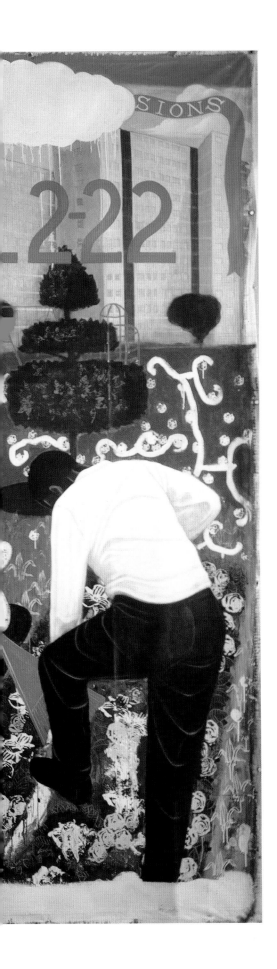

31
Many Mansions, 1994
Acrylic and collage on unstretched canvas,
114 x 135 inches
Art Institute of Chicago

32
Untitled (Altgeld Gardens), 1995
Acrylic and collage on canvas,
78½ x 103 inches
Johnson County Community College,
Overland Park, Kansas

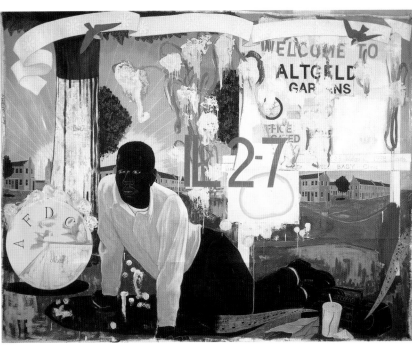

32

a garden of the grim and impersonal no-man's-land created by stopgap urban renewal programs. There children play, and men and women lay claim to their surroundings and their history by the labor of love they devote to the part of America that is theirs. Of course, Marshall's pictures do not fail to show the scars of poverty and of the public policy of "benign neglect" that are part of the heritage of the last forty years of race relations in this country. However, Marshall in effect turns these blemishes into blossoms, using emphatic painterly gestures, vibrant color, and collage techniques that recall the early work of artists such as Picasso and Matisse. In a sense, almost all of Marshall's canvases are collages pieced together from careful observation of the environment around him in South Side Chicago where the artist now lives. To these he adds texts, diagrams, paraphrases of folk art, and a host of other appropriated details that render the complex visual reality of contemporary African-American life.

When paintings deal so straightforwardly with a particular social reality, it

Kerry James Marshall

33
Our Town, 1995
Acrylic and collage on canvas, 100 x 124 inches
Collection the artist, Chicago

is not uncommon for casual observers to
suppose that the works are intended pri-
marily, if not exclusively, for those repre-
sented. Or so the logic of ethnocentricity
goes in this country. But the truth is that
the things that concern Marshall are
no more narrowly addressed to any one
group than are the concerns of Irish-
American poets, Jewish-American novel-
ists, and Italian-American filmmakers in
other contexts. The universal, it has been
said, is the local without walls. What
Marshall does with all mediums he com-
mands is to open gaps in the barriers that
inhibit the view the citizenry at large has
of the African Americans living right next
to them or just across town. The Chicago
Marshall paints is also South Central L.A.,
Birmingham, Atlanta, Baltimore, Detroit,
Newark, New York, and countless other
places in which the African diaspora has
put down roots in a multi-ethnic nation.

And it is Paris, too. Not so much in
the sense that Paris now encompasses a
huge African population, but because one
of the touchstones of Marshall's work is
Georges Seurat's great post-Impressionist
painting of Parisians enjoying their day
off on an island in the Seine. Seurat's
grand tableau *A Sunday Afternoon on the
Island of La Grande Jatte* (1884, fig. 34)
hangs in the Art Institute of Chicago,
where Marshall has spent hours looking
at it. With its almost Egyptian formality,
silhouetted shapes, sparkling tints and
tones, and aura of poise and well-being,

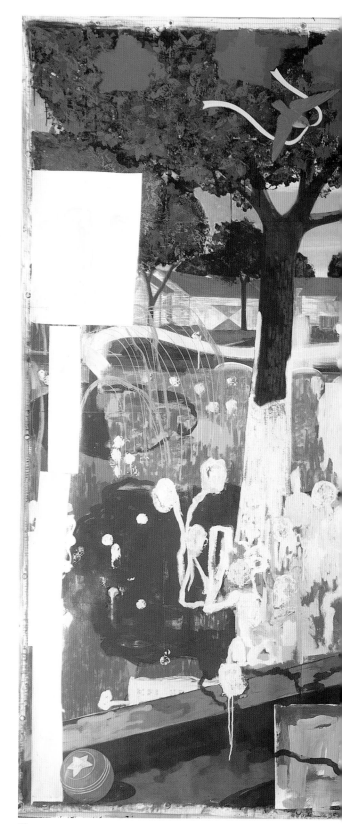

33

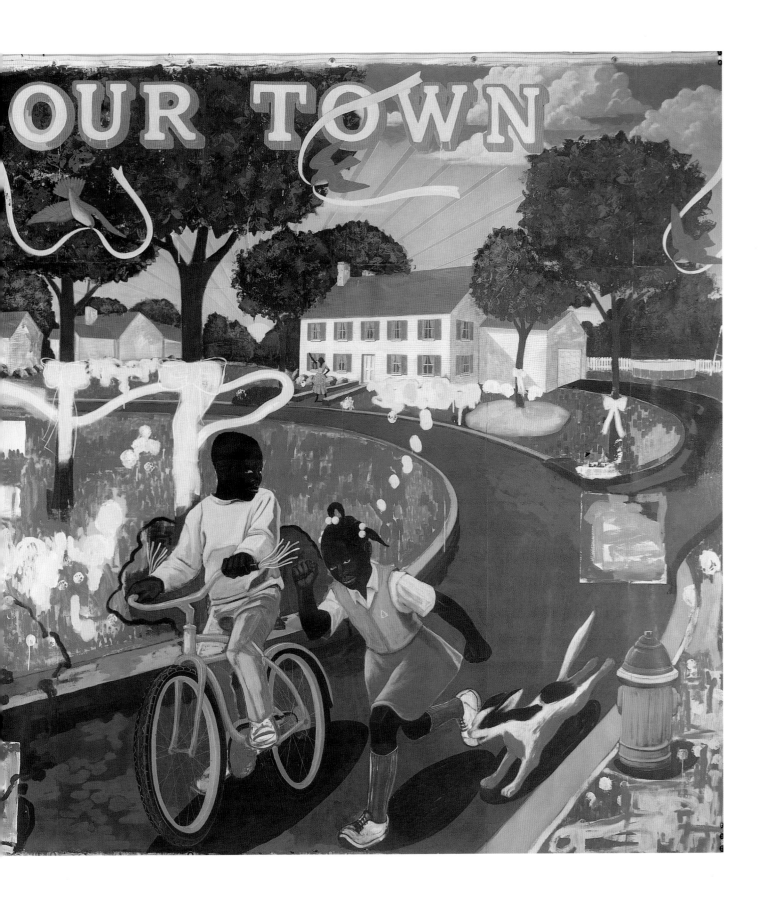

34

35

36

the picture is a mural-scale celebration of collective pleasure. In that regard, it is the antithesis of much of modernist mural painting, which sought to describe class conflict and to advocate revolution. In the 1930s Diego Rivera (fig. 35), José Clemente Orozco, and David Alfaro Siqueiros made many such murals in Mexico and in this country, while painters inspired by them decorated libraries, post offices, and U.S. government buildings for the WPA (fig. 36). Then in the 1960s and 1970s disciples of these Depression-Era artists covered walls in cities around the United States—and in Los Angeles and Chicago in particular—with similarly turbulent, political art. What Marshall has done is to fuse these seemingly opposing paradigms—Seurat and social realism—to create pictures that have all the formal rigor of the former and all the grit, energy, and social commitment of the latter.

In a slightly different vein, Marshall's comic books combine the "zap-kaboom" action stories of the standard superhero strip with archetypes from African lore, thereby fundamentally revamping a popular art form while respecting its still dynamic conventions (fig. 37). Are we dealing, then, with the aesthetic equivalent of the melting pot, a predictable, almost seamless merging of different cultural strains in which the differences themselves are lost sight of? Not at all.

37
Preparatory drawing for *RYTHM MASTR,* 1999–2000
Photocopy of ink drawing, and design marker on
paper, 17 x 11 inches
Collection the artist

37

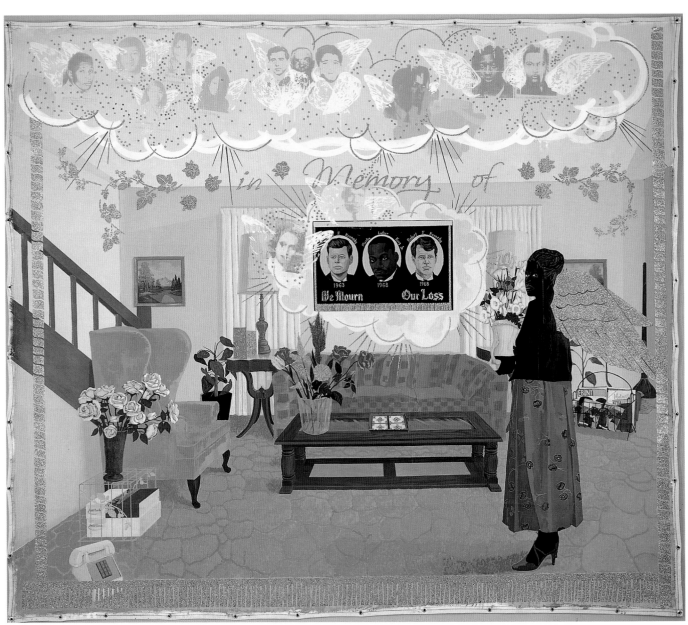

38

Kerry James Marshall

38
Souvenir II, 1997
Acrylic, paper, collage, and glitter
on canvas, 108 x 120 inches
Addison Gallery of American Art,
Phillips Academy, Andover, Massachusetts

39
Souvenir IV, 1998
Acrylic, collage, and glitter on
unstretched canvas, 108 x 156 inches
Whitney Museum of American Art, New York
Purchase with funds from the
Painting and Sculpture Committee

40 FOLLOWING PAGES
Installation view of *Momentos*, 1998,
at the Renaissance Society, University
of Chicago, showing over-size stamps
and "Souvenir" series
Mixed media, dimensions variable

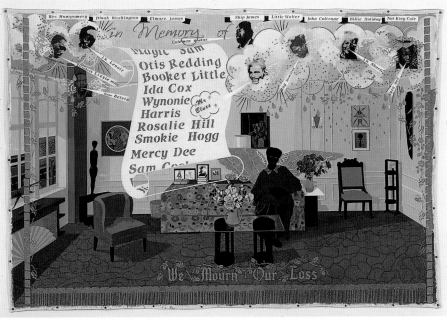

39

Marshall's artistic identity remains clear and distinctive even as he cross-references multiple genres and traditions (figs. 38–40). There is nothing predetermined, averaging, or schematic in the proportions he has given each of the elements of his synthesis. Quite the opposite. The art of his art—in addition to the skill of his hands—is in choosing what to incorporate and rework and what to set aside out of all the combinations his primary sources and his own vision suggest. The hallmark of Marshall's work is in the economy of his means overall and the specificity and vividness of each detail that contributes to the whole. The fabric of connections he thus achieves is correspondingly intricate, taut, and rich.

It is sometimes assumed that for communities to be "inclusive" they must grow out from a more or less homogenous core, absorbing greater degrees of heterogeneity as they proceed but always maintaining order among them by virtue of the greater proportional weight of that core and the gravitational force it exerts. Thus nations implicitly define themselves and their minorities in relation to the dominant culture or language or ethnic makeup of the populace. But what of a nation that is a nation by agreement among diverse peoples, rather than because of any such given superiority of power or numbers? And what of the individuals who simply do not see themselves as being defined by belonging to any group, but rather form their identity in the stresses and possibilities created by hybrid interests, wide experiences, and plural talents? Such is the case of Maya Lin.

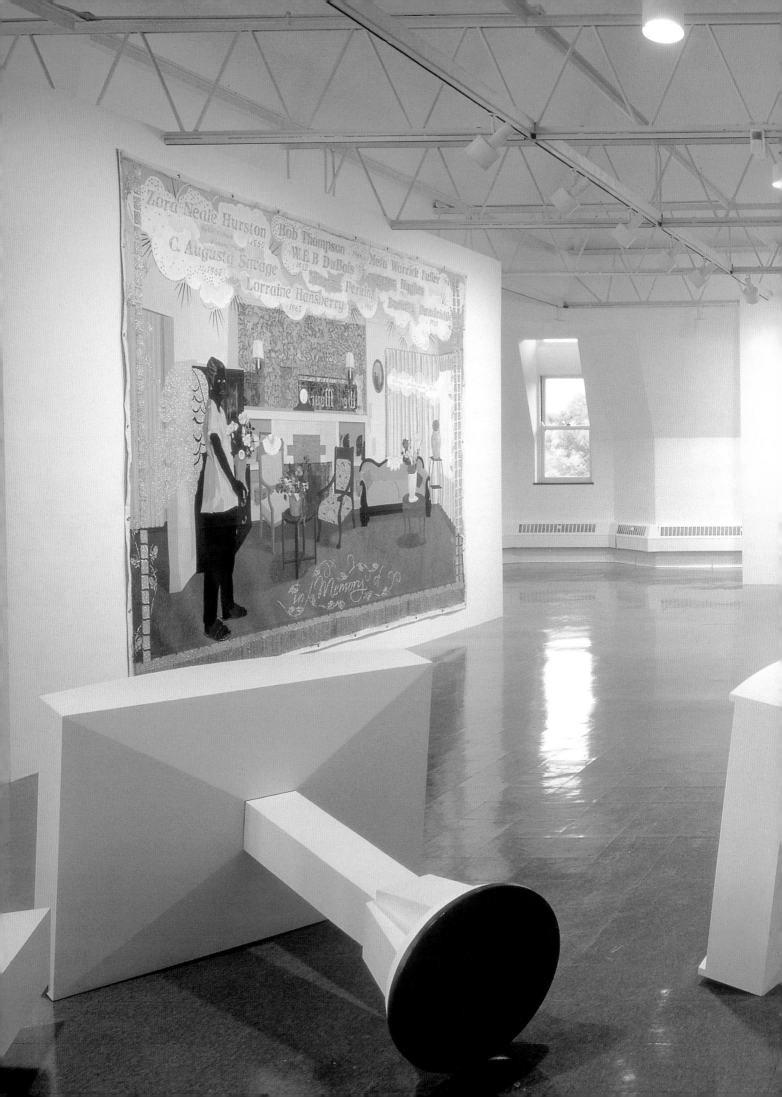

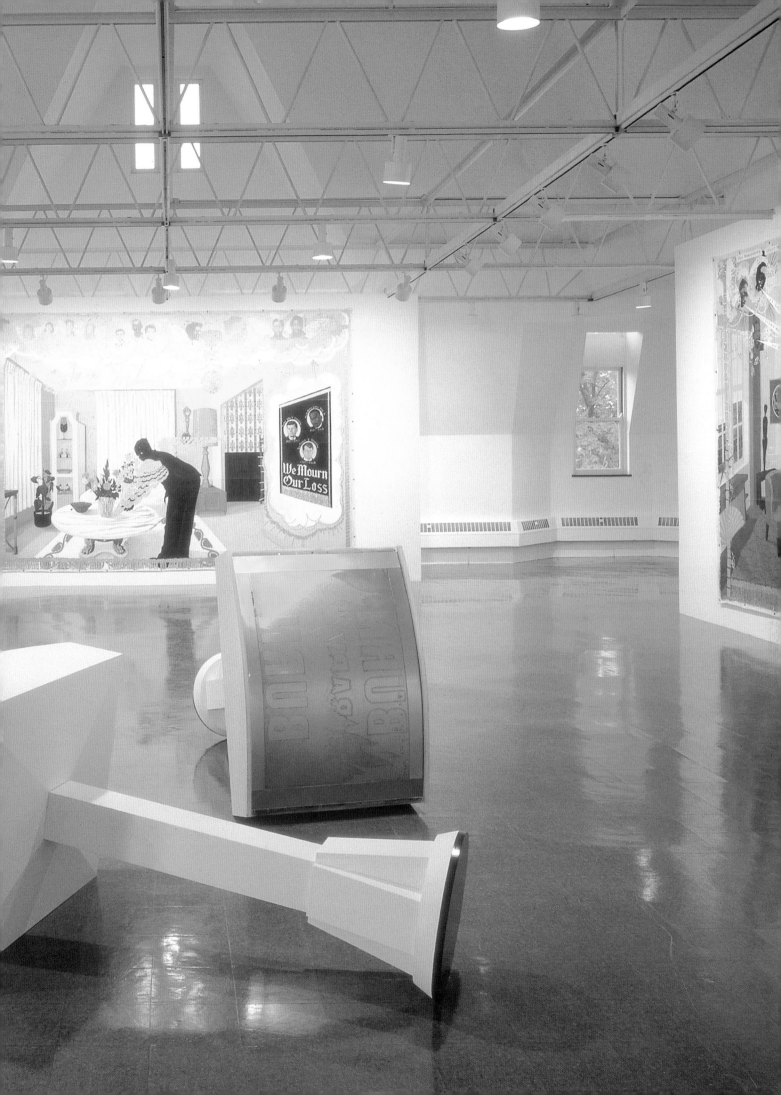

41

Maya Lin

41 (detail), 42
Crater Series 1997
11 beeswax sculptures, dimensions
variable, glass shelf 1½ x 96 x 10 inches
From the *Topologies* exhibit at Grey Art
Gallery, New York Univeristy

43 FOLLOWING PAGES
Rock Field 1997
46 glass components, dimensions variable
From the *Topologies* exhibit at Grey Art
Gallery, New York Univeristy

Born in America to parents who emigrated from China, Lin, by her own account, began life thinking of herself as being "as American as anyone else." And so she was—and is—though she no longer virtually denies her race, but she will never be "as American as anyone else," in the eyes of those who see only race. As Lin grew up in the Midwest, her father and mother—he was a ceramicist and furniture maker, she a poet, and both were educators—said little about their country of origin, though her father's work showed evidence of Asian traditions, and her mother made allusions to family and culture left behind in China. It seems that it was not until Lin won the competition to design the Vietnam Veterans Memorial in Washington, D.C in 1981 that her ethnicity became a central fact of her life.

At the time Lin was an undergraduate student in architecture at Yale University, and the news that the prestigious and hotly contested commission had gone to a young woman still in school made news everywhere. Since the judging was by blind entry, it was also not known until after the decision was made that the winner was of Chinese extraction, but almost immediately it became an issue in the way the story was handled. "At my very first press conference a reporter asked the question 'Isn't it ironic that the war in Vietnam was in Asia, and you are of Asian descent?' I thought the question was completely racist . . . and completely irrelevant," Lin remembers.

Racist certainly, but the question was not, in the final analysis, completely irrelevant. For Lin the controversy served as a

Maya Lin

44
Vietnam Veterans Memorial, 1982
Black granite, each wall: 246 feet
long, 10½ feet high
Washington, D.C.

kind of catalyst in her thinking, resulting
in her becoming increasingly conscious of
her dual heritage and increasingly involved
in finding ways to combine or link its two
primary components. The evidence of this
preoccupation was not in any overt sym-
bolism, any obvious mixing of motifs or
references from East and West, but rather
in striking a tone in her work that allowed
for and encouraged private reflection of
the sort she engaged in when grappling
with the reality imposed on her by a
world obsessed by appearances. Overall,

she came to see her work as that of pro-
viding "passages to awareness, to what
my mother would describe in Taoism as
'the Way': an introspective and personal
searching. . . . I try to think of my working
as creating a private conversation with
each person," says Lin (figs. 41–43, 46, 47).

Lin's Vietnam Veterans Memorial,
whose V-shaped black marble walls spread
like wings and embrace visitors who walk
down the path toward its sunken apex,
achieves an altogether unexpected inti-
macy in circumstances that still echo with

the official rhetoric and public discord that surrounded that divisive conflict (fig. 44). No war in America's history since the Civil War had been more divisive. It is not within the power of art to resolve the political and historical contradictions that made it so, nor to bring the debates it stirred to an end. It is possible to redirect attention from arguments over why people fought or refused to fight to the harrowing fact of how many men and women died, and to quiet those arguments in the souls of the survivors so that they might

ponder their losses. This challenge proved extraordinarily difficult, and the initial criticisms of Lin's concept and the various proposals to alter it, amend it with heroic figures, or replace it altogether demonstrated a general reluctance to trust the evocative power of simple things and the spontaneous reactions of people who bring their sorrows to a place respectfully prepared for them.

The basis of Lin's success was the grandeur and reticence of her design, the calm, expansive embrace of the sunken

wall she created, and in the plain inscription of the names of the dead upon it. Names, of course, are the most basic statement of identity. Cut into the shiny black marble, the more than fifty-five thousand names listed on the memorial make the generalization "American casualties" real in all its horrible extent and human variety, realities amplified and given life by the mirror images of families, friends, and visitors who make the pilgrimage to the site. Their faces are reflected in the surface, becoming in

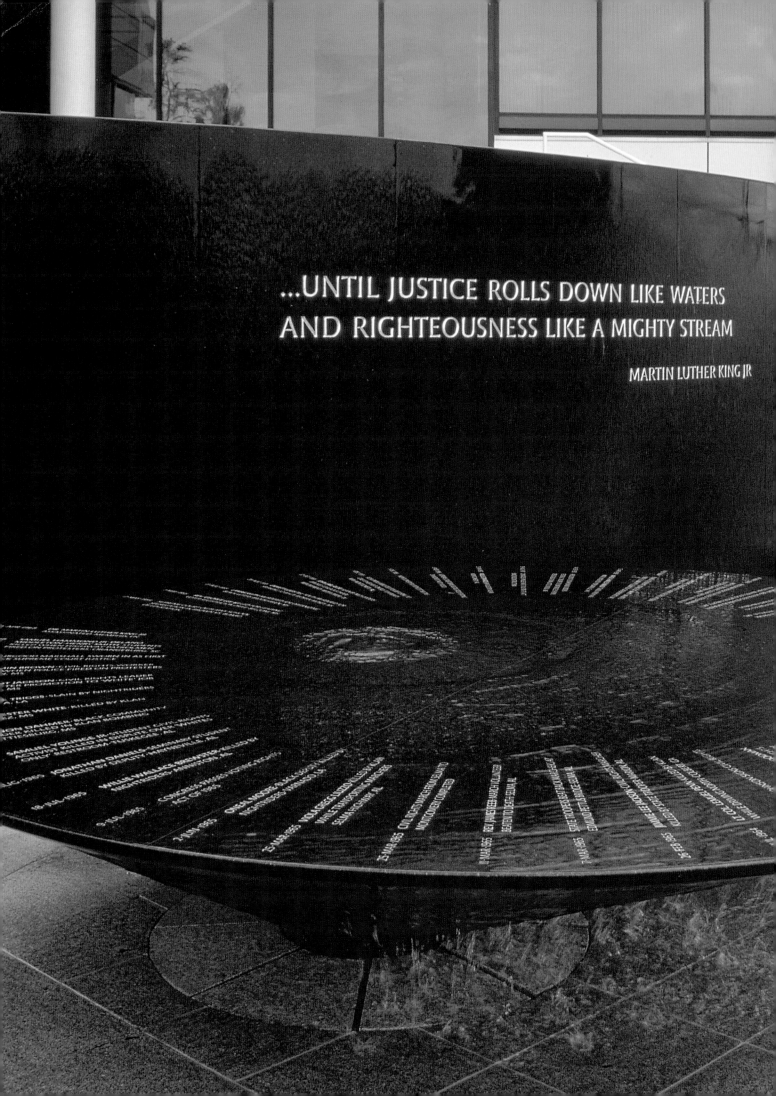

Maya Lin

45
Civil Rights Memorial, 1989
Black granite, water table: 11 feet 6
inches in diameter,
water wall: 40 feet long x 10 feet high
The Southern Poverty Law Center,
Montgomery, Alabama

effect specters of those they come to mourn. Lin's monument makes no assumptions about who they might be, nor, as a traditional sculptor would have done, did she invent "types" to represent a sociological cross-section of the fallen soldiers. Formally abstract, the work is, in every sense that counts, specific about the harsh facts it speaks to, and generous to those to whom it speaks in letting them be themselves, providing a context in which they can think their own thoughts.

Much the same contemplative atmosphere is created by Lin's memorial to the civil rights movement in Montgomery, Alabama (1989, fig. 45). Its dominant element is also in black marble. An inverted cone, inscribed with events in the struggle for racial equality, it is a fountain from whose center water wells in a thin cleansing sheet. Located at the heart of a hot Southern city within sight of the streets, stores, and public buildings where part of the battle for integration was fought, Lin's fountain-plaza is a literal as well as spiritual oasis. Like the Vietnam memorial, it is at once unmistakably modern and fundamentally classical, a blend of aesthetic traditions realized in a unified form. And like the monument in Washington, it is the work of an artist whose gradual discovery of her own heritage, and meditation on and construction of her individual identity, has taken place in a country still in thrall to fixed definitions of "them" and "us," "our kind" and "their kind." It is a positive sign, however, that while a reporter once made a point of the fact that an unknown Asian artist was creating a memorial to an American war in Asia, nobody appears to have raised questions

45

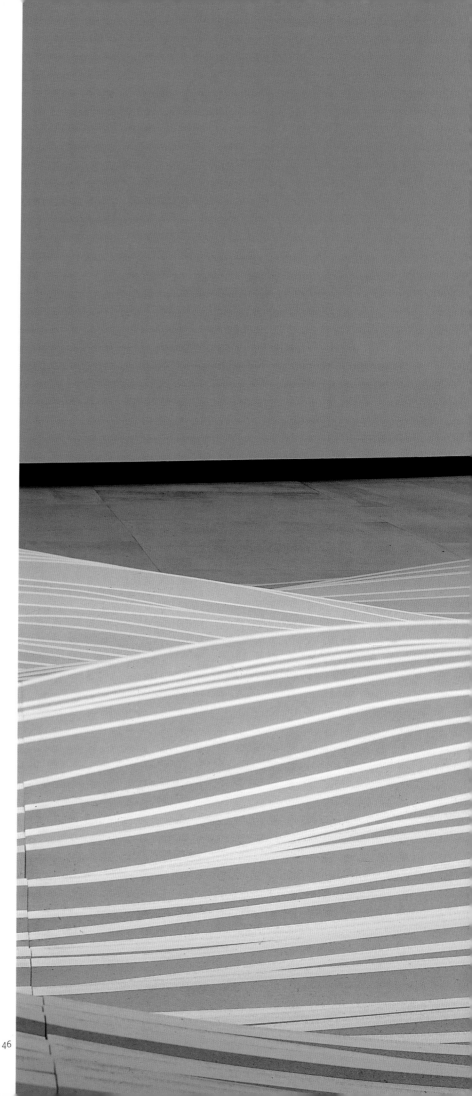

Maya Lin

about a now widely admired Asian artist creating a memorial to the movement to make African Americans fully equal citizens under the law. In the first instance a reporter thought it "ironic" that someone who looked like the enemy should have been chosen for the job; in the second it might have been supposed that only a "black" artist could take on the task of honoring "black" history. But times have changed, and however slowly or unevenly, old attitudes are changing as well.

Gertrude Stein had the first, pointedly capricious word on the question of identity, but the last word belongs to James Baldwin. Like Kerry James Marshall, Baldwin was a cosmopolitan working in a sometimes ingrown and in many ways deeply divided nation, a writer of utter candor in a society prone to ignoring things likely to cause discomfort, and a man for whom the aesthetic was inseparable from the social. However, it was Glenn Ligon, a young African-American artist, who selected the quotation with which this essay ends for a banner used in an installation he created for the Whitney Museum of American Art (fig. 48). It is hardly surprising that the problem of identity should preoccupy artists of color such as Marshall and Ligon; their status as nominal exceptions to the white majority forces them to deal with who they are in ways that whites can, with greater ease, avoid. Though the "whiteness" of white society is more myth than reality: in many parts of this country those with darker skin may, on a daily basis, live comfortably in places where they equal

46

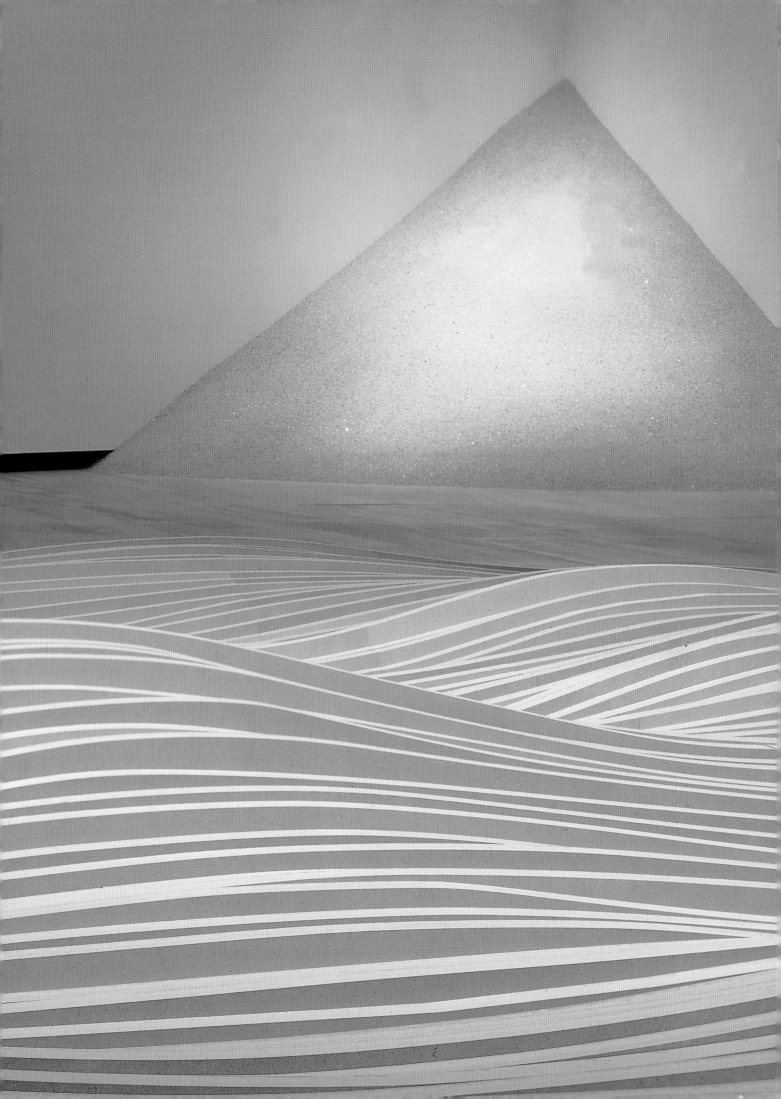

Maya Lin

47
The Wave Field 1995
Shaped earth, 100 x 100 feet
University of Michigan, Ann Arbor

48
Glen Ligon
Installation view of *Good Mirrors
are Not Cheap,* 1992, at the
Whitney Museum of American Art
at Philip Morris, New York

47

Within the image, the following text appears on the banner:

> ...ugh ...es of the
> ...e's nakedness which robes
> be felt, and, sometimes, dis-
> cerned. This trust in one's
> nakedness is all that gives
> one the power to change
> one's robes.
>
> –James Baldwin

48

or outnumber their paler-skinned neighbors. Even then, inherited perceptions rather than percentages are the deciding factor. There are more women than men in this society, yet women too must constantly redefine their identities for themselves if they do not wish to have outmoded or otherwise prejudicial identities imposed upon them. Between Maya Lin, who is in her forties and Louise Bourgeois, who is almost ninety, the continuity of that struggle for self-determination is made manifest. Nor finally, does the pressing need to forge an identity necessarily stem from external misunderstanding, though such misunderstanding frequently sharpens one's vision of what is possible as well as sharpening the pangs that are caused by failing to see things as they are, however good or bad that might be. Nauman makes that plain.

Taking all these considerations into account, however, there is one final warning to be sounded, and Baldwin does so. For, as Baldwin well knew, identity is a straitjacket if it is tailored only so that we may disappear into it in the hope of evading the scrutiny of others and of hiding our imperfections and anomalous thoughts and emotions from ourselves. Too often those who are quickest to assert their identity or loudest in proclaiming it have fastened on a single, supposedly fixed, aspect of their nature or background to the detriment of the rest, allowing just one dimension to overshadow the many dimensions of their true makeup. Sometimes this happens to counter an equally reductive stereotype in the minds of others; sometimes it results from shame or anxiety about one or more components of a plural self. Whatever the reasons for them, the work of the artists discussed here demonstrates the error and the futility of such ostensibly self-protective but in actuality self-restrictive measures.

And so Baldwin writes:

Identity would seem to be the garment with which one covers the nakedness of the self, in which case, it is best that the garment be loose, a little like the robes of the desert, through which one's nakedness can always be felt, and, sometimes, discerned. This trust in one's nakedness is all that gives one the power to change one's robes.

from *The Devil Finds Work* (1976)

All the wolves in the wolf factory paused
at noon, for a moment of silence.

John Ashbery
Wakefulness

 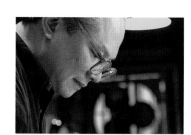

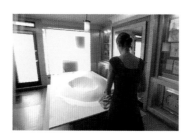

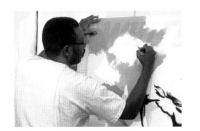

consumption

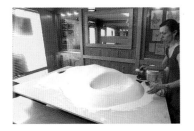

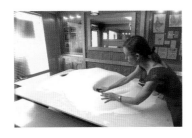

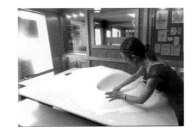

Consuming Art Katy Siegel

Think about great art—what does it do? Italian Renaissance paintings depict religious scenes that instruct and inspire. Ancient Greek and Roman architectural monuments commemorate powerful rulers. African sculptures are beautiful artifacts invested with ritual power. But modern Western art? It seems strangely useless, wielding neither religious nor political power. Art today is primarily a luxury product, an "extra" made possible by capitalism. But it is not all just like a cashmere sweater, existing only to enrich the lives of those who can afford it with beauty and quality. Some art seeks to criticize or shock its audience. Some instructs. Ultimately, all art illuminates the ways in which contemporary society affects not only objects, but the people who belong to that society.

In the eighteenth century, Europe underwent a huge economic shift from a feudal, aristocratic system to a middle-class consumer society. With the opening of foreign markets and the related trade possibilities, a new class of merchant bankers was created, along with a much broader availability of and demand for luxury goods such as fancy clothing, exotic foods, and decorative art. Business- and tradespeople without a family pedigree now wanted these things, previously reserved for the aristocracy, and had the means to pay for them. In 1720 French artist Jean-Antoine Watteau made a remarkable painting entitled *L'Enseigne de Gersaint* (fig. 1). Watteau originally intended the work as a sign for the shop of Gersaint, his dealer. *L'Enseigne* depicts the store's interior, filled floor to ceiling with oil paintings. On the left, assistants crate already purchased art objects. To the right, a shop girl shows customers fine goods that were associated with art as signifying wealth and taste. By this time, painting has clearly become a commodity, an object to be bought and sold, and Watteau's painting advertises its new status.

Over one hundred years later, French Impressionist Claude Monet painted the world around him, most famously beautiful nature scenes. But he also represented the contemporary urban setting of Paris in paintings such as the *Gare St.-Lazare* (fig. 2). The steam engine and train travel symbolized modern life in the nineteenth century, much as airplanes and computers symbolize modern life today. Trains belonged to the industrial revolution, to its new machines and techniques of mass production. Paradoxically, innovations such as mechanized factory production (beginning in the late eighteenth century) and the sewing machine (in the 1860s), which made available relatively inexpensive goods to large numbers of people, increased the prestige of unique, hand-made goods. That is, when everyone can have flawless machine-made clothing, the handmade sweater with its uneven stitches becomes a status symbol. Monet may depict the industrial world around him but, as art historian Richard Shiff has pointed out, he works in a very material, painterly style that emphasizes its own handmade nature, the fact that it is irregular and awkward, not mass produced. Avant-garde artists in the late nineteenth

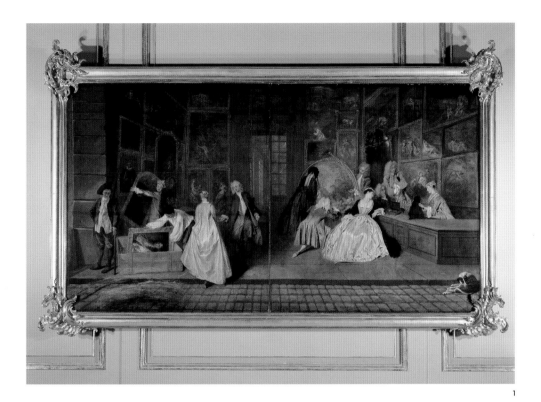

1
Jean-Antoine Watteau
L'Enseigne de Gersaint, 1720
Oil on canvas, 63 ¾ x 121 inches
Staatliche Museen, Berlin

2
Claude Monet
La Gare St.-Lazare, 1877
Oil on canvas, 29 ½ x 39 ⅜ inches
Musée d'Orsay, Paris

1

2

3
Pablo Picasso
Still Life with Chair Caning, 1912
Oil, oilcloth, paper, and rope
on canvas, 10⅝ x 13¾ inches
Musée Picasso, Paris

4
Jackson Pollock
Number 1, 1948
Oil and enamel on unprimed
canvas, 68 x 104 inches
The Museum of Modern Art, New York

5
Claes Oldenburg in *The Store,*
107 East Second Street, New York,
December, 1961

3

4

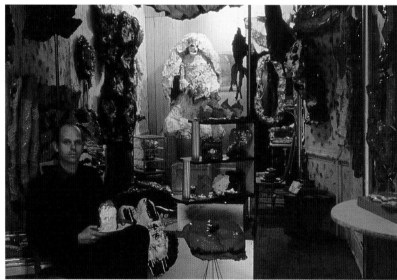
5

century resisted the dominant character of the time—consumerism—despite the fact that the surpluses of that consumer society itself made possible the luxury of art. The sheer uselessness of art itself signified the prosperity of the society, much as extra flesh on an upper-class woman once signified the fact that her family had sufficient money (and more than enough food).

While the Impressionists often chose everyday subjects, mass culture truly invaded the art world in the early-twentieth-century collages of Cubist artist Pablo Picasso. In works such as *Still Life with Chair Caning* (1911–12, fig. 3), Picasso not only drew and painted ordinary objects, he incorporated the real things directly into his artwork: newspaper clippings, menus, even printed oilcloth commonly used as a table covering—the mass-produced, prosaic odds and ends of his everyday life. The oilcloth imitates chair caning, something usually made by hand by a craftsperson; what was once part of a useful object becomes a decorative motif that can be printed onto other surfaces. As these cheap objects such as the oilcloth entered even the sacred realm of high art, many artists and critics worried about their demeaning effect on culture.

Among those who sought to reject this growing trend were the American Abstract Expressionist painters of the 1940s and 1950s, and their great supporter, art critic Clement Greenberg. Painters such as Jackson Pollock began working in a completely abstract style in the wake of World War II's violence and inhumanity. These artists turned their back on what

they perceived to be a corrupt world in order to free themselves to make whatever kind of painting they chose. Pollock's drip paintings of 1947–50 (fig. 4) initially shocked the art world and the public—they seemed to be paintings about nothing, without rhyme or reason. To other artists, they almost immediately became a symbol of the artist as an independent worker, in control of his production, as opposed to the factory worker, forced to repeat the same action over and over for eight hours at a time. Many critics in the 1950s argued that for factory workers, leisure time spent looking at liberating art was supposed to restore some sense of wholeness to their lives.

Despite Pollock's avant-garde style, after his death in 1956 his work commanded high prices, proving that in prosperous postwar America, even the most challenging art could be sold. Claes Oldenburg played on this realization in a 1961 installation called *The Store* (fig. 5), where he sold small sculptures of airmail envelopes, pastry, and pantyhose in a storefront on East Second Street in New York City. Oldenburg was one of the Pop artists (so called because of their interest in popular culture). These artists chose banal consumer goods as their subjects: Coca-Cola, girlie magazines, billboards, toilets, and, most famously, Andy Warhol's soup cans (fig. 6). Warhol began as a successful graphic artist who turned his flat, illustrational style into a fine art career. He embraced the effects of mass production, using photographs and silkscreen techniques to create

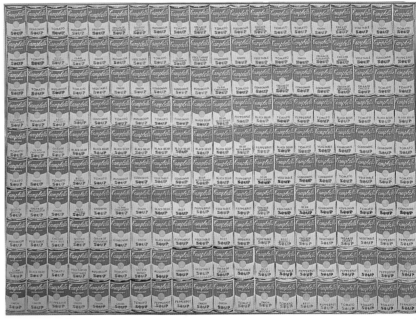

6

repetitive, multiple images, and naming his studio the Factory—a far cry from the attitude of the Abstract Expressionists just a decade before. Art historians are still arguing whether Warhol was celebrating or criticizing our culture: does his work mean that we are all the same, like mass-produced food products, or did he really just like Campbell's soup, perhaps a memory of his working-class childhood? Who knows? Either way, Warhol acknowledges both the larger consumer culture and the commercial nature of the art world.

Warhol predicted a social and artistic shift in emphasis from production to consumption. In the 1980s, Jeff Koons became famous for displaying manufac-

tured commercial products such as vacuum cleaners and basketballs as artworks in museum vitrines. Koons didn't make the objects, he simply changed their context, moving the vacuums from Sears to the museum (fig. 7). Koons's works highlight the role of display in creating the aura surrounding art; Italian artist Maurizio Cattelan takes on the role of the artist as well as that of the art institution. Playing on the idea of artist as celebrity (and the museum as Disneyworld), in 1998 he hired an actor to greet visitors to New York's Museum of Modern Art dressed as Picasso, wearing a giant, papier-mâché head, delighting tourists (fig. 8). Unlike Monet, artists like Koons and Cattelan no longer seem to resist the nature of art

7

8

7
Jeff Koons
New Hoovers, 1981–86
Four Hoover vacuum cleaners, Plexiglas, and
fluorescent lights, 98 x 52½ x 27¾ inches
Private collection

8
Maurizio Cattelan
Untitled, 1998
Performance of actor in papier mâché
Picasso head greeting visitors at
The Museum of Modern Art, New York
© 2000 The Museum of Modern Art, New York

under current conditions, instead embracing consumerism and entertainment.

Of the artists featured in the "Consumption" installment of *Art:21—Art in the Twenty-First Century,* two of them come from commercial art backgrounds (Barbara Kruger and Michael Ray Charles), which they use in their fine-art practice. And all of the artists embrace non-art influences, including design and craft techniques (Andrea Zittel), science, television, and video games (Mel Chin), and film (Matthew Barney). They refer to objects and images familiar to us; they may resist or celebrate the culture, revel in it, or wag their fingers, but like us, they live in the world, and it enters their artwork. Art expresses a social, collective experience as well as the personal thoughts and feelings that make each of the artists unique.

Barbara Kruger began her career at *Mademoiselle* magazine, where she started as an assistant and quickly rose to art director. During the time she worked for the magazine, she moonlighted as a feminist artist, often working with traditionally female craft techniques. By the early 1980s, Kruger realized that she could use her commercial art experience in her fine art to greater effect, and turned to found photos coupled with graphically striking texts phrased in the imperative language of advertising and propaganda. Kruger and other artists like her were influenced by French theorists such as Jean Baudrillard, author of *The Culture of Consumption,* who wrote that modern life was all about images and surface appearances. If what Baudrillard wrote was true, art inevitably became part of a fast-take, quick-buck culture, and needed to compete with other forms of visual culture, such as photography and television, or it would become irrelevant.

Kruger deliberately chose to use advertising strategies to express a political agenda that undermined the usual

Barbara Kruger

9
*Untitled (When I hear the word
culture, I take out my checkbook)*, 1985
Gelatin silver print, 138 x 60 inches
Collection Eileen and Peter Norton,
Santa Monica, California

message of advertising (buy things in
order to feel better). Kruger's works of
the early 1980s (fig. 9) often adopted
threateningly direct terms of address
that implicated the viewer, such as *Your
gaze hits the side of my face* (1981). This
photograph features a sculpture of a
woman's bust in profile; the "you" here
seems to be the male viewer, the "my"
seems to refer to the position of women
as objects for men's gaze, in representa-
tion as well as real life. Her tone is unde-
niably accusatory, discomfiting.

In order to reach a broad audience,
Kruger borrowed the marketing tactic of
creating appealing commodities such as
totebags and T-shirts (perhaps the most
popular bag bore the message, "I shop,
therefore I am," fig. 10). These souvenirs
make full use of the irony that Kruger is
selling something that criticizes the very
centrality of buying and selling in modern
America. Again, the viewer/consumer is
directly implicated in her message.

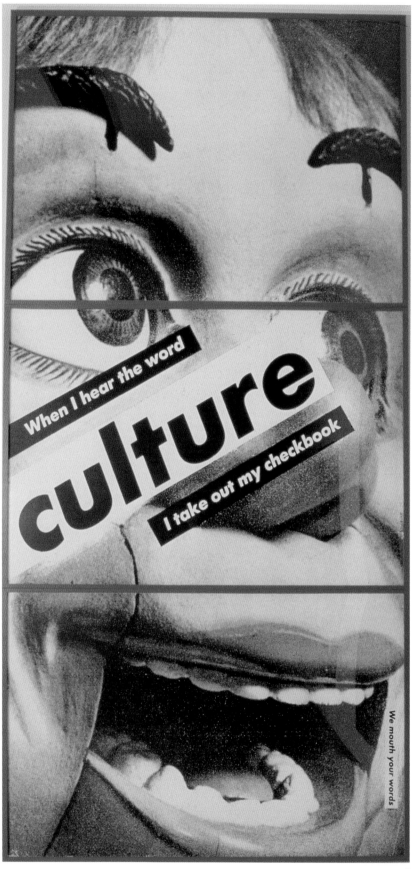

9

Barbara Kruger

10
Untitled (I shop, therefore I am), 1987
Photographic silkscreen on vinyl, 111 x 113 inches

11
Untitled (Your body is a battleground), 1990
Billboard, commissioned by the Wexner Center
for the Arts, Columbus, Ohio, for its *New Works
for New Spaces: Into the Nineties* exhibition

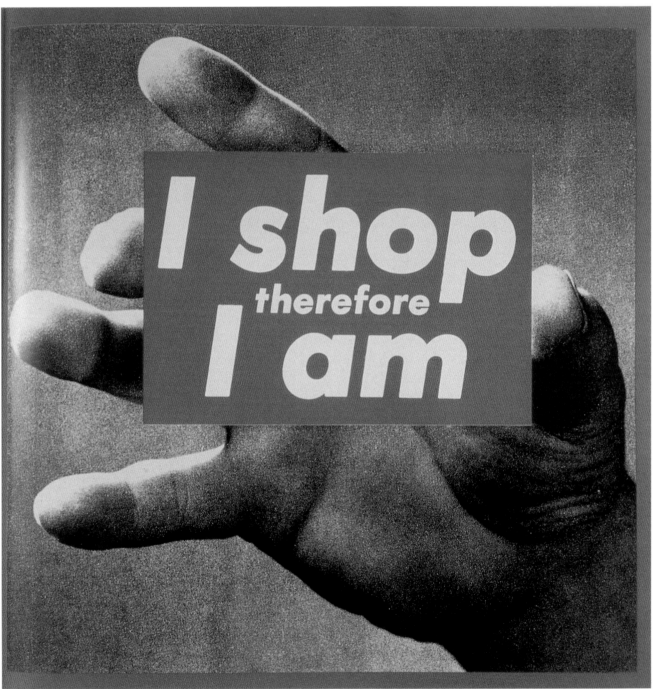

10

Kruger's art is so distinctive and became so influential that political groups asked her to make works for various ad campaigns, most famously the pro-choice lobby image *Your body is a battleground* (1987, fig. 11), here shown on a billboard next to a pro-life billboard in Columbus, Ohio. Kruger's work was so successful that her style was co-opted by the very advertisers and mainstream magazines from whom she appropriated her images.

Michael Ray Charles also has a background in commercial art as well as fine art, initially working in advertising.

A Norman Rockwell fan well before this became fashionable again (one of his early works, *(Forever Free) Home Training,* 1993, quotes Rockwell's *Saturday Evening Post* covers), Charles adopts the stylistic conventions of nineteenth- and early-twentieth-century illustration. His work has a strong graphic impact, with bold lines and clean, bright colors which he then tears, folds, and sands to imitate the effects of aging. His subject matter makes reference to another tradition: marketing black stereotypes such as Sambo to sell consumer goods (figs. 12, 13). Charles's

Michael Ray Charles

12
(Forever Free) *"Servin with a smile,"* 1994
Acrylic latex and copper penny on paper,
40 x 26 inches
Private collection

13
(Forever Free) *Buy Black!* 1996
Acrylic latex, stain, and copper penny on
paper, 30¾ x 24¼ inches
Private collection

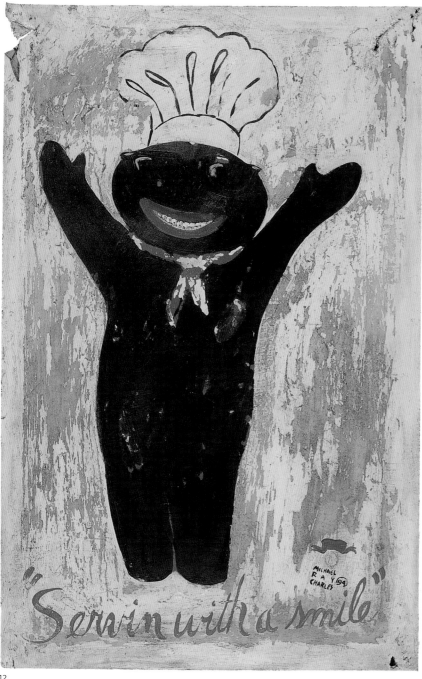

12

weathered surfaces look old, but in recycling the racist representations of the past, he updates the imagery, reminding us that these stereotypes persist today—check your local grocery store for Aunt Jemima pancake syrup and Uncle Ben's Rice.

A series titled "After Black, Before Black" harks back to a series of nineteenth-century engravings by Currier & Ives depicting anecdotal scenes. In paired canvases, Charles portrays a male protagonist with caricatured African-American features. Confounding the usual improvement found in before-and-after images, the protagonist seems to suffer both before and after he is reminded of his black identity—frightened before, cocky and unaware after. The pictures refer to contemporary America, describing the modernized versions of old stereotypes. In *Before Black (To See or Not to See)* (1997, fig. 14), a frightened figure runs at night, eyes wide but looking over his shoulder, and appears to be about to run into a tree. In *After Black (To See or Not to See)* (1997, fig. 15), the same figure wears a blindfold covered with dollar signs and dribbles a basketball, once again about to run into a tree. Like many of Charles's paintings, the diptych comments on the African-American experience of being an economic commodity, here masked as financial opportunity, an experience fundamentally rooted in slavery.

Charles often represents contemporary black athletes and entertainers in the historical figure of the minstrel, or, most commonly, the clown. The artist created a series of paintings called the "Liberty

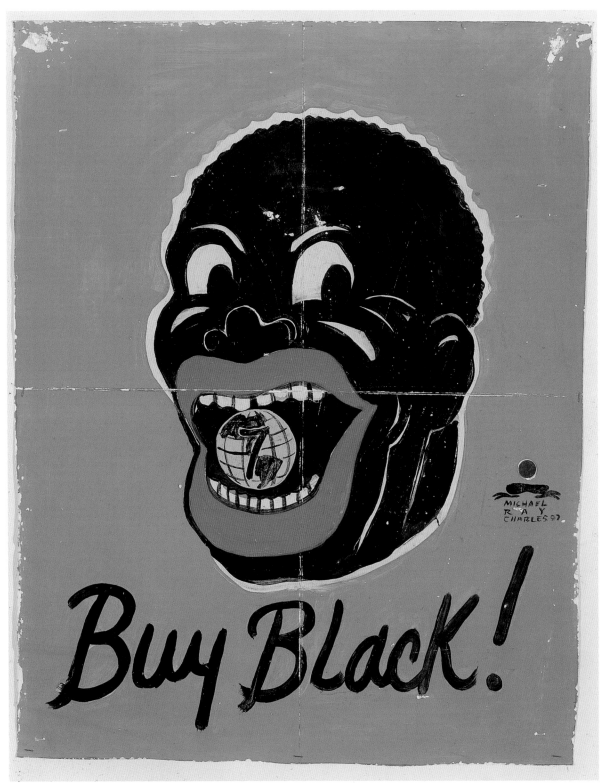

Michael Ray Charles

14
Before Black (To See or Not to See). 1997
Acrylic latex, stain, and copper penny on paper,
60 x 37 ½ inches
Private collection

15
After Black (To See or Not to See), 1997
Acrylic latex, stain, and copper penny on paper,
60 x 36 inches
Private collection

16
(Liberty Brothers Permanent Daily Circus) Blue Period, 1995
Acrylic latex, oil wash, stain, and copper penny on paper,
60 ½ x 36 ½ inches
Private collection

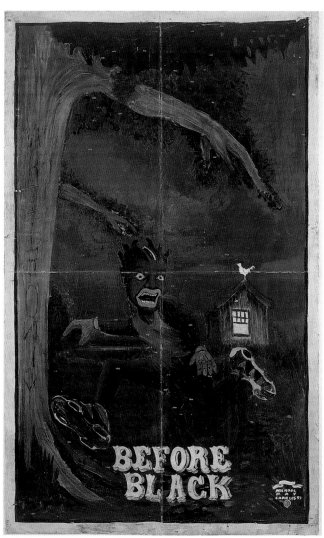

14

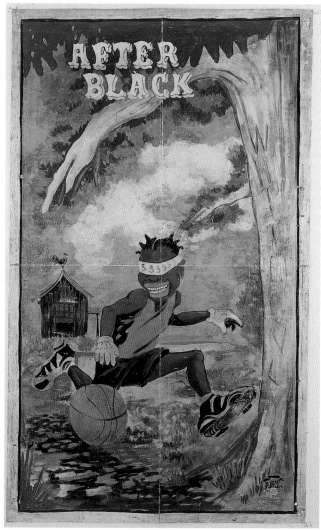

15

Brothers Permanent Daily Circus" as an allegory for the black man's constant daily pressure to perform, to wear a mask, to play the game—even to play the fool. *(Liberty Brothers Permanent Daily Circus) Blue Period* (1995, fig. 16) recalls Picasso's famous "blue period" paintings of 1901–03, such as *The Old Guitarist* (1903), which used cool tones to convey a melancholy mood. For Charles, the title's "blue" refers to the blues, and the painting's sadness comes from its setting: the figure is locked in a prison cell, prison being in a bitter irony, "the greatest show on earth."

Charles depicts twenty-first century African Americans not only as commodities (exploited entertainers), but as consumers, with the great American freedom to buy things. *(Forever Free) Art n American* (2000, fig. 17) features two figures surrounded by consumer goods: a CD player, cell phones, sneakers, and so on. Caricaturing images such as this has earned Charles a certain amount of criticism from African-American artists and viewers; but it is also clear that he is addressing a broader audience. The quest to have these possessions distracts us all from the pursuit of genuine achievement, diverting us into the endless race to have more. One of Charles's starkest, most cutting images is

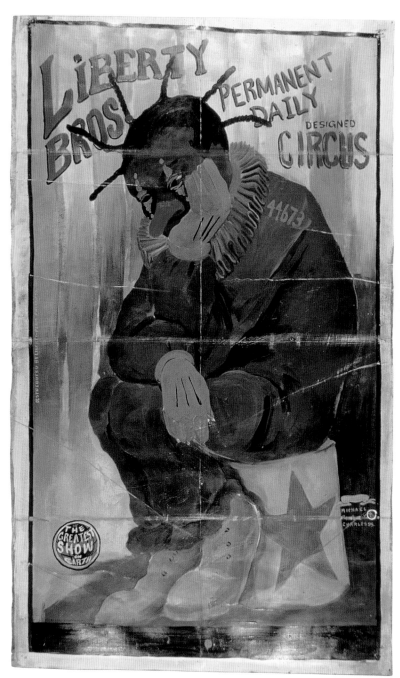

16

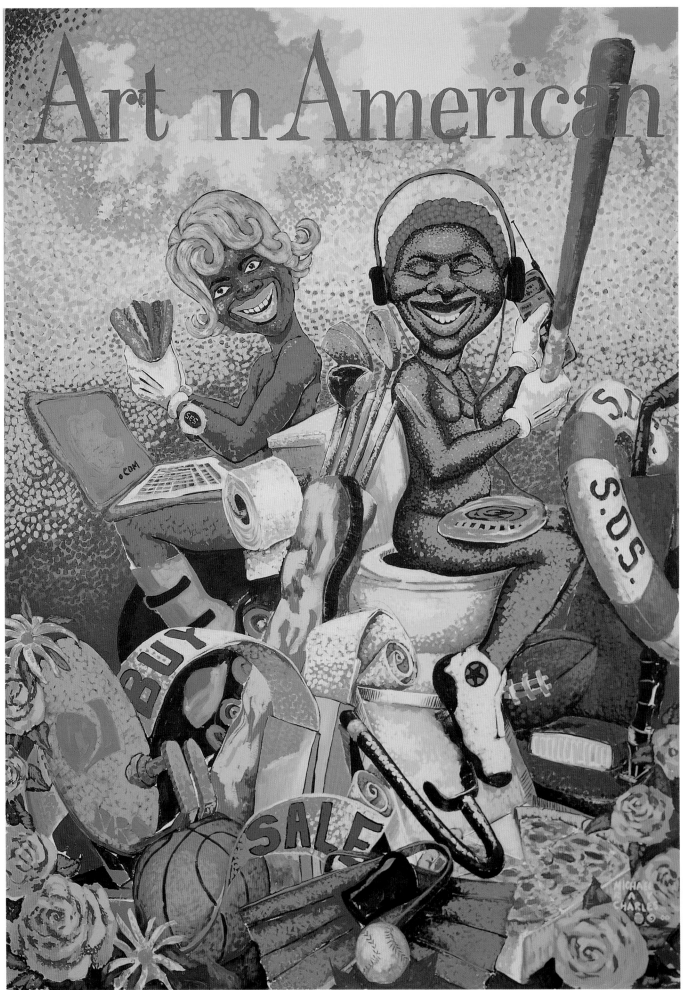

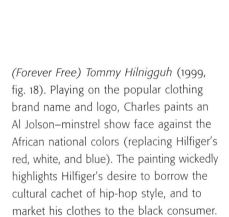

18

(Forever Free) Tommy Hilnigguh (1999, fig. 18). Playing on the popular clothing brand name and logo, Charles paints an Al Jolson–minstrel show face against the African national colors (replacing Hilfiger's red, white, and blue). The painting wickedly highlights Hilfiger's desire to borrow the cultural cachet of hip-hop style, and to market his clothes to the black consumer.

Many of Charles's strongest metaphors are economic, addressing the need for African-American financial independence as well as the more dubious aspects of the American quest for money. In recent works, he often portrays black men as heads with slots, recalling nineteenth-century black "memorabilia" piggy banks. Despite the figures' menacing glares and

watermelon mouths, the reference has the positive connotation of a plea for investing in the mind, as well as the obvious negative connotations. *(Forever Free) Hello I'm Your New Neighbor* (1997, fig. 19) presents the stereotype of the threatening black man as if through the eyes of a white neighbor; in the background, the positive reality of black and white coexistence is presented in the shaking hands. The idea of consumption and money, worth and value is so intrinsic to Charles's art, he has adopted a coin as his trademark. On every painting he makes, Charles attaches a copper penny next to his signature. The penny has the lowest value, it is the only colored coin, and it also bears Lincoln's profile; Charles always

Michael Ray Charles

17
(Forever Free) Art n American, 2000
Acrylic latex and copper penny on canvas,
84 x 60 inches
Private collection

18
(Forever Free) Tommy Hilnigguh, 1999
Acrylic latex, stain, and copper penny on
canvas, 36 x 60¼ inches
Private collection

Michael Ray Charles

19
(Forever Free) Hello I'm Your New Neighbor, 1997
Acrylic latex, stain, and copper penny on paper
60 x 36 inches
Private collection

Mel Chin

20
Schematic drawing for *Revival Field,* 1990
Graphite, ink, and photocopied images on
rag board, 24 x 36 inches

21
Revival Field at Pig's Eye Landfill,
St. Paul, Minnesota, 1991
Plants and industrial fencing on
a hazardous waste landfill,
approximately 60 x 60 x 9 feet

19

turns it upside down, ironizing these conventional meanings. Like all of Charles's work, the penny is layered with contradictory messages.

Mel Chin sees the flaws and failings of contemporary culture, but rather than criticize it with his art, his art becomes part of the system he has chosen (whether it be television or ecologically harmful industrial practices), working to change it from the inside. Chin's most famous piece is *Revival Field* (figs. 20–24), which appeared in three incarnations in the 1990s (in St. Paul, Minnesota, in Pennsylvania, and in the Netherlands) and resurfaced in Germany in 2001–02. In 1990 the artist, working with scientists, planted six different crops engineered to leach heavy-metal contaminants from a Minnesota landfill so polluted it once burned for two months straight. The soil was tested for heavy metal content throughout the project, and the plants were harvested periodically and then burned, making the metals they removed from the soil available again for use (recovered in the ashes). The projects clean up the environment, and their documentation is then presented in the museum or gallery.

Chin is currently working on two new agricultural projects in East Detroit, one of the most depressed urban areas in the United States, often represented in the media as "a hell of burning houses populated by the demonic poor." Both projects build on the tradition of urban agriculture and the imperative of economic self-sufficiency, turning burned-out houses into miniature farming systems.

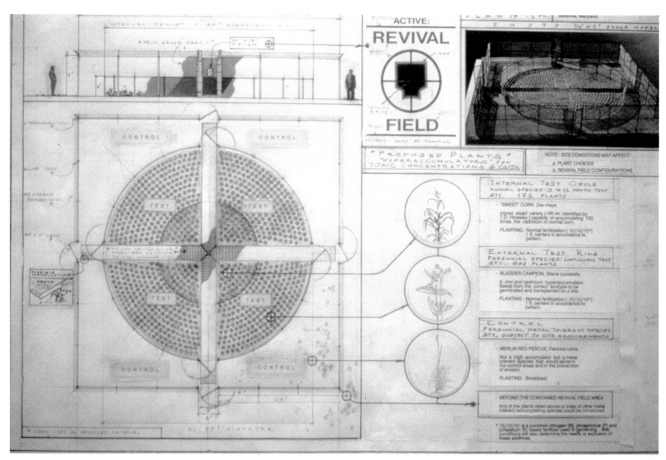

20

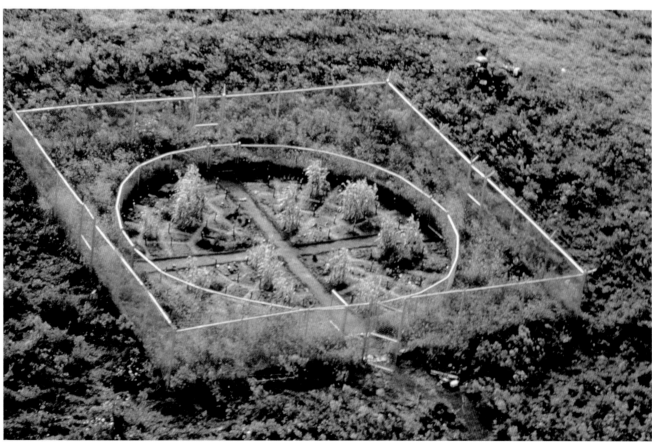

21

22

23

Mel Chin

22
Revival Field at Pig's Eye Landfill, St. Paul,
Minnesota, 1991
Plants and industrial fencing on a hazardous
waste landfill, approximately 60 x 60 x 9 feet
Artist volunteer conducting soil treatment

23
Revival Field at Palmerton, Pennsylvania, 1994
Plants and industrial fencing on a National Priority
Superfund Site, approximately 60 x 60 x 9 feet
Photodocumentation of scientists from the Zinc
Information Center and the United States
Department of Agriculture on site

24
Photodocumentation of the first *Revival Field*
harvest, 1991, on a State Priority Superfund Site

24

In S.P.O.R.E. ("Sustainable Products in Response to the Environment"), Chin removes the roof of a house, placing it on the ground as a cover for fancy mushrooms to be sold for profit at gourmet markets. S.P.A.W.N. ("Sustainable Projects in Agriculture, Worms, and Nature") places an abandoned home on a pivot; when the structure swivels off its foundation, it reveals a nightcrawler farm. The worms will be sold at fishing markets around the Great Lakes. While making money for a few individuals, Chin hopes these projects also serve as models of economic self-sufficiency and as examples of recycling existing structures to sustain a community at risk. As in all of his projects, the artist involves a team of experts from different disciplines, as well as local volunteers; working collaboratively avoids the tradi-tional model of the artist as an autonomous genius and instead activates a network of engaged individuals.

One particularly difficult system to infil-trate is the highly profitable and highly structured world of commercial television. In 1996 Chin formed the GALA Committee with artists and designers in Athens, Georgia (where he was teaching), and in Los Angeles. He then approached the pro-ducers of the hit TV series "Melrose Place," and asked if GALA could collaborate with them. Amazingly, set decorator Deborah Siegel responded, and the committee began creating objects and images with political messages that they insinuated into the program over two seasons. When Alison, a character on the show, acciden-tally became pregnant, she was shown working on a quilt; the quilt's pattern was

Mel Chin

25
Production still from *Melrose Place/GALA Committee*, 1996, showing Alison with *RU 486 Quilt*

26
RU 486 Quilt, 1996
Appliqué on cotton fabric, 62 x 53 inches

27
Production still from *Melrose Place/GALA Committee,* 1997, showing Kyle and Amanda on a date at *In the Name of the Place* exhibition at the Los Angeles Museum of Contemporary Art

28
Production still from *Melrose Place/GALA Committee,* 1997, showing Kyle and Amanda on a date at *In the Name of the Place* exhibition at the Los Angeles Museum of Contemporary Art. Mel Chin and set decorator Deborah Siegel are in the foreground

25

26

actually the formula for RU-486, the French abortion pill, not yet approved in the U.S. (figs. 25, 26). There were also sheets printed with pictures of condoms, Chinese take-out boxes printed with messages about Tiananmen Square, and beer bottles with alcoholism statistics—all woven into the popular nighttime soap. Finally, an episode of "Melrose" was shot in the L.A. Museum of Contemporary Art, completing the intertwining of art and mass media (figs. 27, 28). Most of this went by quickly, unnoticed by the average viewer, but Chin wanted to disseminate ideas almost subliminally. For him, this strategy mimics a virus, which infects a host body that then infects another host in a potentially infinite progression. Chin and his collaborators spread information in such a way.

Chin is always interested in the transmission and persistence of traditional ideas in a culture hooked on novelty. He likes to combine the latest thing with traditional, even disappearing ways. In *KNOWMAD* (1999, figs. 29, 30), Chin brings together video games with the nomadic cultures of the Middle East, Africa, and Asia. *KNOWMAD* is a confederacy of video gamers, artists, and one musician working with Chin and making games using the rug patterns and living structures of ancient nomadic cultures. Chin housed each video game machine in a yurt, a nomadic tent; he based the images in the games on a variety of traditional rug patterns, creating a semiabstract tapestrylike landscape for the player to negotiate on the screen. The games veer away from the Western model of violent competition, offering the player instead a quest to gather pomegranates, with the prize being additional time to visit more of the video game tents.

27

28

Mel Chin
and KNOWMAD Confederacy

29
Installation view of *KNOWMAD*, 1999, at the
Frederick R. Weisman Art Museum exhibition
World Views: Maps & Art
Interactive video installation with Playstation,
vintage carpets, and fabric tent

30
Digital stills from the game *KNOWMAD*, 1999
The images and motifs used in *KNOWMAD* were
taken directly from weavings by nomadic peoples
of Iran, the Caucasus, Afghanistan, Azerbaijan,
Central Asia, and Anatolia (in present-day Turkey)

29

Andrea Zittel

31
A–Z Administrative Services logo, 1997

32
Exterior view of *A–Z Administrative Services,* 1997

33 FOLLOWING PAGES
RAUGH Furniture: Lucinda (foreground detail), 1998
Foam rubber, 60½ x 141 x 102 inches
RAUGH Furniture: Jack (left), 1998
Foam rubber, 101½ x 296 x 214½ inches

31

Just as GALA's political messages will survive in "Melrose Place" reruns, *KNOW-MAD* was designed to preserve and disseminate disappearing nomadic cultural forms in the unlikely format of contemporary American digital representations. Chin envisions art as an inevitable part of an economic system of production and consumption, but also as sustaining ideas and images in a culture with a short attention span, and therefore still a powerful and potentially transformative force.

Andrea Zittel also considers the social realm as the proper venue for art; she sees even traditional painting and sculpture as "representations of peoples' ideas about how the world is constructed. And I don't think what I do is so dissimilar from that," she says. What she does, like many contemporary artists, seems far from traditional art and is inspired by everyday life, by how we eat, sleep, play, dress, and work. The objects that Zittel makes

seem very close to furniture, fashion, and architecture; she even has formed a mock company, "A to Z Administrative Services," with a logo emblazoned on the outside of her home/studio (figs. 31, 32). Zittel investigates how our daily activities shape our environment and how our environment shapes the way we carry out these activities. For example, working from the idea that the chair presents an awkward, unhealthy way to sit, Zittel has designed RAUGH furniture (fig. 33), which draws on natural forms and allows a person to sit and recline in a variety of positions.

Zittel's early work was stimulated by the experience of living in her first home in Brooklyn, a two-room, two-hundred-square-foot storefront—tiny, even by New York standards. The apartment didn't even have a shower. To cope with these conditions, Zittel started thinking about the most efficient use of space and which objects were truly essential. She also

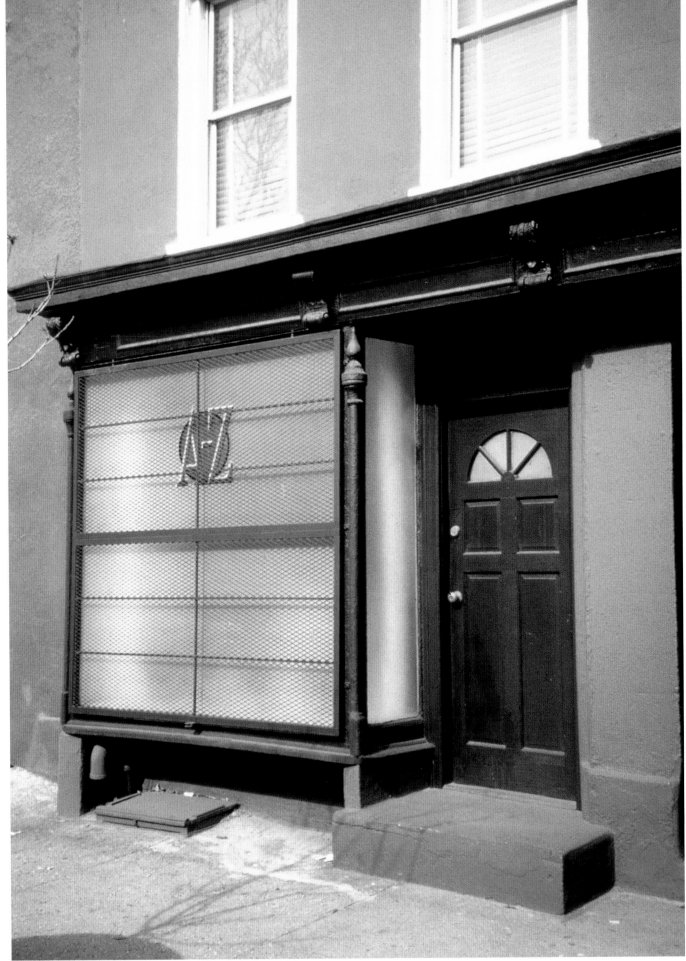

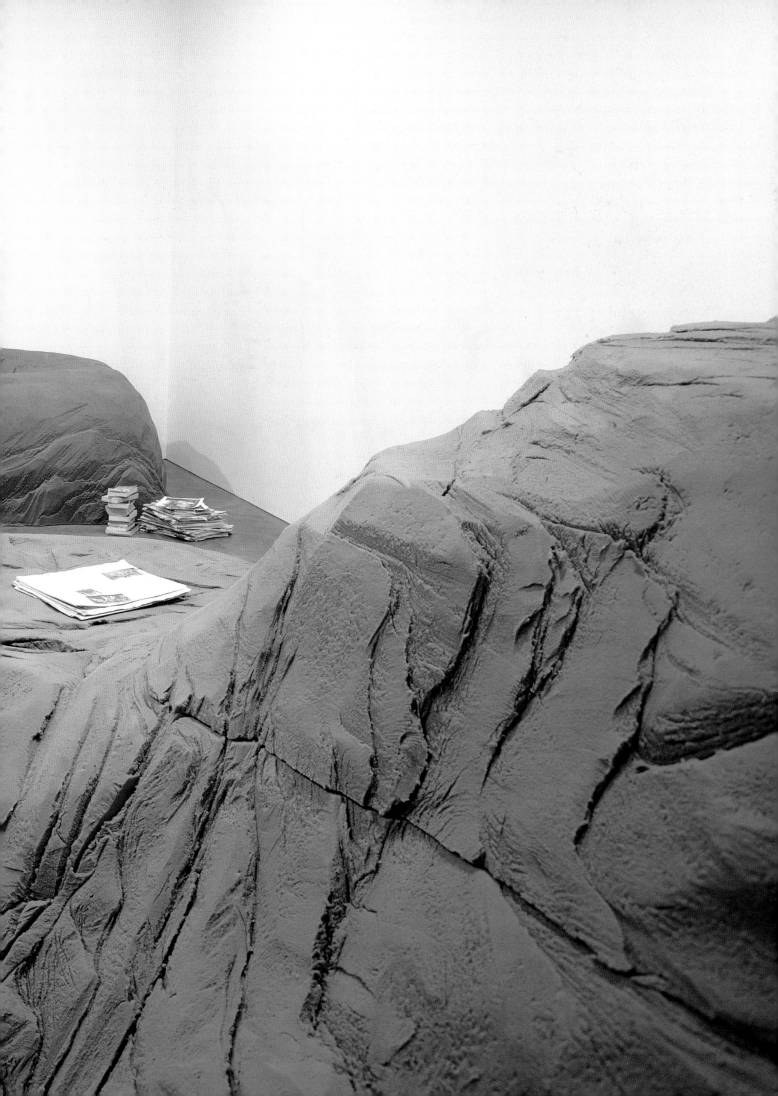

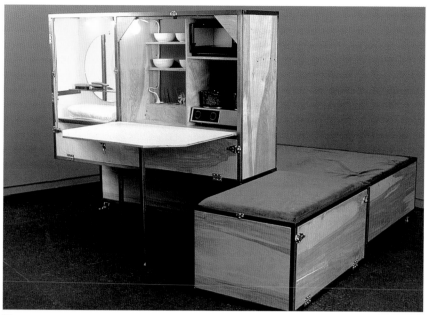

34

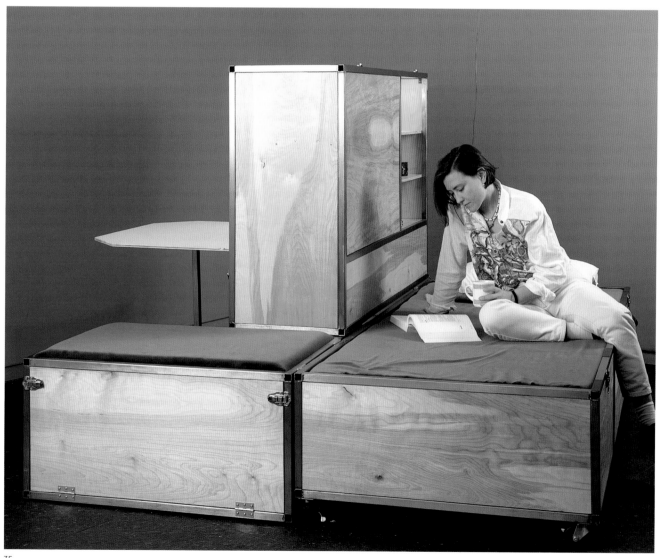

35

Andrea Zittel

34, 35
A–Z Living Unit II (front and rear views), 1994
Steel, wood, metal, mattress, glass, mirror,
lighting fixture, oven, range, velvet upholstery,
utensils, sauce pans, bowls, towel, hairbrush,
pillow, and clock; open: 57 x 84 x 82 inches,
closed: 36¾ x 84 x 38 inches

36
*A–Z Travel Trailer Unit Customized
by Andrea Zittel*, 1995
Steel, wood, glass, carpet, aluminum,
and various objects, 93 x 93 x 192 inches
San Francisco Museum of Modern Art,
Accession Committee Fund

37
A–Z Bathroom, 1997
The bathroom cabinets are divided into
four categories: Addition, Subtraction,
Correction, and Pathology

36

wanted to make her undesirable living
situation seem stylish—even glamorous.
If she couldn't afford to live like other
people, she wanted them to envy her.

These tight living conditions gave birth
to a series of "Living Units," cabinets that
open up to reveal the compact means
to satisfy basic human needs—a place to
sleep, eat, cook, bathe, and work (figs. 34,
35). They were standard forms but could
be customized by individual owners. When
Zittel lived in Los Angeles for a few years in
the mid-nineties, her work adapted to the
local car culture. She worked with car trail-
ers, personalized by people (including her
parents), to allow individuals to take their
homes with them as they drove (fig. 36).

Zittel's ongoing masterpiece is her
current (larger) home, a three-story row
house in Brooklyn, New York. It is also
her laboratory, a constantly evolving work
in progress; every room is a result of
thought and experimentation with its pos-
sible function. The bathroom cabinets
are divided into four categories: Addition,
Subtraction, Correction, and Pathology
(fig. 37). In her kitchen she stocks three
types of bowls—small, medium, and
large—in which all food and beverages
are prepared and served. All of the books
in the office are covered in uniform dark
green tape; you can't tell which book is

37

Andrea Zittel

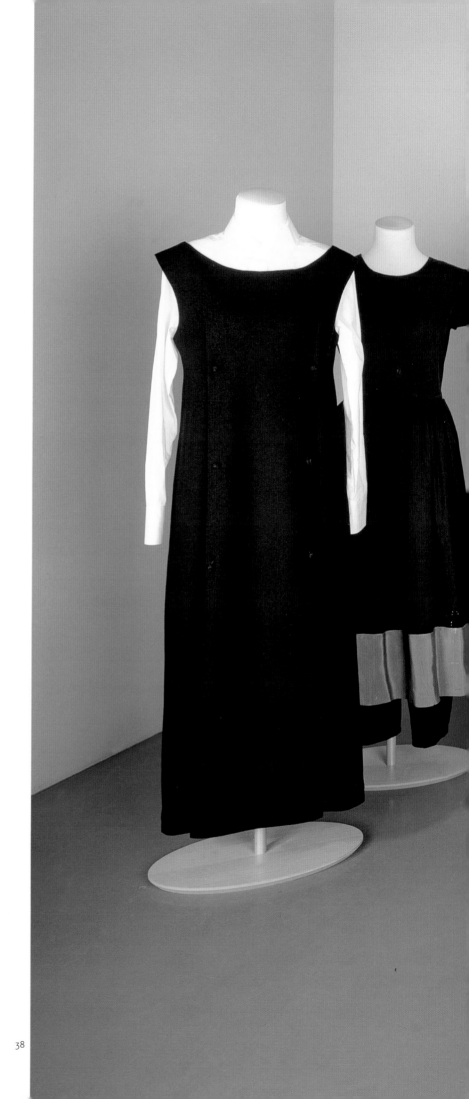

which, but they have a neat, uniform look.
Perhaps most interesting of all is her
clothes closet, which contains only one
outfit. Zittel wears the same outfit every
day, usually a dress of her own design
and making; every four months she
switches to a new outfit for the new sea-
son (fig. 38). Again, she turns a negative—
a limited wardrobe—into a positive, making
the best thing she can think of to wear
and then wearing it every day.

The uniform highlights the paradoxical
quality of Zittel's work: it offers both con-
straint and freedom. You have to wear one
thing all the time, like someone who works
in a corporation, but unlike the McDonald's
uniform, it can be anything you choose; it
also frees you from worrying about what
clothing to put on in the morning. A series
of similar dualisms is embedded in her
work, as in modernism: conformity and
individuality, privacy and publicness.

When she was living in Los Angeles
working on the mobile trailer homes,
Zittel began thinking about much larger
exterior spaces and how we divide them
up, both protecting and isolating our-
selves. *A Pocket Property* (1999, fig. 39) is
very much about that tension between
isolation and community. In 1999, Zittel
built an island out of concrete and steel
and floated it on steel drums, all forty-
four tons of it, off the coast of Denmark.
She and several friends lived there for six
weeks in the summer of 2000. The island
is hollow, with living quarters inside, and
will eventually be entirely self-sufficient,
with solar panels and a water maker,
so that she would never have to leave

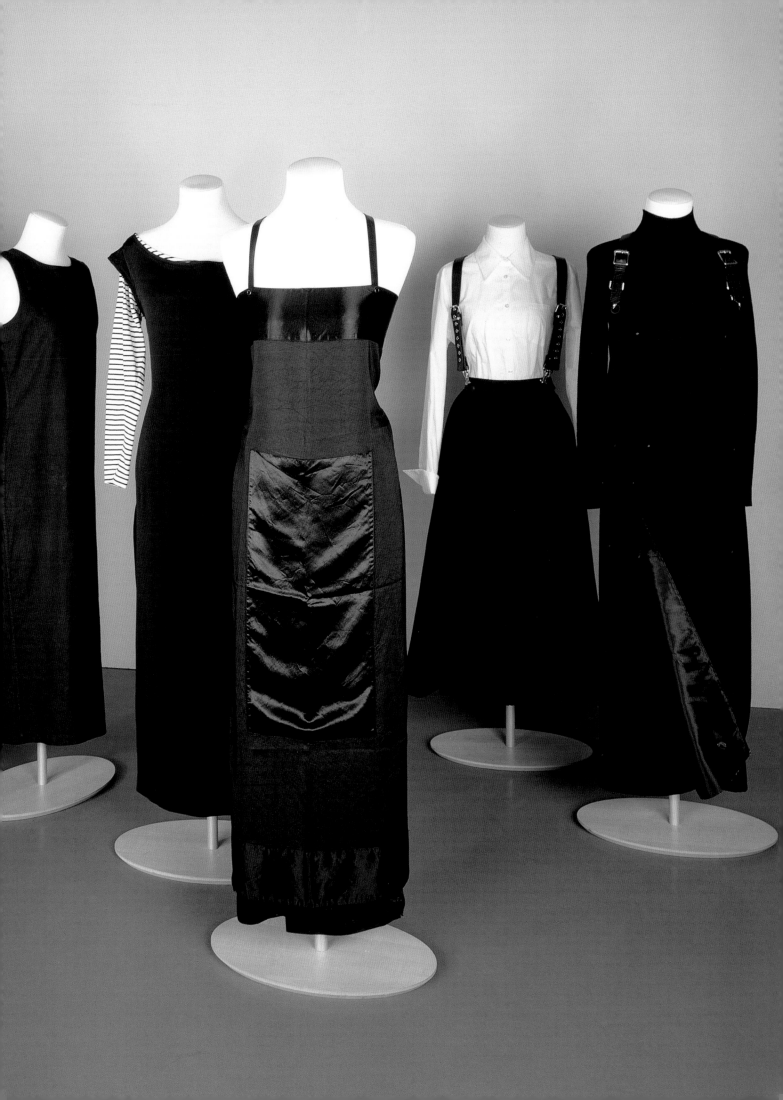

39

Andrea Zittel

39
A–Z Prototype for Pocket Property, 1999, floating off the coast of Denmark
Concrete, steel, wood, dirt, and vegetation, approximately 23 x 54 feet

it. For an artist dealing in experimental living situations, this is certainly the most extreme, combining the fantasy of never leaving the house and getting away from it all, as well as the fear of isolation. Zittel has said that the ultimate audience for her work is her family, and it is probably no coincidence that her parents and her brother both make their permanent homes on sailboats. Even when dealing with broad social issues, artists bring their personal history, particular ideas, and emotions to their art.

Perhaps the most widely discussed figure in the current generation of young artists is Matthew Barney. With a background in sculpture and performance art, his big project is a series of five films, released approximately every other year

from 1992 to 2001. Only the last two have dialogue, and none have a clear plot, but all rather loosely and often mysteriously combine American cultural myths and Barney's personal interests.

Barney was a high school and college football player, and the first of his films takes place largely on a football field, a fantastic one with bizarrely costumed dancing girls and stylized blimps (fig. 40). Others are set in the worlds of car racing, the romantic opera, and the rodeo. He refers to traditional film genres (musical, gangster, sci-fi, romance); the music of our era (opera, heavy metal, country, punk); members of various professions (models, athletes, magicians, cowboys, killers, writers, and artists); great landscapes (New York City, the Rockies); and

Matthew Barney

40
CREMASTER 1
Production stills, 1995
© 1995 Matthew Barney

41

Matthew Barney

41
CREMASTER 2
Production still, 1999
© 1999 Matthew Barney

42
CREMASTER 4
Production still, 1994
© 1994 Matthew Barney

43, 44
CREMASTER 5
Production stills, 1997
© 1997 Matthew Barney

42

countless other American obsessions—cars, football, horses, Mormons, Masons, showgirls, stewardesses. Barney takes the wide view of America, managing to pack into his films many of the themes—both high and low—of America's twentieth century (figs. 41–44).

What is less familiar about Barney's films is the theme tying them all together, their title, *CREMASTER*. Not a word familiar to most of us, the cremaster is the muscle in the male body that raises and lowers the testicles in response to changes in temperature. For Barney, the physiological

process of lowering the testicles symbolizes social difference, the moment when the male becomes most aggressively, fully himself. The fight to individuate from the group (represented by the football team, the Church, and, in the fifth *CREMASTER*, the Rockettes) frames the series' overarching narrative. If this sounds odd, it is; and the particulars are equally odd, including bizarre costumes that combine historical detail (an Elizabethan ruff, for example) with the fantastic (such as extravagant streamers), and prosthetic makeup, like horns and hooves. But Barney's images

43

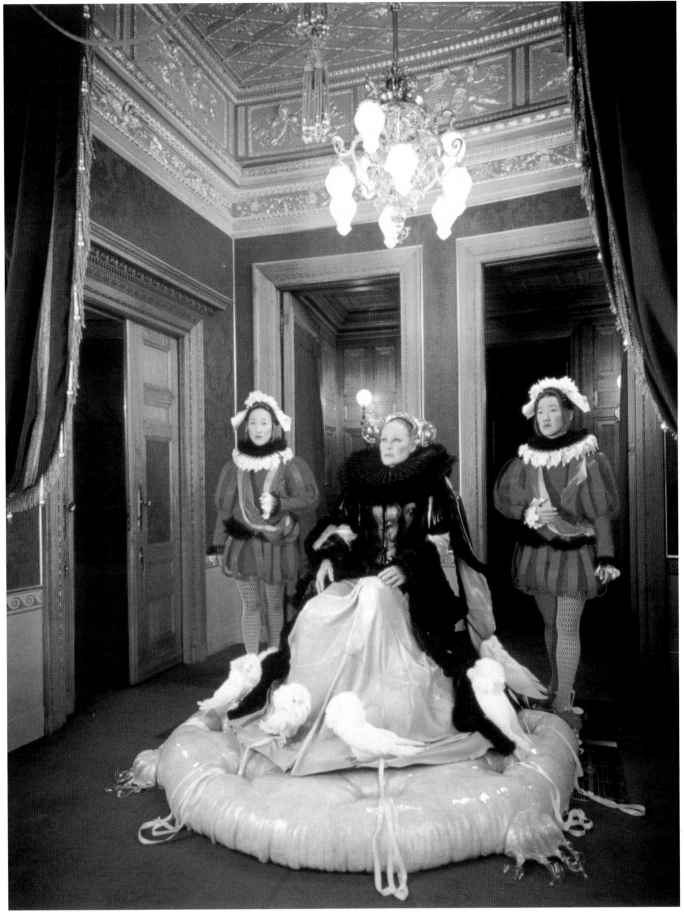

Matthew Barney

45
CREMASTER 3
Production still, 2000
© 2000 Matthew Barney

46
Chrysler Building, exterior. Photograph
by Peter Mauss

47
CREMASTER 3
Production still, 2000
© 2000 Matthew Barney

are as remarkable for their beauty as their oddity: each film has a particular look, unifying the often breathtaking landscapes and architectural settings, abstract symbols and shapes, marvelous characters, and brilliant color schemes.

The final film in the *CREMASTER* series is an allegory of Barney's move to New York City from the West and his struggle to become an artist. Here Barney calls on the conventions of horror and goodfellas Mafia movies, as well as television game shows. The setting is New York in the 1930s, specifically the distinctive architecture of the art deco Chrysler Building (fig. 46) and Frank Lloyd Wright's spiral Guggenheim Museum. Barney crams the two sites extravagantly full of historical details from Masonic societies, the U.S. labor movement, punk rock, and Irish immigration (fig. 45). Underneath lies the more personal story of the tremendous ego required to be an "important" artist, the perfectionism, and the Oedipal wrestling with great artists of earlier generations, represented here by sculptor Richard Serra (fig. 47). Barney weaves a

personal narrative using mass entertainment as his subject and his form.

Art has changed considerably in the past two hundred years. What is it for? What is it now that art no longer means painting and sculpture? It can be intimidating and strange-looking at first; many people resent contemporary art, as if it were trying to exclude them. But, more than ever, contemporary art is attuned to the things most of us are likely to spend our time looking at and thinking about. While most of us spend little time looking and thinking about art, we spend our whole lives training to understand movies and television and video games and clothes and beds and houses. And so contemporary art often invokes these experiences and objects; art often *looks* like a commodity, because in a consumer culture, nothing could be more essential.

Thinking about the great art of the past, we may feel a sense of loss, a sadness that our contemporary culture is so involved in buying and selling, and that even traditionally high-minded pursuits such as art tend to reflect this. The

48
Franco Mondini-Ruiz
Site-specific installation of *Infinito Botanica,* 2000, at the Whitney
Biennial.

49
Felix Gonzalez-Torres
Untitled (USA Today), 1990
Approximately 300 pounds of red, silver, and blue cellophane-
wrapped (endless supply) candies, dimensions variable
The Museum of Modern Art, New York. Gift of Werner and Elaine
Dannheiser

50
David Reed
Installation view of *Scottie's Bedroom,* 1994, from *Two Bedrooms in
San Francisco* at P.S. 1 Contemporary Art Center, New York. The
painting above the bed has been digitally inserted into a video of
Alfred Hitchcock's film *Vertigo,* Universal Pictures, 1958

47

48

positive side of this situation is that art can be for everyone. In Claes Oldenburg's store, anyone could walk in and buy a $4.99 piece of art (a price that has appreciated considerably in the art market of the past forty years); Andy Warhol made huge editions of prints to be bought in department stores for very low prices rather than in art galleries. In 2000, artist Franco Mondini-Ruiz sold beautiful, inexpensive objects referencing Chicano and Anglo kitsch at a cart outside the Whitney Museum of American Art as part of the Whitney Biennial (fig. 48). The late Felix Gonzalez-Torres even gave away his art for free, as in the beautiful candy spills that asked museum and gallery goers to take a few pieces home with them (fig. 49). These artists make it possible for us to own their art in order to symbolize their hope that art is not just for the elite, for the aristocracy. Artists even reimagine the role of painting, historically the most expensive, exclusive form of art, as in painter David Reed's digital insertion of his work into television and popular Hitchcock movies (fig. 50). Kruger's photographs, Charles's advertising-based images, Barney's films, Chin's video games, and Zittel's furniture present complex, difficult ideas, but in forms we all know. Art today reveals our culture, participates in it, tests its limits—and sometimes even imagines how everything could be different.

50

Biographies of the Artists

Matthew Barney

Matthew Barney was born in San Francisco in 1967; at age six, he moved to Idaho with his family. After his parents divorced, Barney continued to live with his father in Idaho, playing football on his high school team, and visiting his mother in New York City, where he was introduced to art and museums. This intermingling of sports and art informs his work as a sculptor and filmmaker. After graduating from Yale in 1991, Barney entered the art world to almost instant controversy and success. He is best known as the producer and creator of the *CREMASTER* films, a series of five visually extravagant works created out of sequence (*CREMASTER 4* began the cycle, followed by *CREMASTER 1*, etc.). The films generally feature Barney in myriad roles, including characters as diverse as a satyr, a magician, a ram, Harry Houdini, and even the infamous murderer Gary Gilmore. The title of the films refers to the muscle that raises and lowers the male reproductive system according to temperature, external stimulation, or fear. The films themselves are a grand mixture of history, autobiography, and mythology, an intensely private universe in which symbols and images are densely layered and interconnected. The resulting Barney-cosmology is both beautiful and complex. His final film in the series, *CREMASTER 3*, begins beneath New York City's Chrysler Building and includes scenes at the Saratoga race track, where apparently dead costumed horses race through a dream sequence, and at the Guggenheim Museum, where artist Richard Serra throws hot Vaseline down the Museum's famous spiral ramp. The film is scheduled for release in 2002. Matthew Barney won the prestigious Europa 2000 prize at the 45th Venice Biennale in 1996. He was also the first recipient of the Guggenheim Museum's Hugo Boss Award.

Louise Bourgeois

Louise Bourgeois was born in Paris in 1911. She studied art at various schools there, including the Ecole du Louvre, Académie des Beaux-Arts, Académie Julian, and Atelier Fernand Léger. In 1938, she emigrated to the United States and continued her studies at the Art Students League in New York. Though her beginnings were as an engraver and painter, by the 1940s she had turned her attention to sculptural work, for which she is now recognized as a twentieth-century leader. Greatly influenced by the influx of European Surrealist artists who immigrated to the United States after World War II, Bourgeois's early sculpture was composed of groupings of abstract and organic shapes, often carved from wood. By the 1960s she began to execute her work in rubber, bronze, and stone, and the pieces themselves became larger, more referential to what has become the dominant theme of her work—her childhood. She has famously stated: "My childhood has never lost its magic, it has never lost its mystery, and it has never lost its drama." Deeply symbolic, her work uses her relationship with her parents and the role sexuality played in her early family life as a vocabulary in which to understand and remake that history. The anthropomorphic shapes her pieces take—the female and male bodies are continually referenced and remade—are charged with sexuality and innocence and the interplay between the two. Bourgeois's work is in the collections of most major museums around the world. She lives in New York.

Laurie Anderson

Laurie Anderson was born in Chicago in 1947. One of eight children, she studied the violin and, while growing up, played in the Chicago Youth Symphony. She graduated in 1969 from Barnard College in New York, and went on to study at Columbia University, working toward a graduate degree in sculpture. The art scene of the early 1970s fostered an experimental attitude among many young artists in downtown New York that attracted Anderson, and some of her earliest performances as a young artist took place on the street or in informal art spaces. In the most memorable of these, she stood on a block of ice, playing her violin while wearing her ice skates. When the ice melted, the performance ended. Since that time, Anderson has gone on to create large-scale theatrical works which combine a variety of media—music, video, story-telling, projected imagery, sculpture—in which she is an electrifying performer. As a visual artist, her work has been shown at the Guggenheim Museum in SoHo, New York, as well as extensively in Europe, including the Centre Georges Pompidou in Paris. She has also released seven albums for Warner Bros., including *Big Science*, featuring the song "Superman," which rose to number two on the British pop charts. In 1999, she staged *Songs and Stories From Moby Dick*, an interpretation of Herman Melville's 1851 novel. With Lou Reed, she recently selected music for Julian Schnabel's film, *Before Night Falls*. She lives in New York.

Michael Ray Charles

Michael Ray Charles was born in 1967 in Lafayette, Louisiana, and graduated from McNeese State University in Lake Charles, Louisiana, in 1985. In college, he studied advertising design and illustration,

eventually moving into painting, his preferred medium. Charles also received an MFA degree from the University of Houston in 1993. His graphically styled paintings investigate racial stereotypes drawn from a history of American advertising, product packaging, billboards, radio jingles, and television commercials. Charles draws comparisons between Sambo, Mammy, and minstrel images of an earlier era and contemporary mass-media portrayals of black youths, celebrities, and athletes—images he sees as a constant in the American subconscious. "Stereotypes have evolved," he notes. "I'm trying to deal with present and past stereotypes in the context of today's society." Caricatures of African-American experience, such as Aunt Jemima, are represented in Charles's work as ordinary depictions of blackness, yet are stripped of the benign aura that lends them an often unquestioned appearance of truth. "Aunt Jemima is just an image, but it almost automatically becomes a real person for many people, in their minds. But there's a difference between these images and real humans." In each of his paintings, notions of beauty, ugliness, nostalgia, and violence emerge and converge, reminding us that we cannot divorce ourselves from a past that has led us to where we are, who we have become, and how we are portrayed. Charles lives in Texas and teaches at the University of Texas at Austin.

Mel Chin

Mel Chin was born in Houston to Chinese parents in 1951, the first of his family born in the United States, and was reared in a predominantly African-American and Latino neighborhood. He worked in his family's grocery store, and began making art at an early age. Though he is classically trained, Chin's art, which is both analytical and poetic, evades easy classification. Alchemy, botany, and ecology are but a few of the disciplines that intersect in his work. He insinuates art into unlikely places, including destroyed homes, toxic landfills, and even popular

television, investigating how art can provoke greater social awareness and responsibility. Unconventional and politically engaged, his projects also challenge the idea of the artist as the exclusive creative force behind an artwork. "The survival of my own ideas may not be as important as a condition I might create for others' ideas to be realized," says Chin, who often enlists entire neighborhoods or groups of students in creative partnerships. In *KNOWMAD*, Chin worked with software engineers to create a video game based on rug patterns of nomadic peoples facing persecution. Chin also promotes "works of art" that have the ultimate effect of benefiting science or rejuvenating the economies of inner-city neighborhoods. In *Revival Field*, Chin worked with scientists to create sculpted gardens of hyperaccumulators—plants that can draw heavy metals from contaminated areas—in some of the most polluted sites in the world. Chin received a BA from Peabody College in Nashville, Tennessee, in 1975, and fellowships from the National Endowment for the Arts in 1988 and 1990. He lives in North Carolina.

John Feodorov

John Feodorov was born in 1960 in Los Angeles of mixed Native-American and Euro-American descent. Brought up both in the suburbs of Los Angeles and on a Navajo reservation in New Mexico, Feodorov early experienced the cultural differences between his dual heritages. He also observed the stereotypes present in American culture at large, where Native Americans were idealized as the living embodiment of spirituality by New Age consumerists. His work addresses this clichéd modern archetype through a humorous interjection of "sacred" items into recognizable consumer products. His kitschy "Totem Teddy" series, for instance, added masks and totemic markings to stuffed toy bears accompanied by booklets declaring the bears to "meet the spiritual needs of consumers of all ages!" He has said: "A major theme in my work is the way Native Americans are still being portrayed, stereotyped, and studied in contemporary America. I've read that the

Navajo Nation is the most-studied group of people on Earth. I don't know whether to be proud or disgusted." Feodorov mixes this analytical critique with installations and sculptural objects that are often whimsical, fantastic, and mythical, creating a new and sometimes genuine sense of the sacred—a sacredness for modern, fractured times. Feodorov holds a BFA in drawing and painting from California State University at Long Beach. He is also a musician, and headlines the band *Skinwalkers*. He lives in Seattle.

Ann Hamilton

Ann Hamilton was born in 1956 in Lima, Ohio. She trained in textile design at the University of Kansas, and later received an MFA from Yale University. While her degree is in sculpture, textiles and fabric have continued to be an important part of her work, which includes installations, photographs, videos, performance, and objects. For example, following graduation she made *Toothpick Suit*, for which she layered thousands of toothpicks in porcupine fashion along a suit of clothes that she then wore and photographed. Hamilton's sensual installations often combine evocative soundtracks with cloth, filmed footage, organic material, and objects such as tables. She is as interested in verbal and written language as she is in the visual, and sees the two as related and interchangeable. In recent work, she has experimented with exchanging one sense organ for another—the mouth and fingers, for example, become like an eye with the addition of miniature pinhole cameras. In 1993, she won a prestigious MacArthur Fellowship. As the 1999 American representative at the Venice Biennale, she addressed topics of slavery and oppression in American society with an installation that used walls embossed with Braille. The embossed Braille caught a dazzling red powder as it slid down from above, literally making language visible. After teaching at the University of California at Santa Barbara from 1985 to 1991, she returned to Ohio, where she lives and works.

Margaret Kilgallen

Margaret Kilgallen was born in 1967 in Washington, D.C. and received her BA in printmaking from Colorado College in 1989. Early experiences as a librarian and bookbinder contribute to her encyclopedic knowledge of signs drawn from American folk tradition, printmaking, and letterpress. Kilgallen has a love of "things that show the evidence of the human hand." Painting directly on the wall, Kilgallen creates room-size murals that recall a time when personal craft and handmade signs were the dominant aesthetic. Strong, independent women seen walking, surfing, fighting, and biking feature prominently in the artist's compositions. Her work has been shown at Deitch Projects and the Drawing Room in New York, Yerba Buena Center for the Arts and the Luggage Store in San Francisco, the Forum for Contemporary Art in St. Louis, and the Institute of Contemporary Art in Boston. Kilgallen's work was recently presented at the UCLA/Armand Hammer Museum, along with that of her husband, artist Barry McGee. They live in San Francisco.

Beryl Korot

Beryl Korot was born in 1945 in New York, where she continues to live and work. An early video-art pioneer and an internationally exhibited artist, her multiple-channel (and multiple-monitor) video installation works, including the four-channel *Dachau 1974* and the five-channel *Text and Commentary* of 1977, explored the relationship between programming tools as diverse as the technology of the loom and multiple-channel video. She has

commented: "Just as the spinning and gathering of wool serve as the raw material for a weave, so the artist working with video selects images to serve as the basic substance of the work." For most of the 1980s, Korot concentrated on a series of paintings that were based on a language she created that was an analogue to the Latin alphabet. Drawing on her earlier interest in weaving and video as related technologies, she made most of these paintings on handwoven and traditional linen canvas. More recently, she has collaborated with her husband, the composer Steve Reich, on *Three Tales*, a documentary digital video opera in three acts and a prologue. It began in 1998 with Act 1, *Hindenburg*. While the *Prologue* contains biblical text about human creation, Act 1 begins with documentary footage of Paul von Hindenburg, last president of the Weimar Republic (who made Hitler chancellor in 1933), and ends with footage of the *Hindenburg* zeppelin and its explosion at Lakehurst, New Jersey, in 1937. Act 2, *Bikini*, is based on footage, photographs, and text from the atom bomb test on Bikini Island and the subsequent removal of the Bikini people. Act 3, *Dolly*, explores the issues revolving around the first cloning of a sheep in Scotland, in 1997. Together, the three individual acts form a progressive investigation of the way technology creates and frames our experience. In the context of Korot's body of work, which began with her early video tapestries, *Three Tales* extends and deepens her interest in both technology as a material in which to make work—video, weaving— and as a relevant exploration of history in which to base her work. She lives in Vermont and New York.

Barbara Kruger

Barbara Kruger was born in Newark, New Jersey, in 1945. After attending Syracuse University, the School of Visual Arts, and studying art and design with Diane Arbus at Parson's School of Design in New York, Kruger obtained a design job at Condé Nast Publications. Working for *Mademoiselle Magazine*, she was quickly promoted to head designer. Later, she worked as a graphic designer, art director,

and picture editor in the art departments at *House and Garden*, *Aperture*, and other publications. This background in design is evident in the work for which she is now internationally renowned. She layers found photographs from existing sources with pithy and aggressive text that involves the viewer in the struggle for power and control that her captions speak to. In their trademark black letters against a slash of red background, some of her instantly recognizable slogans read: "I shop therefore I am," "Your body is a battleground," and "You are not yourself." Much of her text questions the viewer about feminism, classism, consumerism, and individual autonomy and desire, although her black-and-white images are culled from the mainstream magazines that sell the very ideas she is disputing. As well as appearing in museums and galleries world-wide, Kruger's work has appeared on billboards, buscards, posters, a train station platform in Strasbourg, France, and in other public commissions. She has taught at the California Institute of Art, The School of the Art Institute of Chicago, and the University of California, Berkeley. She lives in New York and Los Angeles.

Maya Lin

Born in 1959 in Athens, Ohio, Maya Lin catapulted into the public eye when, as a senior at Yale University, she submitted the winning design in a national competition for a Vietnam Veterans Memorial to be built in Washington, D.C. She was trained as an artist and architect, and her sculptures, parks, monuments, and architectural projects are linked by her ideal of making a place for individuals within the landscape. Lin, a Chinese-American, came from a cultivated and artistic home. Her father was the dean of fine arts at Ohio State University; her mother is a professor of literature at Ohio University. "As the child of immigrants you have that sense of, Where are you? Where's home?

And trying to make a home," remarks Lin. She draws inspiration for her sculpture and architecture from culturally diverse sources, including Japanese gardens, Hopewell Indian earthen mounds, and works by American earthworks artists of the 1960s and 1970s. Her most recognizable work, the Vietnam Veterans Memorial, allows the names of those lost in combat to speak for themselves, connecting a tragedy that happened on foreign soil with the soil of America's capital city, where it stands. Lin lives in New York and Colorado.

Sally Mann

Sally Mann was born in 1951 in Lexington, Virginia, where she continues to live and work. She received a BA from Hollins College in 1974, and an MA in writing from the same school in 1975. Her photographs of her three children and husband resulted in a controversial series called *Immediate Family*. In her recent series of landscapes of Alabama, Mississippi, Virginia, and Georgia, Mann has stated that she "wanted to go right into the heart of the deep dark South." Using damaged lenses and a camera that requires the artist to use her hand as a shutter, these photographs are marked by the scratches, light leaks, and shifts in focus that were part of the photographic process at its inception during the Civil War. Mann has won numerous awards, including Guggenheim and National Endowment for the Arts fellowships. Her books of photographs include *Immediate Family*; *At Twelve: Portraits of Young Women*; and *Mother Land: Recent Landscapes of Georgia and Virginia*. Her photographs are in the permanent collections of many museums, including The Museum of Modern Art and the Whitney Museum of American Art in New York, and the Smithsonian American Art Museum in Washington, D.C.

Kerry James Marshall

Kerry James Marshall was born in 1955 in Birmingham, Alabama, and was educated at the Otis Art Institute in Los Angeles, from which he received a BFA, and an honorary doctorate in 1999. The subject matter of his paintings, installations, and public projects is often drawn from African-American popular culture, and is rooted in the geography of his upbringing: "You can't be born in Birmingham, Alabama, in 1955 and grow up in South Central [Los Angeles] near the Black Panthers headquarters, and not feel like you've got some kind of social responsibility. You can't move to Watts in 1963 and not speak about it. That determined a lot of where my work was going to go," says Marshall. In his *Momentos* series of paintings and sculptures, he pays tribute to the Civil Rights movement with mammoth printing stamps featuring bold slogans of the era—Black Power!—and paintings of middle-class living rooms where ordinary African-American citizens have become angels tending to a domestic order populated by the ghosts of Martin Luther King, Jr., John F. Kennedy, Robert Kennedy, and other heroes of the 1960s. In *Rythm Mastr*, Marshall creates a comic book for the twenty-first century, pitting ancient African sculptures come to life against a cyberspace elite that risks losing touch with traditional culture. Marshall's work is based on a broad range of art-historical references, from Renaissance painting to black folk art, from El Greco to Charles White. A striking aspect of his paintings is the emphatically black skin tone of his figures, a development the artist says emerged from an investigation into the invisibility of blacks in America and the unnecessarily negative connotations associated with darkness. Marshall believes "you still have to earn your audience's attention every time you make something." The sheer beauty of his work speaks to an art that is simultaneously formally rigorous and socially engaged. Marshall lives in Chicago.

Barry McGee

A lauded and much-respected cult figure in a bi-coastal subculture that comprises skaters, graffiti artists, and West Coast surfers, Barry McGee was born in 1966 in California, where he continues to live and work. In 1991 he received a BFA in painting and printmaking from the San Francisco Art Institute. His drawings, paintings, and mixed-media installations take their inspiration from contemporary urban culture, incorporating elements such as empty liquor bottles and spray-paint cans, tagged signs, wrenches, and scrap wood or metal. McGee is also a graffiti artist, working on the streets of America's cities since the 1980s, where he is known by the tag name "Twist." He views graffiti as a vital method of communication, one that keeps him in touch with a larger, more diverse audience than can be reached through the traditional spaces of a gallery or museum. His trademark icon, a caricatured male figure with sagging eyes and a bemused expression, recalls the homeless people and transients who call the streets their home. "Compelling art to me is a name carved into a tree," says McGee. His work has been shown at the Walker Art Center in Minneapolis, the San Francisco Museum of Modern Art, the UCLA/Armand Hammer Museum in Los Angeles, and on streets and trains all over the United States. He and his wife, artist Margaret Kilgallen, live in San Francisco.

Bruce Nauman

Born in 1941 in Fort Wayne, Indiana, Bruce Nauman has been recognized since the early 1970s as one of the most innovative and provocative of America's contemporary artists. Nauman finds inspiration in the activities, speech, and materials of everyday life. Confronted with "What to do?" in his studio soon

after graduating from the University of Wisconsin, Madison, in 1964 with a BFA, and then the University of California, Davis in 1966 with an MFA, Nauman had the simple but profound realization that "If I was an artist and I was in the studio, then whatever I was doing in the studio must be art. At this point art became more of an activity and less of a product." Working in the diverse mediums of sculpture, video, film, printmaking, performance, and installation, Nauman concentrates less on the development of a characteristic style and more on the way in which a process or activity can transform or become a work of art. A survey of his diverse output demonstrates the alternately political, prosaic, spiritual, and crass methods by which Nauman examines life in all its gory details, mapping the human arc between life and death. The text from an early neon work proclaims: "The artist helps the world by revealing mystic truths." Whether or not we—or even Nauman—agree with this statement, the underlying subtext of the piece emphasizes the way in which the audience, artist, and culture at large are involved in the resonance a work of art will ultimately have. Nauman lives in New Mexico.

Pepón Osorio

Pepón Osorio, best known for large-scale installations, was born in Santurce, Puerto Rico, in 1955. He was educated at the Universidad Inter-Americana in Puerto Rico and Herbert H. Lehman College in New York, and received an MA from Columbia University in 1985. Osorio's pieces, influenced by his experience as a social worker in The Bronx, usually evolve from an interaction with the neighborhoods and people among which he is working. "My principal commitment as an artist is to return art to the community," he says. A recent example is *Tina's House*, a project created in collaboration with a family recovering from a devastating fire. The house—a tabletop-size art piece—tells the story of

the night of the fire and those affected, and is traveling the country in a series of "home visits." A home visit invites a new family to live with the art work for a period of at least one week, allowing the story of *Tina's House* to be told in many homes and environments. His work has been shown at the Whitney Museum of American Art and El Museo del Barrio in New York, the Smithsonian Museum of American Art in Washington, D.C., and el Museo de Arte de Puerto Rico and el Museo de Arte Contemporáneo de Puerto Rico. Pepón Osorio lives in Philadelphia.

Richard Serra

Richard Serra was born in San Francisco in 1939. After studying at the University of California at Berkeley and at Santa Barbara, he graduated in 1961 with a BA in English literature. During this time, he began working in steel mills in order to support himself. In 1964, he graduated from Yale University with both a BFA and an MFA. Receiving a Yale Traveling Fellowship, he spent a year in Paris, followed by a year in Florence funded by a Fullbright grant. Serra's early work in the 1960s focused on the industrial materials that he had worked with as a youth in West Coast steel mills and shipyards: steel and lead. A famous work from this time involved throwing lead against the walls of his studio. Though his casts were created from the impact of the lead hitting the walls, the emphasis of the piece was really on the process of creating it: raw aggression and physicality, combined with a self-conscious awareness of material and a real engagement with the space in which it was worked. Since those Minimalist beginnings, Serra's work has become famous for that same physicality, but one that is now compounded by the breathtaking size and weight that the pieces have acquired. His series of "Torqued Ellipses" (1996–99), which comprise gigantic plates of towering steel, bent and curved, leaning in and out, carve very private spaces from the

necessarily large public sites in which they have been erected. Serra's most recent public work includes the 60-foot-tall *Charlie Brown* (1999; named for the *Peanuts* comic-strip character in honor of its author, Charles Schultz, who had died that year), which has been erected in the courtyard of an office building in San Francisco. He lives in New York and Nova Scotia.

Shahzia Sikander

Shahzia Sikander was born in 1969 in Lahore, Pakistan. Educated as an undergraduate at the National College of Arts in Lahore, she received her MA in 1995 from the Rhode Island School of Design. Sikander specializes in Indian and Persian miniature painting, a traditional style that is both highly stylized and disciplined. While becoming an expert in this technique-driven, often impersonal art form, she imbued it with a personal context and history, blending the Eastern focus on precision and methodology with a Western emphasis on creative, subjective expression. In doing so, Sikander transported miniature painting into the realm of contemporary art. Reared as a Muslim, Sikander is also interested in exploring both sides of the Hindu and Muslim "border," often combining imagery from both—such as the Muslim veil and the Hindu multiarmed goddess—in a single painting. Sikander has written: "Such juxtaposing and mixing of Hindu and Muslim iconography is a parallel to the entanglement of histories of India and Pakistan." Expanding the miniature to the wall, Sikander also creates murals and installations, using tissue paperlike materials that allow for a more free-flowing style. In what she labeled "performances," Sikander experimented with wearing a veil in public, something she never did before moving to the United States. Utilizing performance and various media and formats to investigate issues of border crossing, she seeks to subvert stereotypes of the East and, in particular, the

Eastern Pakistani woman. Sikander has received many awards and honors for her work, including the honorary artist award from the Pakistan Ministry of Culture and National Council of the Arts. Sikander resides in New York and Texas.

James Turrell

James Turrell was born in Los Angeles in 1943. His undergraduate studies at Pomona College focused on psychology and mathematics; only later, in graduate school, did he pursue art. He received an MFA in art from the Claremont Graduate School in Claremont, California. Turrell's work involves explorations in light and space that speak to viewers without words, impacting the eye, body, and mind with the force of a spiritual awakening. "I want to create an atmosphere that can be consciously plumbed with seeing," says the artist, "like the wordless thought that comes from looking in a fire." Informed by his studies in perceptual psychology and optical illusions, Turrell's work allows us to see ourselves "seeing." Whether harnessing the light at sunset or transforming the glow of a television set into a fluctuating portal, Turrell's art places viewers in a realm of pure experience. Situated near the Grand Canyon and Arizona's Painted Desert is Roden Crater, an extinct volcano the artist has been transforming into a celestial observatory for the past thirty years. Working with cosmological phenomena that have interested man since the dawn of civilization and have prompted responses such as Stonehenge and the Mayan calendar, Turrell's crater brings the heavens down to earth, linking the actions of people with the movements of planets and distant galaxies. His fascination with the phenomena of light is ultimately connected to a very personal, inward search for mankind's place in the universe. Influenced by his Quaker faith, which he characterizes as having a "straightforward, strict presentation of the sublime," Turrell's art prompts greater self-awareness through a similar discipline of silent contemplation, patience, and meditation. His ethereal installations enlist the common properties of light to communicate feelings of transcendence and the Divine. The recipient of several prestigious awards such as Guggenheim and MacArthur Fellowships, Turrell lives in Arizona.

William Wegman

William Wegman was born in Holyoke, Massachusetts, in 1943. He graduated from the Massachusetts College of Art, Boston, in 1965 with a BFA in painting, then enrolled in the Masters painting and printmaking program at the University of Illinois, Champaign-Urbana, receiving an MFA in 1967. After teaching at various universities, Wegman's interests in areas beyond painting ultimately led him to photography and the infant medium of video. While living in Long Beach, California, Wegman acquired Man Ray, the dog with whom he began a fruitful twelve-year collaboration. Man Ray became a central figure in Wegman's photography and videos, known in the art world and beyond for his endearing deadpan presence. In 1972, Wegman and Man Ray moved to New York. In 1986, a new dog, Fay Ray, came into Wegman's life, and soon thereafter another famous collaboration began, marked by Wegman's use of the Polaroid 20 x 24 camera. With the birth of Fay's litter in 1989 and her daughter's litter in 1995, Wegman's cast grew. His photographs, videos, paintings, and drawings have been exhibited in museums and galleries internationally. A retrospective of his work traveled to museums throughout Europe and the United States, including the Whitney Museum of American Art in New York. His most recent exhibitions have gone to Japan, Sweden, and the Orange County Museum of Art in California. Wegman lives in New York and Maine.

Andrea Zittel

Andrea Zittel was born in Escondido, California, in 1965. She received a BFA in painting and sculpture in 1988 from San Diego State University, and an MFA in sculpture in 1990 from the Rhode Island School of Design. Zittel's sculptures and installations transform everything necessary for life—such as eating, sleeping, bathing, and socializing—into artful experiments in living. Blurring the lines between life and art, Zittel's projects extend to her own home and wardrobe. Wearing a single outfit every day for an entire season, and constantly remodeling her home to suit changing demands and interests, Zittel continually reinvents her relationship to her domestic and social environment. Influenced by modernist design and architecture from the early part of the twentieth century, the artist's one-woman mock organization, "A–Z Administrative Services," develops furniture, homes, and vehicles for contemporary consumers with a similar simplicity and attention to order. Seeking to attain a sense of freedom through structure, Zittel is more interested in revealing the human need for order than in prescribing a single unifying design principle or style. "People say my work is all about control, but it's not really," she remarks. "I am always looking for the gray area between freedom—which can sometimes feel too open-ended and vast—and security—which may easily turn into confinement." Her *Pocket Property*, a 44-ton floating fantasy island off the coast of Denmark commissioned by the Danish government, contrasts the extremes of a creative escape with the isolation that occurs when a person is removed from society. Altering and examining aspects of life that are for the most part taken for granted, Zittel's hand-crafted solutions respond to the day-to-day rhythms of the body and the creative need of people to match their surroundings to the changing appearance of life. Zittel lives in California and New York.

Index

Page numbers in *italics* refer to illustration captions.

Photographic Credits and Copyrights

PLACE: fig. 1, © Museum of the City of New York; fig. 2, photo by Will Brown, courtesy Mr. and Mrs. David Pincus; figs. 3–10, courtesy Edwynn Houk Gallery, New York; fig. 11, photo by Tseng Kwong Chi, courtesy Tony Shafrazi Gallery, New York, © Keith Haring Foundation; fig. 12, courtesy Deitch Projects, New York; figs. 13, 15–18, 20–22, Photos by Robert Wedemeyer, courtesy Deitch Projects, New York; figs. 14, 23, photos by Tom Powel, courtesy Deitch Projects, New York; fig. 19, photo by North Bank Fred, courtesy the artists; fig. 24, photo by Tony Velez, courtesy Bernice Steinbaum Gallery, © Pepón Osorio; fig. 25, courtesy Ronald Feldman Fine Arts, New York; fig. 26, photo by Sarah Wells; figs. 27, 28, photos by Gloria O'Connel, courtesy Bernice Steinbaum Gallery, © Pepón Osorio; fig. 29, photo by Adam Wallacabage, courtesy the artist; fig. 30, photo by Peter Moore; fig. 31, photo by Ann Chauvet; fig. 32, photo by Robert McKeever; figs. 33–35, 37, photos by Dirk Reinartz, Buxtehude; fig. 36, photo by Erika Barahona, courtesy the Guggenheim Museum, Bilbao; fig. 38, photo by Marcia Resnick, courtesy the artist; fig. 39, courtesy the artist.

SPIRITUALITY: fig. 1, photo by Gordon R. Christmas, courtesy PaceWildenstein; fig. 2, photo by Douglas M. Parker, L.A., courtesy The Rothko Chapel; figs. 3, 4, photos by Joe Aker, courtesy Live Oak Friends, Houston and the artist, © Aker/Zvonkovic Photograph; fig. 5, photo by Paula Goldman, courtesy Mondrian, West Hollywood, California; fig. 6, photo by Jean-Luc Terradillos, courtesy Barbara Gladstone; figs. 7, 8, courtesy the Museum of Fine Arts, Houston; fig. 9, photo by Dick Wiser, courtesy The Skystone Foundation and Barbara Gladstone; fig. 10, photo by Florian Holzherr, courtesy the artist; figs. 11, 12, photo by Paul Hester, courtesy the Contemporary Arts Museum, Houston, TX; fig. 13, photo by Jenni Carter, courtesy Sean Kelly Gallery, New York; fig. 14, photo by Thibault Jeanson, courtesy Sean Kelly Gallery, New York; figs. 15, 16, photos by Tom Cogill, courtesy the Bayly Art Museum; fig. 17, courtesy the artist; fig. 18, photo by Luccio Pozzi, courtesy the artist; figs. 19–22, 26, 27, photos by the artist, courtesy the artist; figs. 23, 24, courtesy Sacred Circle Art Gallery; fig. 25, photo by Richard Nicol, courtesy the City of Seattle; figs. 28–33, 35, photos by Tom Powel, cour-

tesy Deitch Projects, New York; fig. 34, courtesy the Whitney Museum of American Art and the artist; figs. 36, 39, photos by Mary Lucier, courtesy the artist; figs. 37, 38, courtesy the artist; fig. 40, photo by Fred Scruton, courtesy the artist; fig. 41, photo by Didi Sattmann, courtesy the artist; figs. 42, 43, digital stills by Beryl Korot, courtesy the artist; fig. 44, photo by Hester + Hardaway, courtesy the artist and Bonakdar Jancou Gallery, New York, and Galeria Camargo Vilaça, São Paulo; fig. 45, courtesy Barbara Gladstone; fig. 46, photo by Mitsuhiko Suzuki, courtesy Eriko Osaka, Contemporary Art Center, Mito-City, Japan; fig. 47, photo by Carlo Valsecchi, courtesy Ceretto Aziende Vitivinicole, Alba, Italy.

IDENTITY: figs. 1–6 © 2001 William Wegman; figs. 7, 8, 10, courtesy Leo Castelli Gallery, New York, © 2001 Bruce Nauman/Artists Rights Society (ARS), New York; figs. 9, 11, 12, courtesy Sperone Westwater, New York, © 2001 Bruce Nauman/Artists Rights Society (ARS), New York; figs. 13, 14, courtesy Donald Young Gallery, Chicago, © 2001 Bruce Nauman/Artists Rights Society (ARS), New York; fig. 15, photo by Michael Tropea, courtesy Donald Young Gallery, © 2001 Bruce Nauman/Artists Rights Society (ARS), New York; fig. 16, photo by Peter Bellamy, courtesy Cheim+Read, New York; figs. 18, 27, photo by Peter Bellamy; figs. 20–23, photo by Allan Finkelman; fig. 24, photo by Beth Phillips, courtesy the artist; fig. 25, photo from Louise Bourgeois's archive; fig. 26, photo by Jeffrey Clements; figs. 33, 37, courtesy of Jack Shainman Gallery, New York; fig. 36, photo by Walker—Missouri Commerce; fig. 39, photo by Tom Vand Eynde; figs. 41–43, 46, photo by Jackson Smith, courtesy South Eastern Center for Contemporary Art and Gagosian Gallery, New York; fig. 44, photo by the artist, courtesy the artist; fig. 45, photo by John O'Hagan, courtesy the Southern Poverty Law Center; fig. 47, photo by Tim Thayer, courtesy the artist; fig. 48, photo © George Hirose, courtesy Whitney Museum of American Art.

CONSUMPTION: fig. 1, photo by Walter Steinkopf; fig. 2, photo by Routhier; fig. 5, courtesy the artist; fig. 6, photo by Art Resource, New York, © The Andy Warhol Foundation for the Visual Arts/ARS New York; fig. 7, © Jeff Koons; figs. 9, 10, courtesy Mary Boone Gallery, New York; fig. 11, photo by Fredrik Marsh, courtesy Wexner Center for the

Arts; figs. 12–19, photo by Beth Phillips, courtesy Tony Shafrazi Gallery, New York; figs. 20–24, courtesy the artist; fig. 23, photo by USDA; fig. 24, photo by the Walker Art Center; fig. 25, courtesy the GALA Committee; fig. 26, photo by the GALA Committee, courtesy the GALA Committee; figs. 27, 28, photo by Paula Goldman, courtesy the GALA Committee; fig. 29, photo by Robert Fogt, courtesy Frederieke Taylor Gallery; fig. 30, courtesy the KNOWMAD Confederacy; figs. 31, 32, 36, 39, photos by Andrea Zittel, courtesy the artist; fig. 33, photo by Orcutt & Van Der Putten, courtesy Andrea Rosen Gallery, NY; figs. 34, 35, courtesy Andrea Rosen Gallery, New York; fig. 37, photo by Orcutt & Van Der Putten, courtesy the artist; fig. 38, photo by Jens Rathman, courtesy the artist; fig. 40, 42, photo by Peter Strietmann, courtesy Barbara Gladstone; figs. 41, 43, 44, photo by Michael James O'Brien, courtesy Barbara Gladstone; figs. 45, 47, photo by Chris Winget, courtesy the artist and Barbara Gladstone; fig. 46, courtesy ESTO, Mamaroneck, New York, © Peter Mauss; fig. 48, photo by Anne Wehr; fig. 49, photo by Peter Muscato, © The Estate of Felix Gonzales-Torres/Andrea Rosen Gallery, New York; fig. 50, photo by Dennis Cowley, courtesy the artist and Max Protetch Gallery, New York

Poetry Courtesy Credits:

PLACE: The lines from Part II "Here is a map of our country": from "An Atlas of the Difficult World," from AN ATLAS OF THE DIFFICULT WORLD: Poems 1988–1991 by Adrienne Rich. Copyright © 1991 by Adrienne Rich. Used by permission of the author and W.W. Norton & Company, Inc.

SPIRITUALITY: Excerpt from "The Cardinal" from KNEES OF A NATURAL MAN: THE SELECTED POETRY OF HENRY DUMAS by Henry Dumas. Used by permission of Loretta Dumas, Eugene B. Redmond, and the Estate of Henry Dumas.

IDENTITY: Gertrude Stein line is courtesy the Estate of Gertrude Stein.

CONSUMPTION: Excerpt from "Laughing Gravy" from WAKEFULNESS by John Ashbery. Copyright © 1998 by John Ashbery. Reprinted by permission of Farrar, Straus and Giroux, LLC.

SHIT AND DIE	SHIT AND LIVE
PISS AND DIE	PISS AND LIVE
EAT AND DIE	EAT AND LIVE
SLEEP AND DIE	SLEEP AND LIVE
LOVE AND DIE	LOVE AND LIVE
HATE AND DIE	HATE AND LIVE
FUCK AND DIE	FUCK AND LIVE
SPEAK AND DIE	SPEAK AND LIVE
LIE AND DIE	LIE AND LIVE
HEAR AND DIE	HEAR AND LIVE
CRY AND DIE	CRY AND LIVE
KISS AND DIE	KISS AND LIVE
RAGE AND DIE	RAGE AND LIVE
LAUGH AND DIE	LAUGH AND LIVE
TOUCH AND DIE	TOUCH AND LIVE
FEEL AND DIE	FEEL AND LIVE
FEAR AND DIE	FEAR AND LIVE
SICK AND DIE	SICK AND LIVE
WELL AND DIE	WELL AND LIVE